EXPLORING COLOR

REVISED EDITION

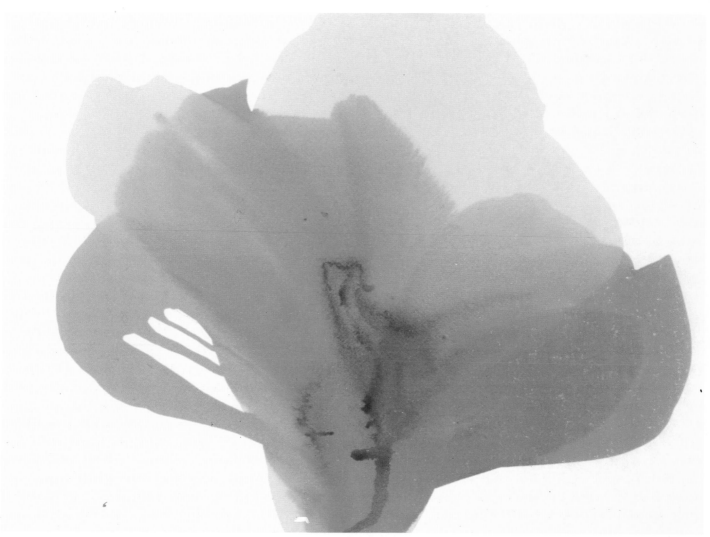

ORCHID
Paul St. Denis
Acrylic and watercolor on paper
22"× 30" (55.9cm × 76.2cm)
Collection of the artist

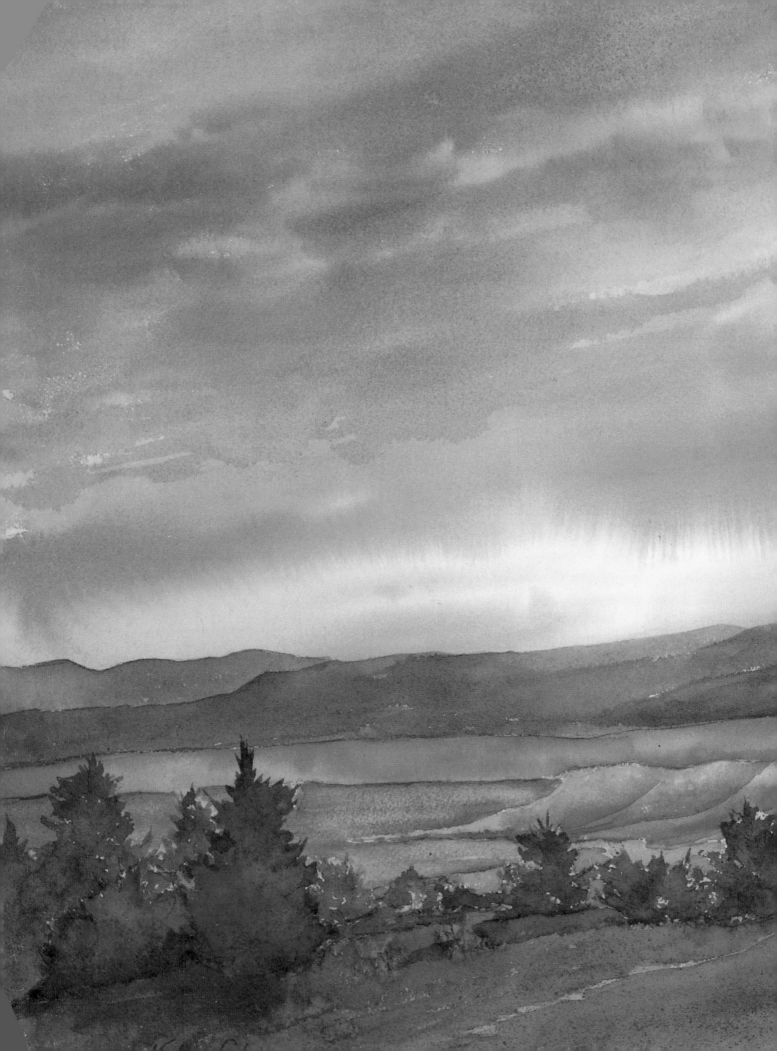

Exploring Color

REVISED EDITION

NITA LELAND

NORTH LIGHT BOOKS
CINCINNATI, OHIO

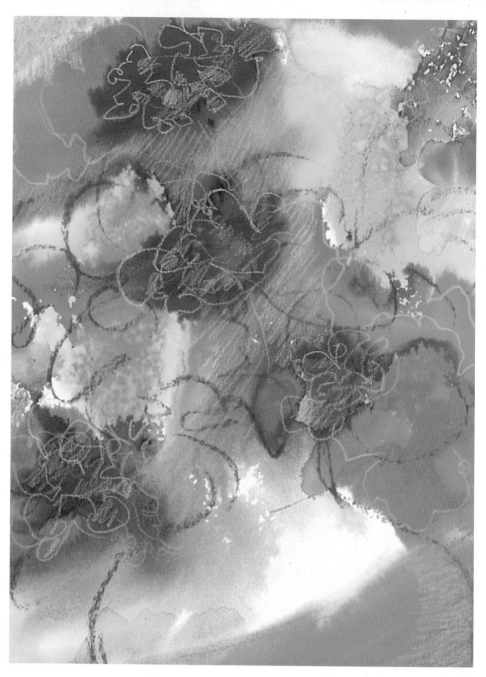

BOUQUET
Nita Leland
Acrylic, charcoal, colored pencil and
pastel on illustration board
10" × 8" (25.4cm × 20.3cm)
Collection of Francesca Tabor-Miolla

**Library of Congress Cataloging in
Publication Data**

Leland, Nita
 Exploring color/Nita Leland—Rev. ed.
 p. cm.
 Includes bibliographical references and
index.
 ISBN 0-89134-846-8 (pbk.: alk. paper)
 1. Color in art. I. Title.
 ND 1488.L44 1998
701'.85—dc21 98—16932

Edited by Pamela Seyring
Production edited by Patrick Souhan and
 Marilyn Daiker
Cover and interior designed by Sandy
 Conopeotis Kent
Interior production by Ruth Preston
Cover illustration: *Garden Series 263—
 Garden Border* by Mary Jane Schmidt,
 acrylic on canvas, 72"× 60"(182.9cm ×
 152.4cm), private collection.

The permissions on page 141 constitute an
extension of this copyright page.

Previous page: ICON II, *Nita Leland, water-
color on paper, 18"× 24" (45.7cm × 61cm), collection
of Audrey and Gordon MacKenzie*

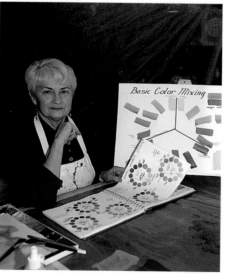

CREDIT: SHARON HUBBARD

ABOUT THE AUTHOR

Nita Leland started her art career in 1970
in a YMCA watercolor painting class, and
now she travels throughout the United
States and Canada as a professional artist,
teacher, author, lecturer and juror.
Designer of the Nita Leland™ Color
Scheme Selector and a featured artist in
Exploring Color Workshop videos, Nita is
the author of three best-selling art instruc-
tion books published by North Light
Books: *Exploring Color, The Creative Artist*
and *Creative Collage Techniques* (with
Virginia Lee Williams). Her informative
articles on color and collage have appeared
in *Watercolor, Watercolor Magic, The
Watercolour Gazette, Art Materials Today*
and *ColorQ Connection.*

ACKNOWLEDGMENTS

As a teacher, I owe my greatest thanks to my students, whose ongoing feedback and support are invaluable. As a student myself, I acknowledge my debt to some special teachers: Br. Joseph Barrish, Mary Todd Beam, Edward Betts, Glenn Bradshaw, Virginia Cobb, Mario Cooper, Ralph Creager, Bing Davis, Jeanne Dobie, Nita Engle, Homer O. Hacker, Barbara Nechis, Joan Ashley Rothermel and Edgar Whitney. Heartfelt thanks to my family, who are always there for me. I'm grateful to Fritz Henning for finding merit in my original manuscript and to David Lewis and North Light Books for believing *Exploring Color* worthy of this revised edition; also, to Rachel Wolf, Pamela Seyring, Marilyn Daiker, designer Sandy Conopeotis Kent, Ruth Preston, Michelle Howry and Patrick Souhan for their contributions. Thanks to George Bussinger and Lesley Walton of McCallister's Art Store, Mark Golden and Michael Townsend at Golden Artist Colors, Inc. and Wendell Upchurch and Lynn Pearl of Winsor & Newton for technical information. And finally, I'm deeply indebted to the artists whose magnificent works grace the pages of this book.

DEDICATION

In loving memory of my parents,

Carl E. and Martha S. Shannon

and to R.G.L.

RAINBOW FALLS
Nita Leland
Watercolor on paper
19" × 12" (48.3cm × 30.5cm)

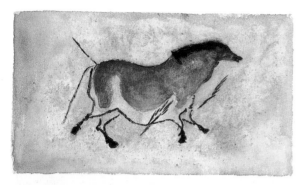

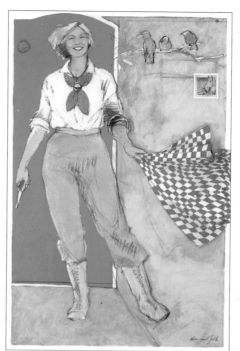

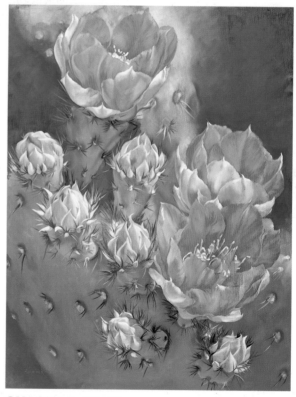

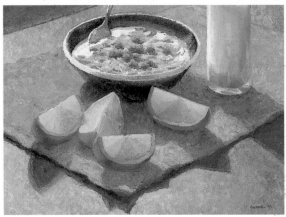

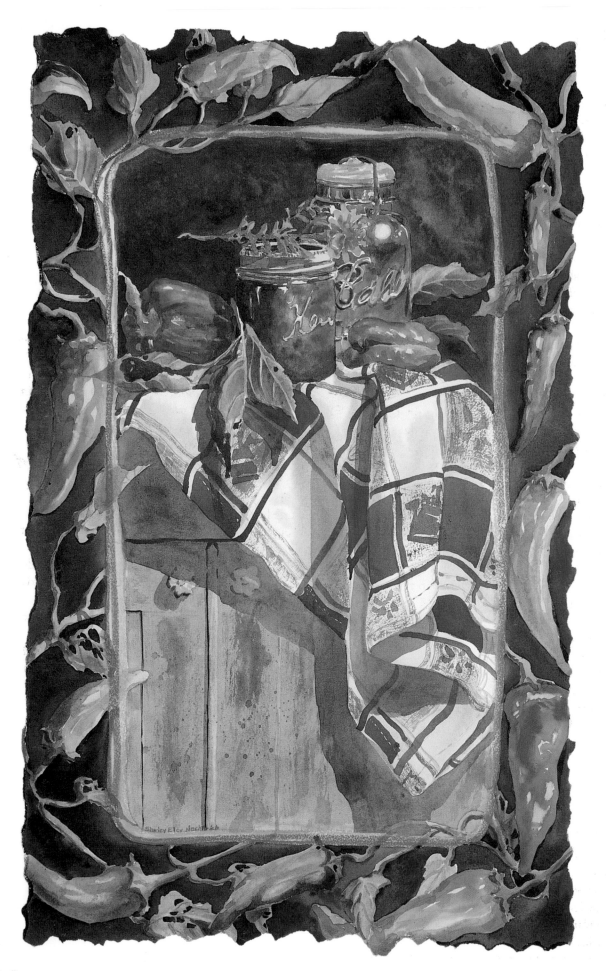

SALSA GARDEN
Shirley Eley Nachtrieb
Watercolor and water-
color crayons on paper
29" × 17¹/2"
(73.7cm × 44.5cm)
Collection of the artist

Study Other Artists

Examine the work
throughout this book
to see how artists use
color. For example,
notice how the color
patterns in this still life
are picked up in the
border and keep the
eye circulating
throughout the entire
piece. This helps to
unify the painting,
while dynamic con-
trasts between comple-
mentary colors make
the colors sing.

Introduction

Art without color? Inconceivable! But why settle for ordinary color when you can create works of radiant color? Play with color and have fun while you learn. Any artist in almost any medium can adjust and do most of the exercises in this book. Collect as many color samples or paints as you can, and use them for the exercises. Share with your artist friends and make exploring color a group project. As you do the exercises, you'll see that mastery of color is an achievable goal. Exploring color will make you aware of your color preferences and strengthen your color knowledge.

When we start out in art, our instructors usually emphasize values and shapes rather than color. That's good, because values are easy to understand. Shapes are, too, since we identify objects by their shapes. But values and shapes make contact with the intellect. Color touches the heart. Now, discover the joy of color.

Color is important, whether you're a fine artist, graphic designer, decorative painter or fiber artist. After all, to paint is to color a surface; to weave is to mingle colors. But do you really know what you're doing with color? How much time do you spend in trial and error, looking for suitable paint, the right color or the best mixture? Suppose you want to mix a sky color, a skin color or a tree color. Or perhaps you need to match a color for a specific application. Can you use a recipe? Formulas may offer temporary solutions, but one-size-fits-all doesn't work with

> 'The elements of color theory have been neither analyzed nor taught in our schools of art....according to the saying, Draughtsmen may be made, but colorists are born. Secrets of color theory? Why call those principles secrets which all artists must know and all should have been taught?'
>
> EUGÈNE DELACROIX

color. Develop your color sensitivity and color knowledge, so you can use color with confidence, devising your own solutions to color problems with style and elegance.

COLOR CAN BE LEARNED

More than one teacher told me that color can't be taught—that it is intuitive. But the great colorists of the nineteenth century, J.M.W. Turner, Eugène Delacroix and Vincent van Gogh were well versed in color theory and science. Their beautiful color was no happy accident. And you can have fantastic color, too. This book will help you:

- develop your appreciation of color science, history and theory
- build your color vocabulary
- explore the strengths, limitations and idiosyncrasies of your paints or medium of choice
- make intelligent choices from basic and expanded palettes

- understand and use color schemes and design
- experiment and develop distinctive ways of using color based on sound theory

Reserve some time every day to do an exercise from this book. Play with color in any medium or make a sketch. In no time you'll be solving the mysteries of color, well on your way to becoming a master colorist. Johannes Itten wrote in *The Art of Color*, "[Color] affords utility to all, but unveils its deeper mysteries only to its devotees." That means if you love color, you can unlock its secrets—if you work at it. Color can be learned. Mastering basic color mixing, exploring compatible triads and using expanded palettes, you'll build a solid foundation for creative color.

If you don't understand color, you're a traveler who left your luggage at home. Sooner or later you'll have to go back and get it, if you want to go very far. So begin your travels now in the world of color— and have a great trip.

Explore Other Media

In exploring color you can use every type of artists' paint, pastel, oil pastel, colored pencil, yarn, fabric or paper collage— whatever medium you work with. Make color collages with Color-aid papers to design your paintings; or make watercolor or acrylic sketches to plan your oil canvases. Color knows no boundaries in art media.

Exploring the History, Science and Theory of Color

Connecting With the Past

> 'The use of expressive colors is felt to be one of the basic elements of the modern mentality, an historical necessity, beyond choice.'
>
> HENRI MATISSE

When I saw the great Hall of the Bulls at Lascaux, France, in 1956, I was awed by the lines and colors applied by prehistoric artists on the wall of a cave more than twenty thousand years ago. You and I are the spiritual heirs of these unknown artists. From cave paintings to contemporary art, color has evolved from the use of simple, natural materials to a complex modern science. The colors we see today in decorative and practical arts, as well as in the fine and graphic arts, derive from a growing understanding of how color works.

EARLY USES OF COLOR: A CHROMATIC ODYSSEY BEGINS

Early civilizations made colored pigments from available materials, using them mostly to decorate functional objects like pottery and tiles. In the Middle Ages, colors in illuminated manuscripts and stained-glass windows were flat with few value or color gradations, because techniques for applying colors were simple and didn't allow for modeling of three-dimensional form. More symbolic than descriptive, colors often had religious meanings.

The Renaissance was a cultural and artistic revolution that originated in northern Italy in the fourteenth century. Renaissance artists depicted their subjects more realistically than did medieval artists, for a number of reasons. As attitudes centered more on individual human interests, painting for private ownership increased and the demand for portraits grew. Most Renaissance painters used a relatively limited palette, emphasizing value rather than color. For example, the use of chiaroscuro, favored by Leonardo da Vinci, as well as others, featured strong contrasts of light and dark values. Many artists started with *grisaille*, a monochrome underpainting in umber or gray, to establish forms through values, then applied color in transparent glazes over this neutral underpainting.

Improved materials for oil painting appeared early in the fifteenth century, and easel painting joined architectural embellishment as proper study for an artist. Matthias Grünewald was one of just a few artists still working in a medieval style to display the richness of a master colorist in his Isenheim altarpiece (ca. 1515).

In the sixteenth century, value was still preeminent, but color was employed with subtlety and grandeur. Titian used color as a design element, repeating colors to enhance pictorial unity. El Greco departed from custom with highly emotional color and a distinctive distortion of form. Peter Paul Rubens followed Titian's lead, but Caravaggio and Velázquez continued value traditions of earlier masters. In the seventeenth century, Rembrandt also emphasized value relationships in powerful portraits of his contemporaries, while Jan Vermeer painted stunning effects of light in his remarkable interior scenes.

During the seventeenth and eighteenth centuries, color expression was secondary to storytelling, while strict control by the art academies and the demands of wealthy patrons determined what and how artists would paint. The magnificent craftsmanship of Jacques-Louis David and Jean-Auguste-Dominique Ingres was the hallmark of such neo-Classical art, which relegated color to a minor role.

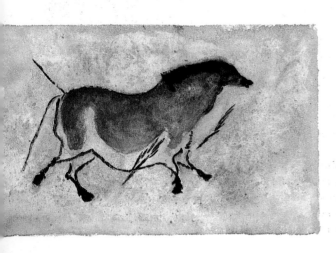

Making Art Is Human Nature
This simulation of a Lascaux, France, cave painting (ca. 20,000 B.C.) mimics the way prehistoric painters used such materials as clay, berries, animal substances, charred wood, and iron and manganese oxides. They mixed these substances with water or animal fat, then brushed or blew them onto the cave walls to make timeless art. Dampness sealed the images into the rock, and lack of exposure to air and light preserved them.

THE NINETEENTH CENTURY: COLOR COMES INTO ITS OWN

The early nineteenth century marked the beginning of an upward spiral for color, when J.M.W. Turner and Eugène Delacroix began using color as a vital, expressive element in painting. Turner defied classical and academic traditions, both in color and technique, by painting luminous, nearly abstract canvases and watercolors.

Delacroix recorded his color observations and details of the colors he used. He regarded good color as fundamental to fine painting. Still, during this Romantic period of the nineteenth century, artists adhered to strict academic standards that placed drawing and illustration above color, usually painting religious or historical subjects. John Constable was among the first to turn to landscape as a subject, but he, too, used representational color.

Near the end of the nineteenth century, artists explored theoretical relationships of colors using new, synthetic pigments created in the laboratory. Delacroix's dissertations, along with M.E. Chevreul's *The Law of Simultaneous Contrast of Colors* and Ogden Rood's *Modern Chromatics*, became a point of departure for Impressionist and neo-Impressionist explorations into color as light.

Impressionist painters, united by a spirit of rebellion against academic standards, ignored academic rules and stepped outside to paint light, using color theory to support their observations. Their revolt evolved into a quasi movement aimed at freeing art from classical tradition, with new ideas centered on light and color. Impressionist painters recorded changing light and color bouncing and reflecting from one object to another. For example, Claude Monet was preoccupied with capturing the quality of light at different times of day. As the Impressionists de-emphasized value contrasts, their colors appeared more luminous. James A. McNeill Whistler used color that reflected the influence of both Japanese art (Oriental woodcuts were finding their way to European markets) and the Impressionists.

The invention of photography also spurred artists to look within themselves for subject matter beyond the reach of the camera, using color to express emotion, to make visible the invisible.

Though the fellowship of Impressionists scattered, their central ideas about color and light continued. Georges Seurat, one pioneer of Pointillism (also known as neo-Impressionism), juxtaposed small dots of color, reasoning that pigments would reflect more brilliantly if mixed by the eye, rather than on the palette.

Vincent van Gogh, one of the greatest post-Impressionists, recorded intense feeling with blazing color and violent brushstrokes. The canvases of his friend Paul Gauguin are also brilliantly colored and alive with symbolism. By the end of the nineteenth century, Paul Cézanne was creating form primarily through value and temperature change—not an illusion of three-dimensional form, but a two-dimensional representation of limited space and volume.

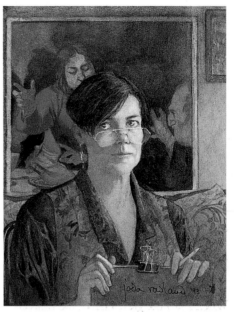

ME IN MILAN
Jada Rowland, watercolor on paper
9" × 7" (22.9cm × 17.8cm), collection of the artist

Connect With Tradition

Rowland has cleverly incorporated an image of an old master painting in her self-portrait, painted in the warm tonality of the early painters. The result is a unified color effect that reaches back in time to connect with artistic tradition. Study the masters and use their color ideas to create a sense of time and place.

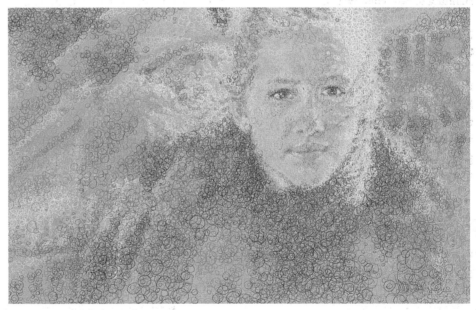

STILL HOPEFUL, *Maggie Toole, colored pencil on rag board, 16" × 30" (40.6cm × 76.2cm)*

Contemporary Technique Based on Tradition

In the spirit of Impressionism, a major movement in nineteenth-century art, Toole uses high-key values to express a luminous light, avoiding strong darks. She calls her contemporary colored pencil technique *circulism*, drawing entirely with circles, resulting in an appearance similar to the optical mixing of Pointillism, a technique practiced by some neo-Impressionists.

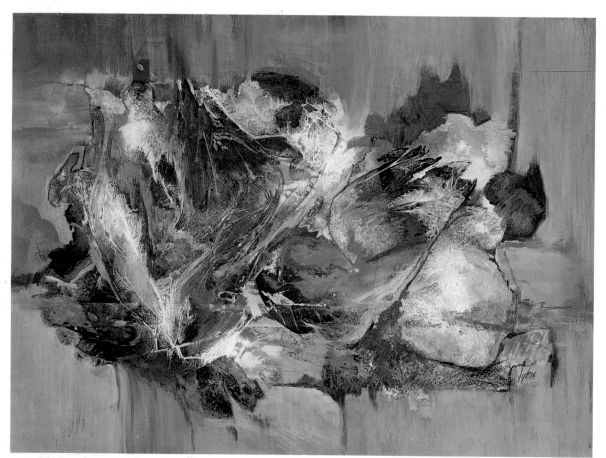

FIRE OPAL
Ortrud M. Tyler
Acrylic and inks on paper
22" × 30"
(55.9cm × 76.2cm)
Collection of the artist

Vibrant Color Expression

During the twentieth century, color advanced well beyond the limitations of natural colorants. A more vibrant color expression is possible with synthetic paints, along with a freer hand when applying the paint. As in Tyler's colorful painting, the trick is to make color relationships work, using a combination of logical color principles and your intuition.

THE TWENTIETH CENTURY: COLOR GOES IN AND OUT OF STYLE

At the turn of the twentieth century, Fauvism erupted with the uninhibited, decorative use of pure color as the all-important theme. Thus Maurice de Vlaminck and Henri Matisse led the way to the powerful Expressionist ideal of color as a way to express emotion. The Expressionists painted impulsively, with passion and drama. Emil Nolde, Marc Chagall, Paul Klee and Franz Marc all used color with apparent abandon. Wassily Kandinsky, a pioneer of abstract painting, wrote of the inner necessity of artists to express themselves freely, but he and many of the others possessed a solid grounding in color theory.

Cubism, the first abstract art style of the twentieth century, largely abandoned color. The movement was led by Pablo Picasso, Georges Braque and Juan Gris. Cubist paintings used a virtually monochromatic palette, representing objects seen from several viewpoints. Cubists suggested a shallow illusion of depth with value gradation, declaring that three-dimensional representation was a violation of the integrity of the two-dimensional picture plane.

But color was still around in the early twentieth century. Robert Delaunay developed an abstracted style called Orphism that revered color as the soul of painting: color for its own sake. Not technique, not values, not form—only colors and their relationships mattered.

Delaunay and Hans Hofmann laid the foundation for Abstract Expressionist painters such as Helen Frankenthaler, color-field painter Mark Rothko, and Kenneth Noland, whose colorful paintings vibrate on the walls. Anni Albers, a talented textile artist, struck down color taboos in the fiber arts in the 1950s.

Minimal, conceptual and environmental art then eclipsed color in the late 1950s and 1960s. Along with movements that glorify color, opposing schools have continued to appear in which movement, shape, techniques and materials acquire greater significance than color. But color always makes a comeback as a powerful symbolic tool for artistic expression.

E X E R C I S E

Do You Know What You Like?

Find out what colors resonate with you by starting a color journal in a sketchbook. First, make a list of artists whose work you like. Then study their work by visiting a museum, art gallery, library or bookstore, or by browsing the Internet. Original art is best, of course, because color reproductions may not be accurate. Figure out what you like most about these artists. Is it brilliant color or strong values? Can you distinguish between value painters and colorists? Do you like unusual color? Do you prefer subtlety to boldness? Write down your reactions. Get a sense of what attracts you—and what you don't like—so you can relate this information to what you learn as you explore color. ■

The Science of Color

Color is a culturally conditioned phenomenon that virtually shapes our world. This fact influences color theory and color perception to a surprising degree. Physiologists study color sensation and how the eye perceives color. Psychologists research the mystery of how the brain interprets color. Physicists deal with light as the source of color, a measurable entity. Chemists investigate pigments, which reflect the colors that we see. Color theorists and artists alike study how colors affect each other in mixtures and relationships in art and design.

COLOR PERCEPTION

Science is beginning to understand how color is perceived and how different people see color. For example, we know about such phenomena as *simultaneous contrast* (the result of placing two colors side by side), *successive contrast* (the complementary afterimage that appears after an object is removed from view), *accidental color* (the consequence of injury, eye pressure or drug use) and *color constancy* (the accommodation of the eye for changes in illumination).

Visual perception depends primarily on the brain's interpretation of a stimulus received by the eye. Light stimulates normal color sensation in the eye, but the eye sometimes sees a color the brain tells it to see—even when the color isn't there. Human beings have a better sense of vision, as well as greater color perception, than many other animals, pointing to the important part played by the highly developed brains of humans in perceiving color. Color is one way the eye and the brain work together to define the external world. However, not all cultures see color in the same way, nor do they give it as much importance as in western culture.

HUMAN RESPONSE TO COLOR

To most people, color is important in decoration and personal adornment. The colors you surround yourself with in your clothing and home reflect your personality and affect your behavior.

Specialists believe appropriate color facilitates learning, hastens healing and increases production in the workplace. For example, in the late nineteenth century Edwin D. Babbitt gained fame with color healing, an aspect of popular psychology in the twentieth century as well. Such psychologists concern themselves with symbolic meanings and emotional responses to light and color.

Children tend to use color symbolically in their drawings and nearly always relate objects by color. Mystical interpretations of color appear in our earliest records, giving color remarkable powers in the hands of the tribal shaman, a religious leader who uses ritual magic to cure the sick and gain political control.

Specific qualities are sometimes assigned to individual colors, for example: red = excitement, courage; yellow = happiness, ebullience; blue = tranquility, serenity; green = fertility, pride; orange = tension, energy; violet = fantasy, magic. However, our language is replete with color expressions that deviate from the above list, for example: yellow coward, blue Monday, green envy and purple passion.

On a global scale, color has meanings that vary widely from one culture to another. Northern societies, where snow conditions revealed by subtle changes in the color of the snow are a matter of life or death, have many words for *white*. While western cultures associate white with purity, in some cultures white is the color of death.

Shape vs. Color
An object is identified by shape, no matter how bizarre its color. Apparently, shape recognition is a function of the intellect, while color awareness is intuitive. You have a great deal of freedom in choosing colors when you're working with a recognizable shape. A blue pear? A purple cow? You can be whimsical, dramatic, even absurd, if you like.

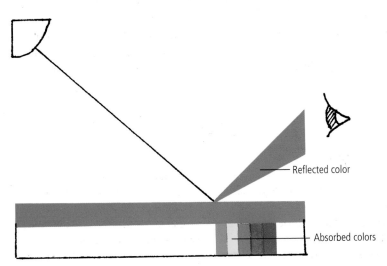

Reflected color

Absorbed colors

How We See Color
When white light strikes a surface, you see reflected light rays that are the color of the surface. All other colors naturally present in white light are absorbed.

The Physical Properties of Light

Physicists research how light is reflected, transmitted or absorbed. They measure the physical properties of light and characterize its movement, speed and color in precise scientific terms.

Sir Isaac Newton described the color *spectrum* in 1666, when he observed that sunlight separates into bands of bright colors when projected through a prism. More than a century later, Count Rumford found that individual colored lights, gathered together in correct proportions, combine into white light when projected through a prism—an inversion of Newton's discovery.

Scientists after Newton determined that the color of a pigmented object is observed when white light strikes its surface because the color of the object is reflected and the remaining light rays are absorbed (see illustration on page 13). This discovery led to the definition of two distinct types of color: *additive* and *subtractive*.

ADDITIVE COLORS

Additive color mixing is the scientific term for mixing colors in the form of light rays. It is important in theater lighting, television screens and computer monitors. As additive colors are mixed, the total light rays reflected from the surface they are projected on increases, so each additive mixture is perceived by the eye as lighter than the original colors combined to create it.

The additive primaries are red, green and blue-violet. When lights in these colors are combined (added), they produce

The Electromagnetic Spectrum
Light consists of a long band of radiant energy that includes invisible heat and infrared rays at one end, X rays and ultraviolet rays at the other. This band embraces a relatively short section of visible light rays, where all color resides, in what we call simply the *spectrum*.

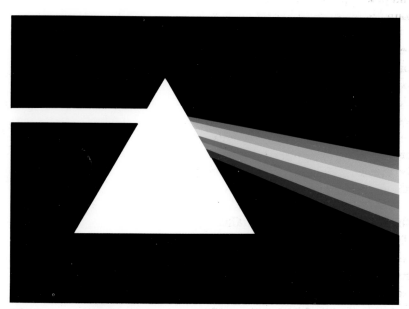

The Prism and White Light
Sir Isaac Newton named seven fundamental colors: red, orange, yellow, green, blue, indigo and violet. Why seven? Presumably because seven was considered a mystical number of great power. Indigo, which isn't a high-intensity hue like the six colors of the spectrum, is not included in most contemporary color theory.

the following secondaries: red + green = yellow; red + blue-violet = magenta; blue-violet + green = cyan. A mixture of all three colored lights of the correct intensity (red + green + blue-violet) results in white, because all colors are reflected and none are absorbed.

SUBTRACTIVE COLORS

Subtractive color mixing is the method of mixing transparent colors in such a way as to reduce the total light rays reflected from the color. Subtractive colors are pigment or dye mixtures that absorb (subtract) the light waves of all colors but those of the color of the pigment or dye, which is reflected and perceived by the eye, so each subtractive mixture is darker than the original colors combined to create it. These mixtures are usually connected with the transparent inks and dyes used in color photography and process printing but may also be found in transparent pigment mixtures.

The subtractive primaries are magenta, yellow and cyan. When transparent colorants in these primaries are mixed in printing and color photography, they produce the following secondaries: magenta + cyan = blue; magenta + yellow = red; yellow + cyan = green. When all of the colors are mixed together, the result is black, because the light waves of all the colors are absorbed and none are reflected.

ARTISTS' SUBTRACTIVE COLORS

The subtractive primaries of artists' pigments, which you no doubt recognize, differ from the subtractive primaries of the transparent colorants just described. Ground pigments, which contain impurities and lack spectral clarity, are more opaque than dyes, therefore it is difficult to mix pure colors. Ideally, red, yellow and blue pigments should produce the following secondaries: red + blue = violet; red + yellow = orange; yellow + blue = green (see "Basic Color Theory," page 16). These mixtures are always darker than the colors combined to create them. They are used with acrylics, gouache, oils, watercolors and other art media. As you work through this book, you'll learn how to make the subtractive primaries of artists' pigments work more effectively for you.

Additive and Subtractive Color

Each type of color mixture has a different set of primary colors. The additive colors that combine in light are red, green and blue-violet. Those of transparent colorants are magenta, yellow and cyan. The subtractive paint colors that mix to make all the others are red, yellow and blue. Read the adjacent text for a fuller explanation of how these mixtures work.

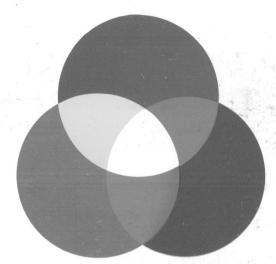

Additive primaries and secondaries (light)

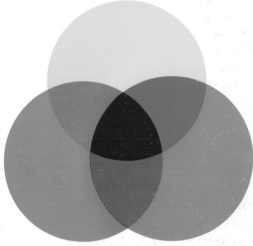

Subtractive primaries and secondaries (transparent colorants)

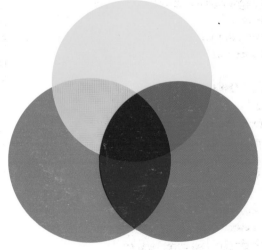

Subtractive primaries and secondaries (pigments)

Basic Color Theory

In basic color theory, the *primary colors*—red, yellow and blue—cannot be mixed from other colors. Mix the primaries to get *secondary colors:* red + yellow = orange; yellow + blue = green; blue + red = violet. Mix a secondary with the primary on either side of it on the color wheel to get *tertiary colors:* orange + yellow = yellow-orange; orange + red = red-orange; green + yellow = yellow-green; green + blue = blue-green; violet + blue = blue-violet; violet + red = red-violet.

Color Chemistry

Chemists study the structure of pigments, testing their characteristics and making paints from colorants. Starting with William Henry Perkin's discovery in 1856 of aniline dyes made from coal tar, the quality and performance of traditional artists' pigments have improved greatly in modern times. Many synthetic pigments now available have great beauty, strength and durability, and are safer for artists to use. Reliable substitutes replace most *fugitive colors* (colors that may fade or change color).

Conservators work continually to combat the harmful effects of contaminated air on artwork, relying on chemistry for restoration and preservation. Microscopic examination of colors to determine chemical properties combines with the physicist's expertise in analyzing the damaging effects of both visible and invisible electromagnetic energy to enable conservators to replicate colors in damaged art. Scientists have saved centuries-old paintings for us through their knowledge of the composition and permanence of pigments.

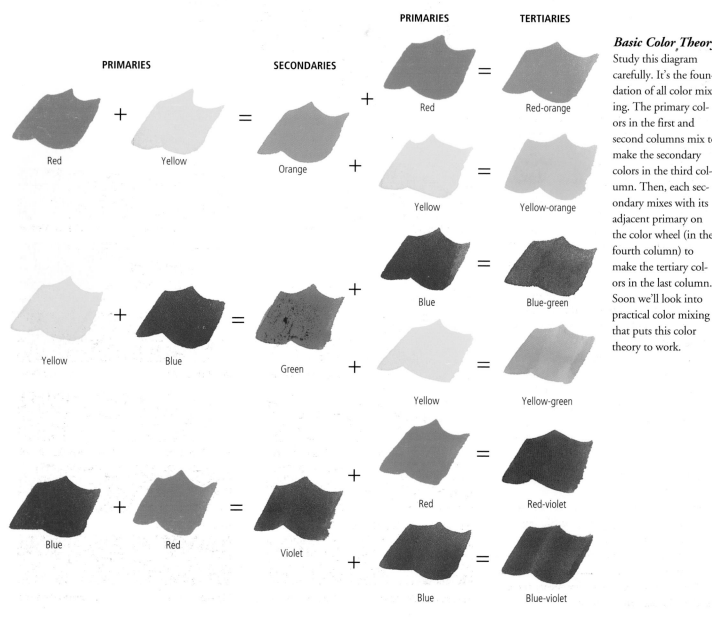

PRIMARIES SECONDARIES PRIMARIES TERTIARIES

Red + Yellow = Orange

Red + Red = Red-orange

Orange + Yellow = Yellow-orange

Yellow + Blue = Green

Blue + Blue = Blue-green

Green + Yellow = Yellow-green

Blue + Red = Violet

Red + Red = Red-violet

Blue + Blue = Blue-violet

Basic Color Theory

Study this diagram carefully. It's the foundation of all color mixing. The primary colors in the first and second columns mix to make the secondary colors in the third column. Then, each secondary mixes with its adjacent primary on the color wheel (in the fourth column) to make the tertiary colors in the last column. Soon we'll look into practical color mixing that puts this color theory to work.

Basic Triads

Three basic types of triads make up a complete *color wheel* of twelve colors, including three primaries (large circles), three secondaries (medium circles) and two sets of three tertiaries (small circles). Each triad is connected on this wheel by an equilateral color-coded triangle. Learn these triads well, so you can expand your color use beyond the traditional red, yellow and blue primaries.

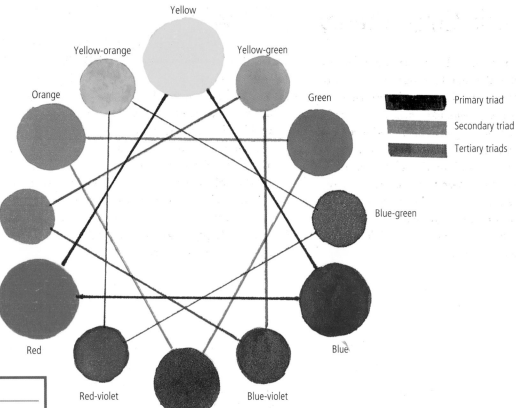

Yellow

Yellow-orange Yellow-green

Orange Green

Red-orange Blue-green

Red Blue

Red-violet Blue-violet

Violet

 Primary triad
Secondary triad
Tertiary triads

EXERCISE

Combining Assorted Primaries

See what mixtures you can make with the colors you have now. Sort your colors into groups of red, yellow and blue. Put all other colors aside. Then mix every combination of your different reds and yellows to see what oranges result. Label each mixture with the names of the colors you use. Repeat the exercise with every yellow and blue (for green), then with every red and blue (for violet). Study the mixtures for a while. Do some of them seem muddy? Look again. Maybe that dusky purple is just right for a blue grape, or the dull orange might be a good shadow color for a pumpkin. I'll bet the olive-green mixture looks more natural than a bright Phthalo Green. Learn to appreciate the unique beauty of different mixtures. You'll soon be able to make brighter mixtures when you want them. ■

Different Mixtures With Different Pigments

Which colors should you use for your primaries? Here's where theory begins to get confusing. You can see how different these acrylic mixtures are when I use different paint colors for my primaries. When you understand the characteristics of paint, you'll be better able to apply color theory and get just the color mixture you want.

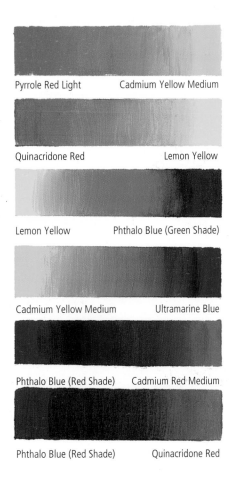

Pyrrole Red Light Cadmium Yellow Medium

Quinacridone Red Lemon Yellow

Lemon Yellow Phthalo Blue (Green Shade)

Cadmium Yellow Medium Ultramarine Blue

Phthalo Blue (Red Shade) Cadmium Red Medium

Phthalo Blue (Red Shade) Quinacridone Red

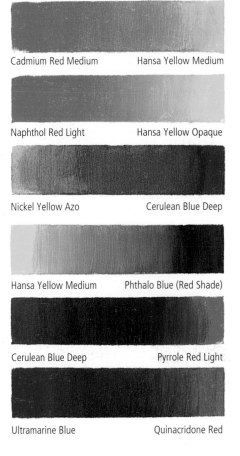

Cadmium Red Medium Hansa Yellow Medium

Naphthol Red Light Hansa Yellow Opaque

Nickel Yellow Azo Cerulean Blue Deep

Hansa Yellow Medium Phthalo Blue (Red Shade)

Cerulean Blue Deep Pyrrole Red Light

Ultramarine Blue Quinacridone Red

Color Systems

In the fourteenth century, Cennino Cennini wrote the first known treatise for artists, *Il libro dell'Arte* (ca. 1390), in which he set forth a color system for painters. During the fifteenth century, Leonardo da Vinci defined the property of value and the characteristics of the *psychological primaries* (colors that the eye sees as unmixed with other colors): red, yellow, green, blue, black and white. Then, in the sixteenth century, Newton devised the color circle, which set the stage for color theory as we know it but was inadequate for representing several aspects of color at once. In 1730, J.C. Le Blon detailed the primary nature of red, yellow and blue pigments, and described the secondary colors. Moses Harris, an engraver, published the first color wheel in full color in 1766.

CHEVREUL'S IDEAS

M.E. Chevreul, Director of Dyes at the Gobelins tapestry works in France, published his great work, *The Law of Simultaneous Contrast of Color*, in 1839. Chevreul touched on little-understood ideas of how the eye perceives color in myriad combinations, pointing out that the more colors and objects that appear in a composition, the more difficulty a viewer experiences in locating the focal point. Chevreul's experiments became the starting point for the explorations of the Impressionists in late nineteenth-century painting.

EXERCISE

Chevreul's Discovery

To see how your eye is affected by strong color, stare at the red X on this page for ten to twenty seconds, then look away at a white space. You'll see the complement (opposite) of red, which is green. Try it again, this time looking at the yellow area on the page. The complementary green mixes with the color you're looking at, turning yellow into yellow-green. This phenomenon— successive or mixed contrast—affects the way you see color as you work, so rest your eyes frequently when working intensely with color. ∎

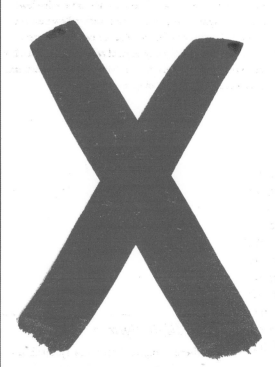

Successive or Mixed Contrast
Stare at the red X for several seconds, then look at the yellow swatch. The yellow-green X that appears on the yellow background is a mixture of yellow and the complement (green) of the red you were staring at.

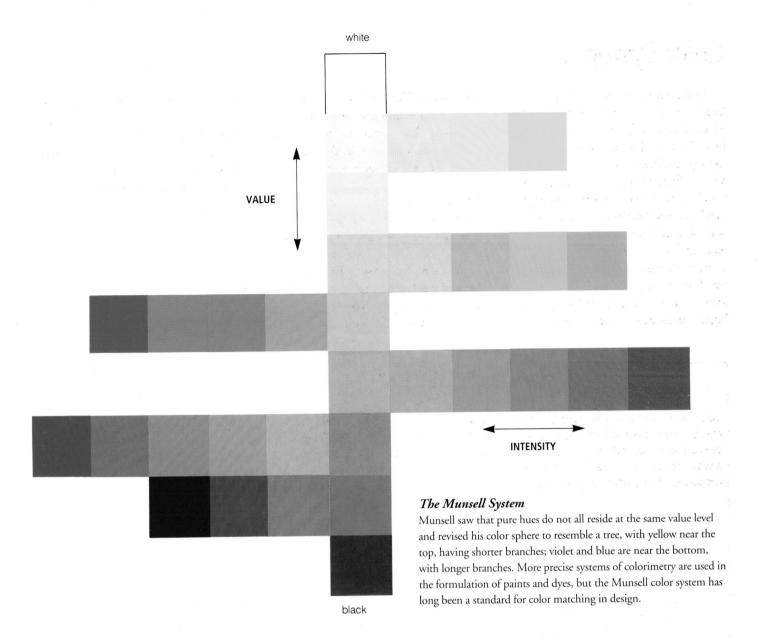

white

VALUE

INTENSITY

black

The Munsell System

Munsell saw that pure hues do not all reside at the same value level and revised his color sphere to resemble a tree, with yellow near the top, having shorter branches; violet and blue are near the bottom, with longer branches. More precise systems of colorimetry are used in the formulation of paints and dyes, but the Munsell color system has long been a standard for color matching in design.

MUNSELL'S COLOR SYSTEM

Eventually color theorists devised three-dimensional *color solids* to show changes of hues in value and intensity (see chapter two for more detailed explanations of these color characteristics) on a single structure. Albert C. Munsell developed a numerical color notation system (introduced in 1915 and still in use today) based on five colors: red, yellow, green, blue and purple. Munsell's original sphere contains ten pure hues around its perimeter. Colors mixed with white become *tints*, moving up a vertical scale; mixed with increasing amounts of black, they move down the scale, as *shades*. The colors also move on a horizontal scale toward the center, modified gradually in purity as they become neutral gray *tones*.

OTHER INFLUENCES ON COLOR THEORY

Color theoretician Josef Albers urged his students at the Bauhaus in Germany, and later in the United States at Yale University, to learn color through experience. Johannes Itten, in *The Art of Color* (1961), formulated experiments to raise students' awareness of the effects of color juxtaposition. Another leading theorist of the twentieth century, Faber Birren, wrote many books on aspects of color, from its mystical beginnings to the mundane walls of the workplace.

The Right System

Is there a single, right color system? Yes. The right color system for you is the one that gets the results you want. The systems described in this book give you many options to help you achieve those results.

Color in Your Art

Why bother with color theory? Why not simply use color formulas? Is color study worth the effort? You must answer these questions for yourself. You probably started out using your teacher's colors or copying a palette from a book. Perhaps you've been painting long enough to have developed a color style that clearly distinguishes your work from others. But do your colors always say what you want them to say? Do you find you're repeating yourself with colors? Do you limit your subjects only to those suitable for certain colors?

Learn color theory and experience for yourself how color works in your medium, because every medium has its own color idiosyncrasies. Then you can trust your intuition to lead you to unique color expression.

EXERCISE

Alizarin Crimson
New Gamboge

French Ultramarine

Explore Your Present Palette

Let's find out what you're doing with color now. Divide a sheet of paper, illustration board or canvas into four sections. Using the colors and the medium you're most familiar with, sketch the four seasons, or make abstract color sketches of this subject in collage or fibers. If you prefer, you can make a nonobjective design of geometric shapes. Be inventive with the colors you have, but don't experiment with new colors yet. These sketches are a record of how you use color now; they're not meant to be finished work. Keep them for comparison with later exercises. ■

The Four Seasons

Your first paintings of the four seasons should show the range of color effects you can get with your present palette, before exploring color. I've used the three colors I was allowed when I first started painting. The little sketches turned out all right, but some color mixtures aren't exactly what I wanted.

SLIPPED COG—SELF-PORTRAIT
Stephanie H. Kolman
Watercolor on paper
30" × 20" (76.2cm × 50.8cm)

Creative Primary Palette

Here's an interesting variation on a primary palette. Opera by Holbein is used as red, French Ultramarine is the blue and Burnt Sienna takes the place of yellow. You might not have thought to try this, but it works because Burnt Sienna can be used as a low-intensity yellow. You'll learn more about creative primary palettes as you continue exploring color—and about this "magic color," Burnt Sienna.

SONGS FOR THE PIECUTTER
Donna Howell-Sickles
Acrylic, charcoal and
pencil on paper
60" × 40"
(152.4cm × 101.6cm)

Simply Beautiful Color

Color can be as simple or complex as you care to make it. Howell-Sickles takes the route of simplicity,
using primary red, yellow and blue, beautifully balanced in strong shapes and clever color repetition.

Learning the Language of Color

The Properties of Color

When you visit a foreign country, you're more comfortable if you understand the language. The same is true with using color. Artists use several commonly accepted terms to describe the *properties of color*. Hue, value and intensity are the foundation words of color in every medium. *Hue* is the name of a color; *value* is its lightness or darkness; *intensity* is its purity or grayness. One more property, color *temperature* —the warmth or coolness of a color— critically affects color relationships.

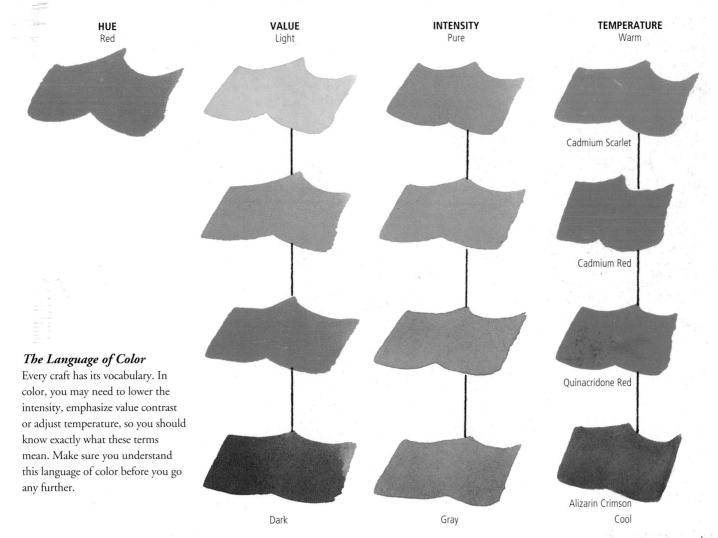

| **HUE** Red | **VALUE** Light | **INTENSITY** Pure | **TEMPERATURE** Warm |

Cadmium Scarlet

Cadmium Red

Quinacridone Red

Alizarin Crimson

Dark | Gray | Cool

The Language of Color
Every craft has its vocabulary. In color, you may need to lower the intensity, emphasize value contrast or adjust temperature, so you should know exactly what these terms mean. Make sure you understand this language of color before you go any further.

Hue vs. Paint Name

Hue is the name or attribute of a color that permits it to be classed as red, orange, yellow, green, blue or violet, which are primary and secondary colors, as discussed in chapter one. As each color moves toward the next on the color wheel, it assumes the characteristics of its neighbor. The names of these in-between tertiary colors indicate this: red-orange, yellow-orange, yellow-green, blue-green, blue-violet and red-violet. All of these colors comprise the twelve hues on the color wheel shown here.

Hue and *color* are general terms; pigment and paint names are very specific. Although there are only twelve hues on the color wheel, there are hundreds of pigment and paint variations of every hue. For example, Cadmium Red and Alizarin Crimson are both red pigments. However, not all paints with the same names are made with the same pigments. To further confuse matters, manufacturers continue to invent fanciful color names, such as Saffron, Heliotrope or Brandy, and it's anybody's guess what those colors might be. The trend toward naming paint colors for the pigment they're made of is a good idea. Although some of the words are tricky, artists are becoming accustomed to using abbreviated forms, such as "phthalo" for phthalocyanine and "quin" for quinacridone.

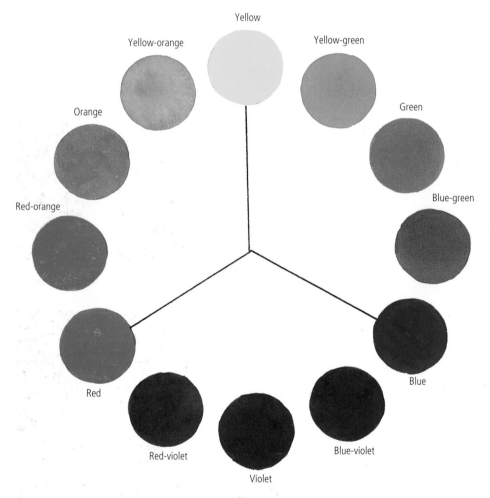

The Color Wheel

The color wheel establishes logical relationships useful in color mixing and design. You'll frequently use the wheel to organize and study these relationships, so get to know it well. Familiarize yourself with the exact locations and names of hues around the circle. Always orient your color wheels like a map, with yellow, the lightest hue, at the top (north) and violet, the darkest, at the bottom (south). Place primary red to the lower left (southwest) on the wheel and blue to the lower right (southeast).

EXERCISE

Exploring the Color Wheel

Use this exercise to further enhance your awareness of color placement on the color wheel. Look at the color mixtures you made in chapter one (page 17) and select a tube each of the red, yellow and blue paints you think will make the brightest color wheel. Don't use tubes of orange, green or violet; mix them using primary colors. If you're not a painter, make your wheel with colored pencils, fibers, collage papers or whatever your medium is. Don't worry if you can't achieve the purity of spectral color with paints just yet. We'll work on this in chapter four. Lay out a color wheel that resembles the face of a clock, beginning with yellow at the top (twelve o'clock). Move clockwise toward green, in the following order: yellow, yellow-green, green, blue-green, blue (four o'clock), blue-violet, violet, red-violet, red (eight o'clock), red-orange, orange and yellow-orange. Label your wheel with the names of the paints or colors you used in each mixture, as well as brand names, for future reference. (I didn't label my paint colors because I want you to use your own colors for this wheel.) ■

Identifying Colors

Colors can be described by their hue name, paint name, pigment name or color index number. For most artists, the paint name is the most familiar, but many are now learning pigment names so they can understand their materials better.

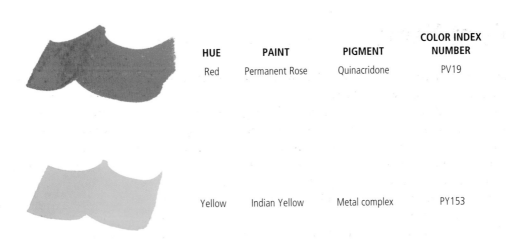

HUE	PAINT	PIGMENT	COLOR INDEX NUMBER
Red	Permanent Rose	Quinacridone	PV19
Yellow	Indian Yellow	Metal complex	PY153
Blue	Cerulean Blue	Oxides of cobalt, tin	PB35

Chromatic vs. Achromatic

White, gray and black are *neutral*, or *achromatic*, meaning colorless. All other hues are *chromatic*, having color, although as you can see, some colors are much brighter than others. Artists frequently refer to low-intensity colors as neutrals. I call them *chromatic neutrals* to differentiate between them and true neutrals, white, gray and black.

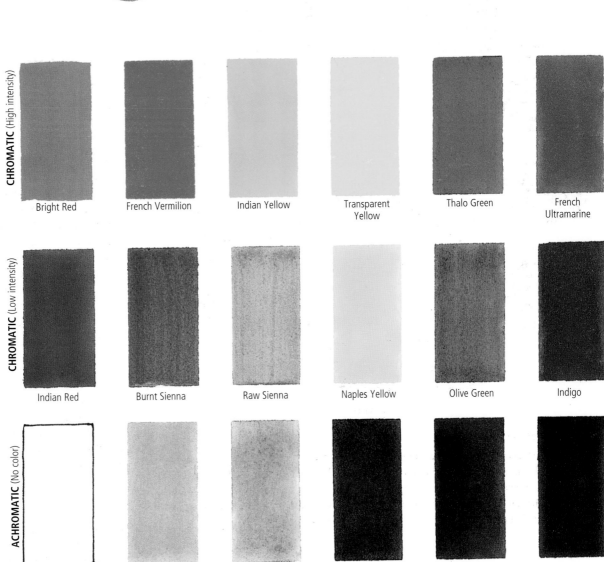

CHROMATIC (High intensity)

Bright Red | French Vermilion | Indian Yellow | Transparent Yellow | Thalo Green | French Ultramarine

CHROMATIC (Low intensity)

Indian Red | Burnt Sienna | Raw Sienna | Naples Yellow | Olive Green | Indigo

ACHROMATIC (No color)

White | Grey of Grey | Davy's Gray | Ivory Black | Payne's Gray | Neutral Tint

Value

Value is the degree of light or dark between the extremes of black and white. A tint moves toward white; a shade moves toward black. Yellow is the lightest color, becoming white in just a few value steps; violet is the darkest color, quickly descending to black. All other colors fall between. Red and green, which are similar in value, are situated near the middle of the value scale. Use value to create contrasts between colors, adding visual impact and drama.

Value Comparison in Color and Black and White

Get a good sense of how values work in color by placing a color scale next to your black-and-white scale. No color is as bright as white or as dark as black, but every color in its pure state has a value that corresponds to a level on the black-and-white scale.

Comparing Value Scales

Distinguishing values is one of the most important skills in art. Make a value scale from light to dark, showing discernible differences between value levels on the scale. If you paint, add Payne's Gray, Ivory Black, Neutral Tint or some other dark neutral for dark values, and diluent or white for light values. If you work in fibers, select different values of materials from your scrap basket. You may also use colored pencils or make a collage chart of different values clipped from magazines and pasted to paper or cardboard. Divide a 1" × 7" (2.5cm × 17.8cm) vertical column into seven 1-inch (25mm) segments. At the bottom of the scale, place a swatch of black. Leave the top section white, and below the white, place a light gray. Fill in the remaining spaces with intermediate values, showing distinct, progressive steps toward black. When you have a good grasp of black-and-white values, make a chart indicating the approximate color values corresponding to black, gray and white, as shown in the illustration. ■

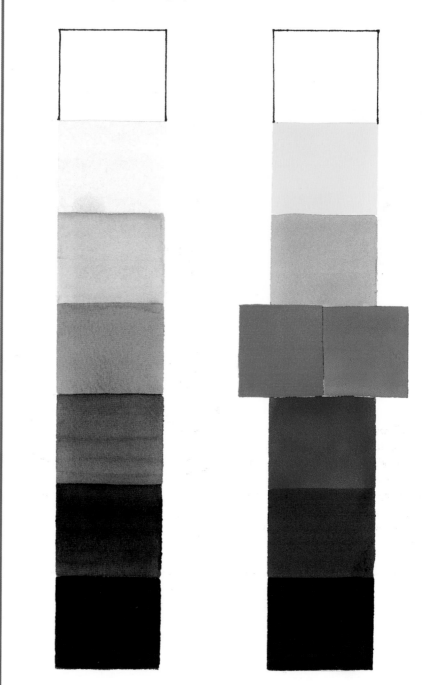

Working out Value Scales in Color

Select six or more bright colors from your palette, including the purest red, yellow and blue you have. Place each color on a chart at its proper value level, using the seven-step black-and-white chart on the previous page for reference. Mixing with thinner or white to make lights and Neutral Tint or Payne's Gray for darks, make a value range for each color. Place the values above and below the pure hue, as shown. From one value step to the next, show a discernible difference apparent to the critical eye. ■

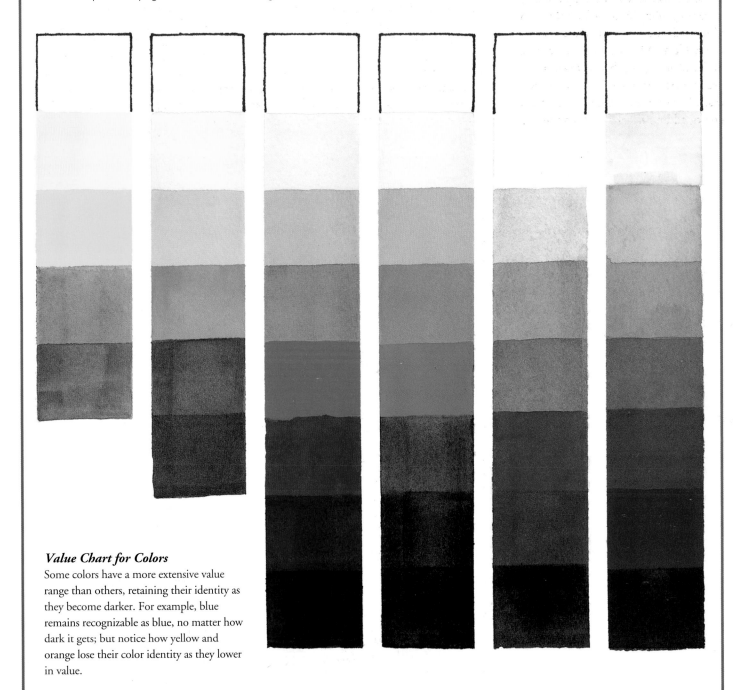

Value Chart for Colors

Some colors have a more extensive value range than others, retaining their identity as they become darker. For example, blue remains recognizable as blue, no matter how dark it gets; but notice how yellow and orange lose their color identity as they lower in value.

Intensity

The intensity of a color, sometimes called *chroma* or *saturation*, is its brightness (purity) or dullness. A pure, bright color is high intensity; a grayed color is low intensity. The extreme of low intensity is neutral gray. Such colors as Permanent Rose, Cadmium Yellow and Ultramarine Blue are high-intensity colors, but no matter how bright they look, they can't match the brilliance of projected or transmitted light. Varying intensity gives you control over compositional emphasis and creates a setting for extraordinary color effects.

When you mix two neighboring high-intensity colors, the mixture is slightly lower in intensity than either color by itself. Intensity declines most in mixtures when the two parent colors are far apart on the color wheel. Other ways to lower intensity are to mix bright colors with gray, black or an earth color. But remember, when you have lowered the intensity of a color, you can't turn it back into a pure hue, no matter how hard you try. Once a mixture gets muddy, it never seems to improve.

Tube Colors
Colors like Vermilion, Cadmium Yellow and Ultramarine Blue are high intensity as they come from the tube. Others, like Brown Madder, Yellow Ochre and Indigo, are low-intensity paint variations of red, yellow and blue. In fibers, heather yarns and natural-dyed fabrics are low-intensity materials. Learn to see the difference.

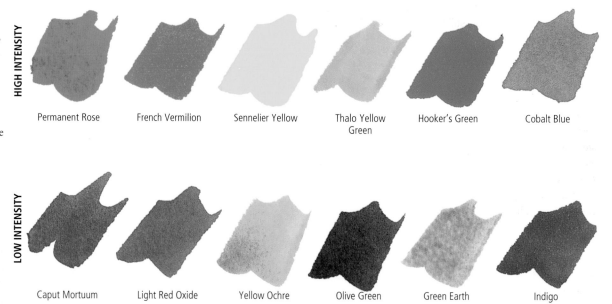

HIGH INTENSITY

Permanent Rose · French Vermilion · Sennelier Yellow · Thalo Yellow Green · Hooker's Green · Cobalt Blue

LOW INTENSITY

Caput Mortuum · Light Red Oxide · Yellow Ochre · Olive Green · Green Earth · Indigo

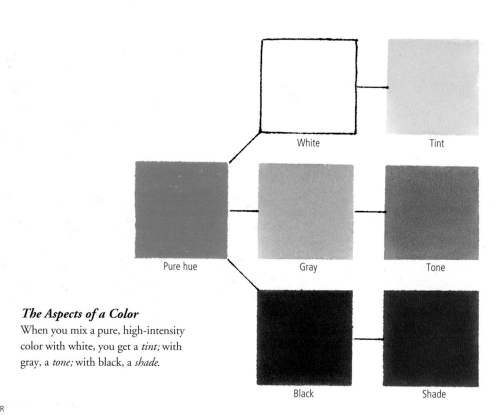

White · Tint

Pure hue · Gray · Tone

Black · Shade

The Aspects of a Color
When you mix a pure, high-intensity color with white, you get a *tint;* with gray, a *tone;* with black, a *shade.*

Controlling Intensity

Starting with a high-intensity color like Ultramarine or Phthalo Blue, make a vertical value scale from light to dark on the left side of your paper or canvas, using only water or white to change the value. Then, with Neutral Tint or some other neutral, mix a light gray. Add a small amount of this gray to the tint on your palette, matching the value level of the tint at the top of your chart as closely as you can. Place a swatch of this slightly grayed mixture to the right of the tint.

For the next swatch add more gray and less color, again matching the value level of the tint at the top of your chart as closely as you can. Place a swatch of this mixture to the right of the first slightly grayed mixture. For the next swatch, again add more gray and less color, still matching the value level of the original tint.

Continue across the row, until the final swatch is gray, with barely a trace of the original color. Move to each of the next rows, carefully matching the value level across each row as you lower the intensity of the color.

Repeat this exercise with your other colors, remembering always to match the value level of the first color in the row. Notice how colors with a lighter value, such as yellow, make appealing tints, but change drastically as they darken. Colors of darker values, such as red and violet, make rich tones and shades and still retain their color identity throughout the change.

Experiment also using earth colors to lower intensity. ■

Intensity Chart

It's important to be able to see—and create—subtle differences in intensity. Make a chart like this one with every color you use. The first column is a value scale of tints and pure color, with no gray added. I've added gray to all the other columns, as described in the exercise, to make low-intensity hues at different value levels.

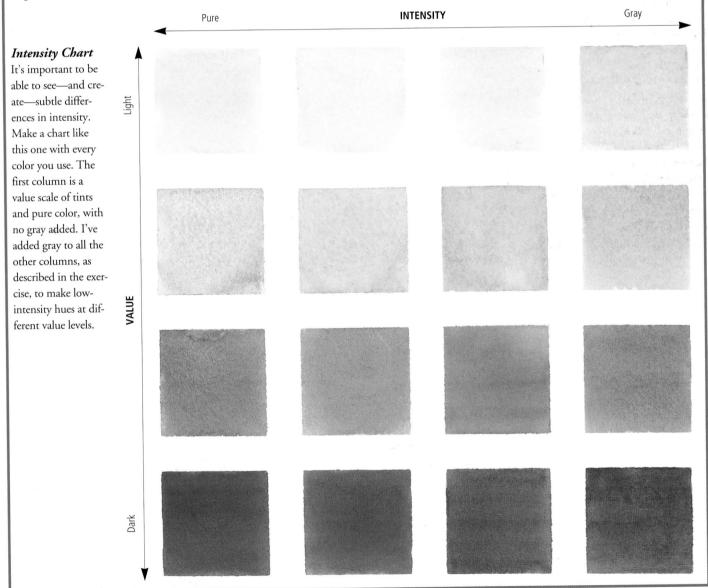

Temperature

Color temperature helps you create depth, movement and mood. Warm colors are aggressive and appear to advance; cool colors are passive and seem to recede. The wrong temperature in one area may disturb balance in a piece, but the correct warm/cool contrast can add the zing you need for your focal point.

Red-orange is the warmest color, so as you move away from it in either direction, your colors all seem cooler, until they reach blue-green, which is the coolest color. Then, as you return from blue-green to red-orange, your colors get warmer. Take the time to study this on your color wheel, so you can see clearly how it works.

Color temperature is relative. The color that appears warm in one place may look cool in another. Although you know blue is a cool color on the spectrum, when you

line up a series of blue paints, pastels or fibers, you'll see that some are warmer blues, leaning toward violet, while others are cooler, with a bias toward green. Every color has many temperature variations in pigment. Practice will help you see the differences.

Spectral Temperature

The spectrum contains both warm and cool colors. Yellow, orange and red in the top row are the warm colors of sunlight and fire; green, blue and violet (below) represent the coolness of grass, water and shadow. This is the most easily recognized distinction in color temperature.

Temperature Is Relative

Colors move from warmer to cooler in these collage studies. The top row starts with a cool red, but the temperature becomes even cooler as it moves toward blue, stopping at blue-violet. That same blue-violet begins the bottom row as the warmest color, moving toward a cool blue-green. The temperature turns slightly warmer as the last chip picks up some green on the other side of blue-green.

Warmer Cooler

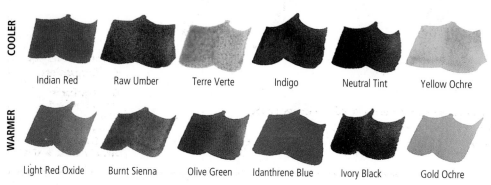

COOLER

| Indian Red | Raw Umber | Terre Verte | Indigo | Neutral Tint | Yellow Ochre |

WARMER

| Light Red Oxide | Burnt Sienna | Olive Green | Idanthrene Blue | Ivory Black | Gold Ochre |

Temperature of Earth Colors

As a group, earth colors are generally cooler than spectral colors, because they are low-intensity, grayed versions of colors. But there are still noticeable differences in color temperature from one earth color to another. Compare the temperature of the colors in the top row to the ones directly below them.

Seeing How Temperature Works

Sort your high-intensity colors into the twelve primary, secondary and tertiary colors of the color wheel. Put away your earth colors for the time being. Starting with a true yellow (not greenish or orangish) at the top, make swatches of colors moving clockwise on a color wheel, toward green. Label the colors carefully as you go along. Continue adding swatches around the wheel, showing a gradual change in color temperature leading from one color to the next and returning to yellow. You may have to compare the colors before placing them on the wheel. Rest your eyes occasionally, so you can see the colors more accurately. When you feel confident you recognize temperature differences in pure colors, make a similar chart using the earth colors. ■

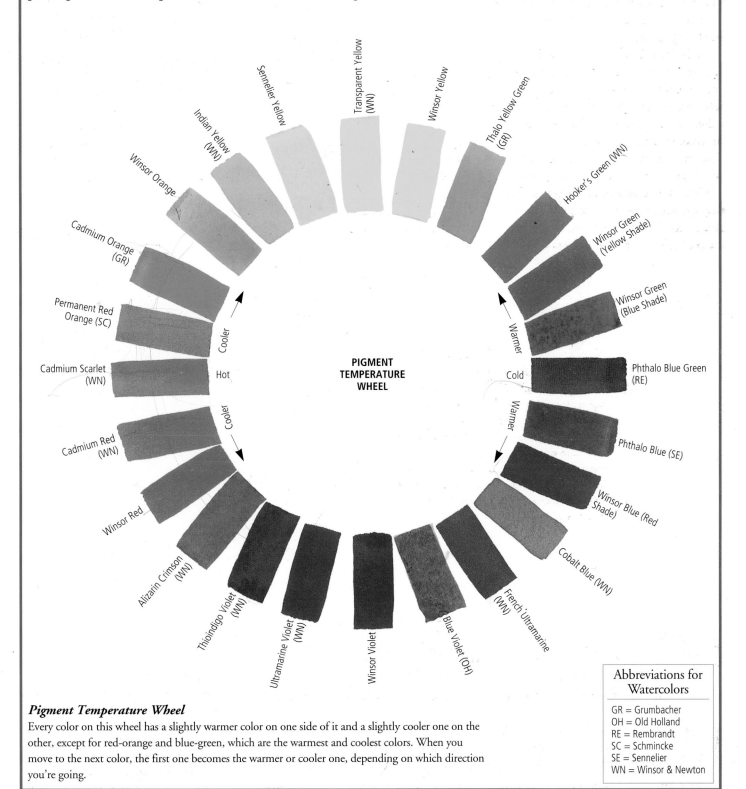

Pigment Temperature Wheel

Every color on this wheel has a slightly warmer color on one side of it and a slightly cooler one on the other, except for red-orange and blue-green, which are the warmest and coolest colors. When you move to the next color, the first one becomes the warmer or cooler one, depending on which direction you're going.

Abbreviations for Watercolors
GR = Grumbacher
OH = Old Holland
RE = Rembrandt
SC = Schmincke
SE = Sennelier
WN = Winsor & Newton

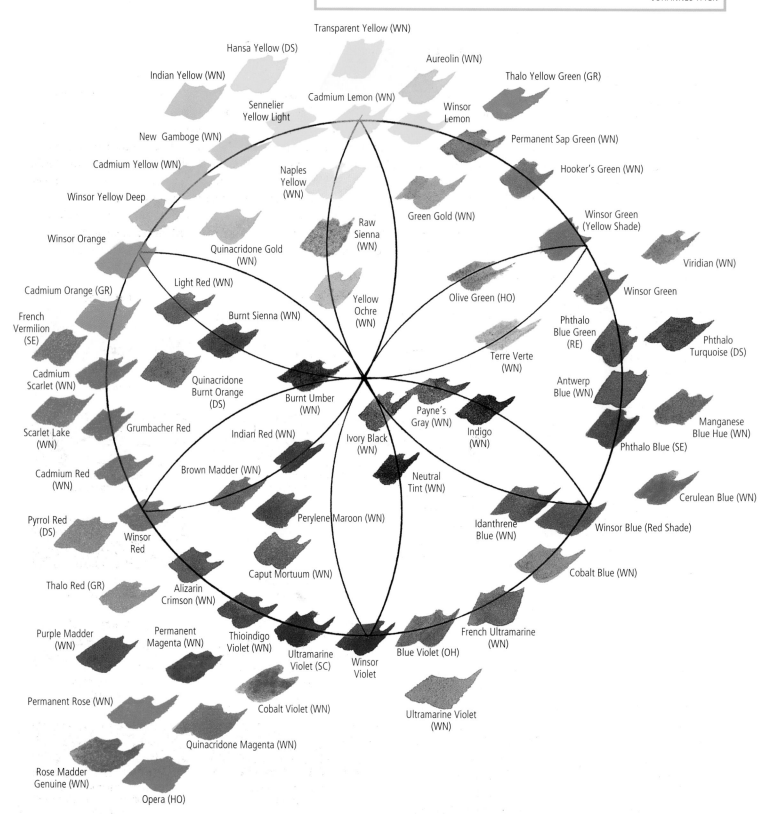

Transparent Yellow (WN)

Hansa Yellow (DS)

Indian Yellow (WN)

Aureolin (WN)

Thalo Yellow Green (GR)

Cadmium Lemon (WN)

Sennelier Yellow Light

Winsor Lemon

New Gamboge (WN)

Permanent Sap Green (WN)

Cadmium Yellow (WN)

Hooker's Green (WN)

Naples Yellow (WN)

Winsor Yellow Deep

Green Gold (WN)

Winsor Green (Yellow Shade)

Raw Sienna (WN)

Winsor Orange

Quinacridone Gold (WN)

Viridian (WN)

Light Red (WN)

Winsor Green

Cadmium Orange (GR)

Yellow Ochre (WN)

Olive Green (HO)

Burnt Sienna (WN)

French Vermilion (SE)

Phthalo Blue Green (RE)

Terre Verte (WN)

Phthalo Turquoise (DS)

Cadmium Scarlet (WN)

Quinacridone Burnt Orange (DS)

Antwerp Blue (WN)

Burnt Umber (WN)

Payne's Gray (WN)

Scarlet Lake (WN)

Grumbacher Red

Indian Red (WN)

Indigo (WN)

Manganese Blue Hue (WN)

Cadmium Red (WN)

Ivory Black (WN)

Phthalo Blue (SE)

Brown Madder (WN)

Neutral Tint (WN)

Cerulean Blue (WN)

Pyrrol Red (DS)

Perylene Maroon (WN)

Idanthrene Blue (WN)

Winsor Red

Winsor Blue (Red Shade)

Thalo Red (GR)

Caput Mortuum (WN)

Cobalt Blue (WN)

Alizarin Crimson (WN)

Purple Madder (WN)

Permanent Magenta (WN)

Thioindigo Violet (WN)

French Ultramarine (WN)

Ultramarine Violet (SC)

Blue Violet (OH)

Permanent Rose (WN)

Winsor Violet

Cobalt Violet (WN)

Ultramarine Violet (WN)

Rose Madder Genuine (WN)

Quinacridone Magenta (WN)

Opera (HO)

Exploring Color Characteristics

Is it Pigment or Paint?

Ground, powdered *pigments* are the coloring substance of artists' paints, which are made by combining the pigments with a medium or vehicle that surrounds the pigment particles and binds them to the support. The degree to which color reflects from the paint molecules or passes through transparent colors to reflect the support may be determined by the grinding of the pigment particles, the inherent properties of the pigment material and/or the nature of the support.

Paint is pigment *suspended* in a liquid, which forms a layer on the painting surface. *Dyes*, which are substances *dissolved* in liquid, are absorbed into the surface. Dyes are more likely to fade than pigments.

No doubt you've noticed that paints aren't cheap. Manufacturers prepare some colors from costly metallic pigments, like

Classification of Pigments

Pigments are classified as organic or inorganic, depending on the source of the coloring matter. This distinction is important only if you prefer traditional colors with specific characteristics, such as granulation. But it really doesn't matter whether a color is a natural material or synthetic, as long as it's the color you want.

ORGANIC	INORGANIC
Rose Madder Genuine NR9 (natural)	Raw Sienna Pbr7 (iron oxide)
Quinacridone Magenta PR122 (synthetic)	Burnt Sienna Pbr7 (calcined iron oxide)
Hansa Yellow PY97 (synthetic)	Indian Red PR101 (red iron oxide-synthetic)
Phthalo Green PG7 (synthetic)	Cadmium Red PR108 (metallic)
Idanthrene Blue PB60 (synthetic)	French Ultramarine PB29 (complex sodium aluminum silicate with sulphur)

cadmium and cobalt, as well as from rare organic materials, such as genuine rose madder. Artists' colors contain more colorants than student-grade and children's paints, which include fillers that dilute the pigment and produce a weak, unsatisfactory paint at low cost to make them more affordable. Buy the finest paint you can, because you'll get better results with concentrated pigment. Many well-known brands are reliable in most media, but you will probably find you prefer the working characteristics of some brands over others. Expect to pay more for top-quality paint. If you must begin with student paints, upgrade as soon as possible. Prices within a brand will vary according to the availability of colorants and the cost of processing them. Artists' quality pigments are usually compatible between brands, except for some acrylics. Check with the manufacturer to be sure. No "correct" brand of paint exists.

Some manufacturers prefer using a single pigment in each paint formula, although many mixed colors are still available. Pigment mixtures, such as Sap Green, Hooker's Green and Payne's Gray, vary greatly between brands. Paints with the same name are sometimes made using entirely different pigments. Exploring color will train your eye to see distinctions between colors.

Organic pigments come from compounds containing carbon, often from living matter—plant or animal material. For example, Rose Madder Genuine is made from plant material; Sepia once came from the ink sacs of the cuttlefish; Phthalocyanine Blue is a synthetic organic pigment.

Inorganic pigments come from earth materials (Raw Sienna and Raw Umber), calcined earth materials (Burnt Sienna and Burnt Umber) and minerals or metals (Cadmium Red, Cobalt Blue, Manganese Blue). The minerals are often brilliant and opaque; the earth colors are usually less intense.

Some materials are costly and difficult to obtain. Other pigments contain unique properties that can't be duplicated in synthetic paints. For example, costly Cobalt Blue simply can't be matched in delicacy and beauty by substitutes formulated using Phthalocyanine Blue or Ultramarine. Substitutes should be labeled *hue* or *tint* to indicate they're not genuine pigments. Manufacturers have developed satisfactory synthetic replacements for some colors, but only you can decide if these substitutes are acceptable.

Another development in modern paint chemistry is interference paint. Ordinary paint both absorbs and reflects color; metallic pigments simply reflect; refraction (interference or iridescent) pigments reflect different colors, depending upon how many layers of titanium dioxide or iron oxide are attached to mica particles in the paint binder. A special class of interference paints, pearlescent paints, may have sparkle, rather than the lustrous sheen of other interference paints. Use these special-effect paints sparingly, and note that they usually don't photograph or reproduce well in print.

Paint Composition

MEDIUM	BINDER	DILUENT/SOLVENT	CHARACTERISTICS
acrylic paint	acrylic polymer emulsion	water/denatured alcohol (limited use)	fast drying (dries darker); opaque or transparent
alkyd paint	oil-modified alkyd resin	oil medium/pure gum turpentine, mineral spirits	similar to oils, but fast drying; compatible with oils; opaque
casein paint	milk solids	water	fast drying; opaque; matte
colored pencil	wax, gum	mineral spirits, colorless marker	applied in layers; waxy; buff for shine
gouache paint	natural gum	water	fast drying; opaque; matte
gouache paint (acrylic)	acrylic	water	same as gouache; dries water resistant
ink (pigmented)	gum, shellac or acrylic emulsion	water/denatured alcohol	fast drying; transparent, brilliant color; use lightfast only
oil paint or oil sticks	natural oils (linseed, poppy, safflower)	oil medium/pure gum turpentine, mineral spirits	slow drying; opaque
oil paint (water miscible)	modified linseed oil	pure gum turpentine, mineral spirits/water for cleanup	slow drying; loses water miscibility if too much oil is used
pastel	weak gum solution	only for water-soluble soft pastel	brilliant pure color; opaque; soft or hard
pastel (oil)	natural oils and wax	pure gum turpentine, mineral spirits	opaque pastel effect with no dust
tempera paint	egg yolk	water	fast drying; opaque; translucent layers
watercolor paint	natural gum	water	fast drying (dries lighter); transparent; matte
watercolor pencils or sticks	water-soluble gum	water	mostly transparent; can be wetted for wash effects

Exercises for Exploring Color

There are two types of exercises for exploring color in this chapter: (1) testing paints or dry media—to familiarize you with the color characteristics of your medium; and (2) making mixtures—to show you how colors work together.

EXERCISE

Your Color Journal

Again keep a journal of your adventures with color. Record the colors you use and comment on your reactions to them. Sharpen your color awareness by comparing new colors with more traditional colors, or those you tend to use most often. Critique your color effects. Why did you choose that color? Did it give the result you wanted? Make your sketchbook a sounding board for your use of color in your art.

List the colors you have now and mark the ones you use the most. How do you use them in your art? Jot down the names of colors you want to try. Note ideas for new color combinations. Keep track of your exercises and write your reactions to the colors as you use them. Which do you like best? What did you learn from doing each exercise? How might you use the colors in your artwork? ■

Suggestions for Nonpainters

You can do many of the exercises in this chapter with colored pencils, collage, fibers or whatever medium you choose. For collage charts, collect and file colored paper or clippings in various hues, values, intensities and temperatures. Fiber artists can use swatches of assorted yarn or fabric samples; compare how textures, patterns, length and density of fibers, as well as the shine of metallic threads, affect colors.

EXERCISE

Comparing Mass Tones and Undertones

What you see when you squeeze paint out of a tube isn't always what you get when you use it. There may be an actual change in the color bias. For example, in watercolor, Aureolin (as it comes from the tube) looks like honey mustard, but when you thin it you get a lovely transparent yellow. Check your paint colors, first diluting each color to about half strength and then to a thin wash, painting swatches of each variation next to a swatch of the full-strength color. ■

Phthalocyanine Blue

Aureolin

Mass tone

Undertone

Undertone

Mass Tone and Undertone

Some colors change significantly when they're reduced from their full-strength mass tone to a lighter, diluted undertone.

Supplies for Exploring Color Characteristics

Now's your chance to find out what your colors can do. As best you can, find colors in your chosen medium and match them to the list of paint colors below. Add any you don't have. Remember that not all colors are available in every medium or brand, nor do similar colors always have the same name.

HIGH-INTENSITY COLORS

Rose, Red and Red-Orange
Rose Madder Genuine (WN)
Permanent Rose
Quinacridone Magenta
Alizarin Crimson or Permanent Alizarin Crimson
Cadmium Red Medium
Winsor Red, Permanent Red (HO) or Pyrrole Red (GO)
Cadmium Scarlet (WN), Cadmium Red Orange (HO), French Vermilion (SE) or Cadmium Red Light (SE)
Scarlet Lake

Orange and Yellow-Orange
Cadmium Orange or Winsor Orange
New Gamboge (WN), Indian Yellow, Cadmium Yellow Deep or Winsor Yellow Deep

Yellow and Yellow-Green
Cadmium Yellow Light, Cadmium Yellow Medium, Hansa Yellow Light, Hansa Yellow Medium, Sennelier Yellow Light or Sennelier Yellow Medium
Transparent Yellow (WN)
Aureolin
Cadmium Lemon, Lemon Yellow or Winsor Lemon
Permanent Green Light (SC), Permanent Sap Green (WN) or Thalo Yellow Green (GR)

Green and Blue-Green
Hooker's Green (WN, HO)
Jenkins Green (GO)
Phthalocyanine Green, Thalo Green (GR) or Winsor Green (Blue Shade)
Viridian
Phthalo Blue Green (RE)

Blue and Blue-Violet
Cerulean Blue
Manganese Blue Hue (WN)
Phthalocyanine Blue, Phthalo Blue (DS), Thalo Blue (GR), Winsor Blue (Red Shade) or Winsor Blue (Green Shade)
Cobalt Blue
French Ultramarine or Ultramarine
Old Holland Blue Violet

Violet and Red-Violet
Dioxazine Purple or Winsor Violet
Permanent Magenta or Thioindigo Violet

LOW-INTENSITY COLORS
Brown Madder
Burnt Sienna
Indian Red
Perylene Maroon (WN, DS)
Quinacridone Gold (WN, DS)
Raw Sienna
Yellow Ochre
Olive Green
Indigo
Idanthrene Blue (WN) or Idanthrone Blue (DS)

NEUTRALS
Neutral Tint
Ivory Black
Payne's Gray
Flake White (oil, alkyd), Zinc White (acrylic, gouache, watercolor) for mixing
Titanium White for opacity

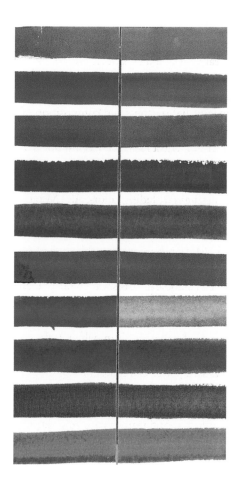

Making Sectioned Sheets
To make a sectioned sheet mark grids on your paper or canvas, sized to the exercise you're going to do, using low-tack white drafting tape, which won't damage the surface when you remove it. As you work, write the names of the paints you use on the tape. After your paints are dry, transfer the names to the paper as you remove the tape. The white strip between the colors makes it easier to evaluate them.

Permanence Varies
Some colors change quickly when exposed to light over a period of time, and others don't appear to fade at all. In this test, the colors that faded the most over a three-year period showed a marked tendency to fade within the first two weeks of exposure to direct sunlight. Others showed little fading or color shift throughout the test. Fortunately, some of the colors used in this test are no longer being manufactured.

Differences in Brands
Be careful about switching brands of a specific color (even if it has the same name) in the middle of a painting. Brands may vary to a surprising degree in color bias, transparency and tinting strength. The same color may also look quite different in oils, watercolors and acrylics. Here's Cobalt Blue in watercolor, showing a range of color bias and strength across different brands.

Winsor & Newton | Grumbacher | Impellist | Holbein | Maimeri | Holbein (hue)

COBALT BLUE

Working with Paints

Artists of the past mixed their paints from scratch. Now you buy them ready-made, but how do you know what you're getting? Don't depend on printed color charts; ask your dealer to show you charts with painted chips whenever possible. Many modern synthetic pigments have jaw-breaking names—quinacridone, anthraquinoid, idanthrene—but once you've seen the colors, you'll want to find a place for them on your palette. If the pigment and binder have separated in a newly purchased tube of paint, or the paint is hard to squeeze out of the tube, return it to the dealer immediately or call the manufacturer.

The American Society for Testing and Materials (ASTM) and the Art and Creative Materials Institute (ACMI) set voluntary standards for labeling, so you may find answers to your questions about toxicity, lightfastness and composition of paint on the label. If not, consult the manufacturer. Most have toll-free numbers for consumer services.

Check lightfastness ratings and avoid using fugitive, fading colors. ASTM ratings of I and II are reliable. Colors designated N/R haven't been rated by the ASTM, but those produced by reliable manufacturers have been tested to meet ASTM standards. Insist on colors that are rated high in lightfastness. When in doubt, test them yourself. Paint a brushstroke on a piece of paper, cut it in half and place one half in a sunny window and the other in a dark place. Compare the two once a month to see how long the color takes to fade. Most colors are reliable under normal conditions, but atmospheric pollution may be a problem. It's probably fair to say that nothing can be absolutely guaranteed.

ADDITIONAL MATERIALS FOR DRY OR WET MEDIA
- an old ¹/₂-inch (12mm) flat brush
- Pelikan waterproof India ink
- Sketchbook or paper
- ¹/₂-inch (12mm) low-tack white artists' tape (Scotch brand #285) for sectioning sheets of paper
- mat board

- paper towels, rags, sponge
- Pigma Micron waterproof, fadeproof pens
- "Yes"! paste or liquid acrylic medium to adhere color clippings or fabric scraps

MATERIALS FOR PAINTING
Palette
- 12-inch (30.5cm) or larger white palette (the Speedball ColorWheel Palette is good for basic color mixing)
- For acrylics: Cut freezer paper to fit your palette and use with the waxy side up

Supports
- For watermedia: watercolor sketchbook, or 90-140-lb. (190-300g/m²) white watercolor paper (Arches, Bockingford, Fabriano, Montval or Winsor & Newton)

- For oil and acrylic paints: Fredrix canvas paper or prepared canvas

Brushes
- no. 6 or no. 8 pointed round brush
- For watermedia: ¹/₂-inch (12mm) blend (Isabey Syrus 6239) or synthetic (Winsor & Newton 985) flat brush

Diluents and Mediums
- For watermedia: water
- For acrylics: water and acrylic medium (use no more than 50 percent water, then continue to thin with liquid medium); alcohol
- For oil and alkyd paints: pure gum turpentine or mineral spirits, Liquin (WN) to speed drying of oils

Containers
- Large ones for water (2)
- Smaller ones for mineral spirits, turpentine or acrylic medium

Setting Up Your Palette

There's more than one way to set up a *palette*. A beginner might include just the basic primaries. One logical arrangement is to place your colors in the order of the spectrum: red, orange, yellow, green, blue, violet. Another way is to place the warm colors on one side (red, orange, yellow) and the cool colors on the other (green, blue, violet). Still another is to separate bright colors from earth colors. Once you've decided on a general layout for your palette, use it for exploring the colors in this chapter.

Eventually you'll arrange a painting palette based on your favorite setup.

Use fresh, clean color for the exercises in this chapter. Don't use your old palette unless you've washed off all the contaminated paint. Go on, you'll be glad you did!

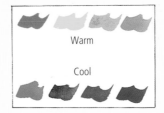

Warm

Cool

High intensity

Low intensity

Spectral

Split primaries
(see page 48)

Your Own System
Arrange the colors on your palette according to a system that makes sense to you and place your colors in that same arrangement every time you use them. Be organized and consistent. Mark the name of each color on a piece of masking tape or a small sticker next to a color as soon as you put it on the palette, so you don't get your colors confused. You'll find your colors easily once you get used to your own setup.

Transparency and Opacity

A transparent layer of paint permits a previously applied color, or the white reflective surface of the support, to shine through it. *Transparency*, a natural characteristic of certain pigments, is useful in glazing (page 110–112). Most watercolor paints are transparent to a degree; a few oils and acrylics also have this trait, although they are more commonly used in an opaque manner. Gouache, casein and tempera are opaque watercolors containing substances that induce *opacity*. Pastels and oil pastels vary in this characteristic. A painting done in opaque colors looks very different from one done with transparent paints.

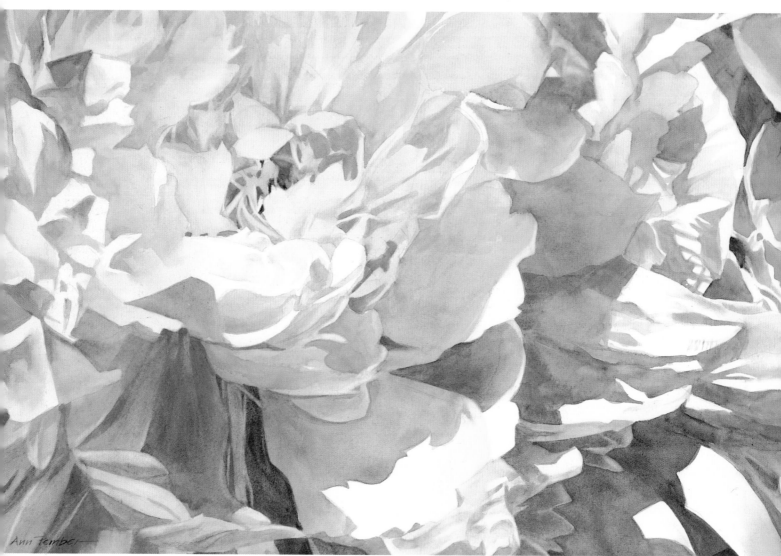

PEONY BLOOM
Ann Pember
Watercolor on paper
14¹/₂" × 21¹/₂" (36.8cm × 54.6cm)

Importance of Transparency
The delicate radiance of sunlit flowers calls for transparent glazing, so you can see the value of knowing the difference between transparent and opaque colors. Transparency allows your support, in this case white watercolor paper, to emit luminosity through several layers of color. Every brushstroke on this watercolor is transparent, including the dark accents between petals at the bottom of the page.

Identifying Transparency and Opacity

Using an old ½-inch (12mm) brush, paint several strips of undiluted India ink on watercolor paper (for waterborne or dry media) or on canvas (for oils, alkyds, oil pastels or oil sticks). Let the ink dry thoroughly. With every color you have, paint a band across the ink strip, adding enough thinner to make the paint flow without losing its brilliance; arrange the colors by families for easy comparison, leaving spaces between color groups to add new colors. Notice how some of the colors seem to disappear when they cross the ink strip; these are transparent colors. Others cover the black entirely; these are opaque. *Semitransparent* or *semiopaque* colors leave a haze or translucent film. Record your observations in your color journal. ■

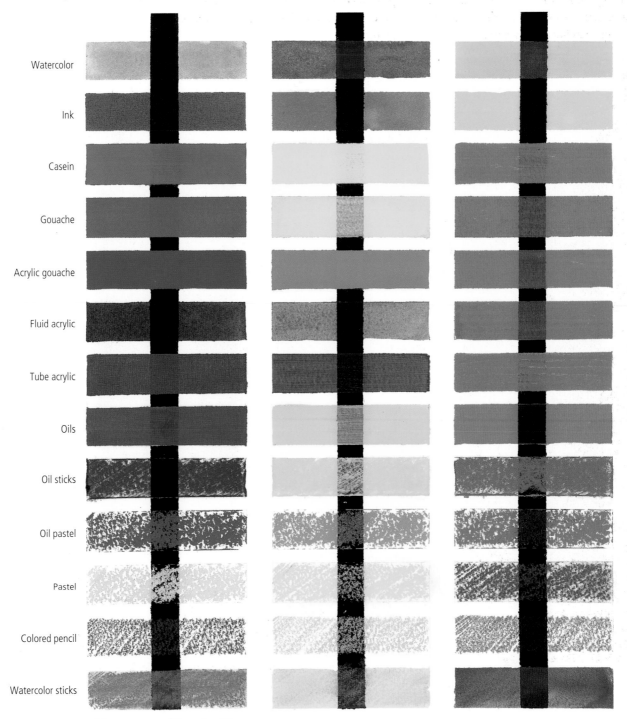

Watercolor

Ink

Casein

Gouache

Acrylic gouache

Fluid acrylic

Tube acrylic

Oils

Oil sticks

Oil pastel

Pastel

Colored pencil

Watercolor sticks

Transparency/Opacity Chart
Transparency and opacity are obvious on this chart, which shows the characteristics of different media. Notice the extremes of transparent ink and opaque casein. You don't need to test different media; just study your own medium thoroughly so you can easily recognize transparency and opacity.

Staining Quality

Staining colors penetrate the fibers of a support and can't be removed without leaving a trace of color or damaging the support. You can't completely sponge or lift them out to correct mistakes. They will stain clothing, fingers and probably your palette. If you're a beginner, you may want to use nonstaining colors.

But don't be too quick to banish staining colors, because they can be some of the most beautiful available. If you paint with little correction or scrubbing, you won't have problems with staining colors. Some artists even use transparent stains in an interesting stain-and-glaze technique, sponging off the surface after the paint stains the support, then glazing with another layer. You can use staining colors for glazes, but handle with care. Even a diluted wash may stain slightly, or an underlying stain color may bleed through a glaze. Surprisingly, some powerful colors don't stain, while other weaker colors do. But don't guess. Test your colors to identify their staining tendencies.

MEMORIES OF MAUI #1—RED GINGER
Lynn Lawson-Pajunen, watercolor on shuen rice paper 19" × 19" (48.3cm × 48.3cm)

Using Staining and Opaque Colors
Lawson-Pajunen layers intense staining colors that penetrate the rice paper, then brings out the image on top of the stains with several layers of opaque paint. You can't scrub the paint off rice paper, but you can add opaque paint to develop your image after your paper has been stained. You can do this on other surfaces, too, as long as your paints stain the fibers of the support and don't lift easily when opaque layers are applied.

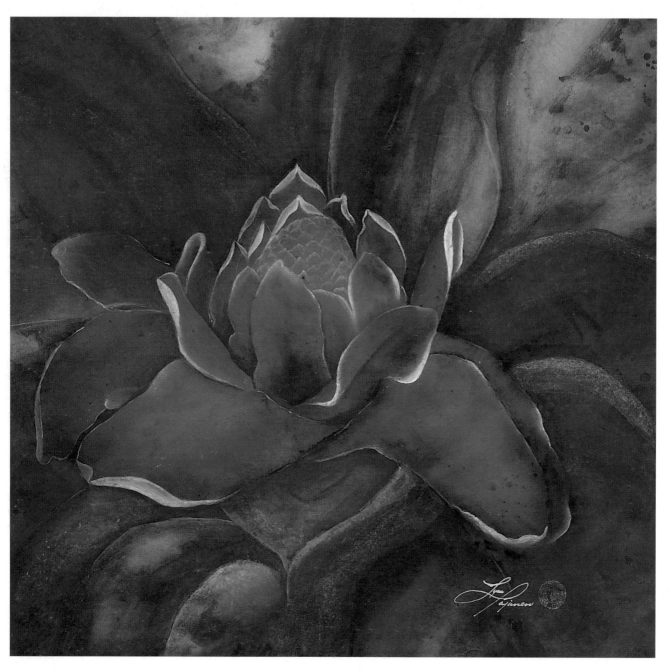

Recognizing Staining and Lifting Pigments

Paint a 2-inch (51mm) square of every color on a sectioned sheet of paper or canvas. Let watercolors dry thoroughly, then cover one side of each square with a scrap of mat board and scrub the visible half with a sponge, picking up loosened pigment with a rag or paper towel. For other paint media, scrub off the color with mineral spirits (oils and alkyds) or alcohol (acrylics) after the paint sets, but before it dries completely. When you add new colors to your palette, test them for this property. Label your chart and list the staining colors in your color journal. ■

Testing Staining Properties

When testing the staining property of your paints, scrub vigorously enough to loosen the surface color without damaging the support. Some colors can be completely removed, but others stain the support permanently. Also note that some supports tend to stain more easily than others, for example, highly sized papers are more resistant to staining. You can also use Prepared Size, a gelatine sizing by Winsor & Newton, to make your surface less subject to staining.

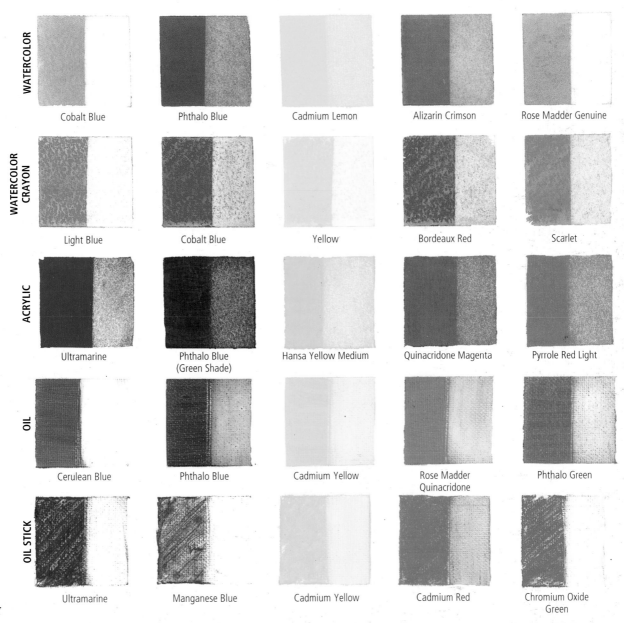

WATERCOLOR

Cobalt Blue Phthalo Blue Cadmium Lemon Alizarin Crimson Rose Madder Genuine

WATERCOLOR CRAYON

Light Blue Cobalt Blue Yellow Bordeaux Red Scarlet

ACRYLIC

Ultramarine Phthalo Blue (Green Shade) Hansa Yellow Medium Quinacridone Magenta Pyrrole Red Light

OIL

Cerulean Blue Phthalo Blue Cadmium Yellow Rose Madder Quinacridone Phthalo Green

OIL STICK

Ultramarine Manganese Blue Cadmium Yellow Cadmium Red Chromium Oxide Green

Staining Quality

No amount of scrubbing will remove some of these colors without making a hole in the paper. Test all your colors so you don't get a nasty shock when you're painting. Many synthetic pigments are particularly staining.

Tinting Strength

In color mixing, *tinting strength* is the power of a color to influence a mixture; this is usually determined by the pigment the paint is made of. Some pigments overpower nearly every color you combine them with. Others are so delicate that, even in their most concentrated form, they have little impact on stronger colors. Be careful about combining colors that vary too much in tinting strength. Mix delicate colors only with those they have some effect on when mixed in normal proportions. For example, Rose Madder Genuine will have almost no effect on Phthalo Green in a mixture, so this is a poor combination. Better choices would be Rose Madder Genuine and Viridian (both delicate) or Alizarin Crimson and Phthalo Green (both powerful).

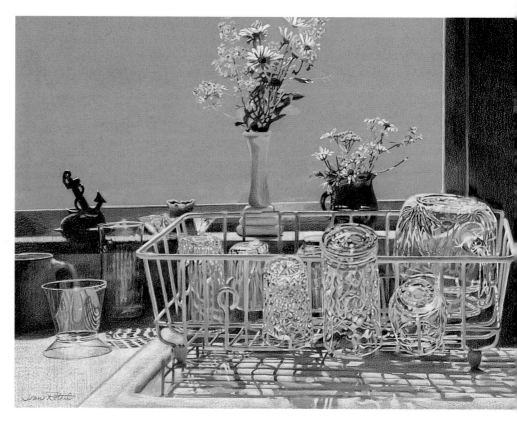

▲
THE MORNING
AFTER
Joan Rothel, AWS, NWS
Prismacolor pencil on
Canson paper
20" × 26"
(50.8cm × 66cm)
Collection of the artist

EXERCISE

Comparing Tinting Strengths of Paints

Sort your colors into groups according to hue, such as Alizarin Crimson, Rose Madder Genuine and Cadmium Red; Phthalo Blue, French Ultramarine and Cobalt Blue; Phthalo Green, Hooker's Green and Viridian; Winsor Yellow, New Gamboge and Aureolin. Include other colors in addition to those listed. Paint a 1-inch (25mm) square chip of each color on your paper or canvas. As you work, observe which colors seem more powerful and which appear weaker. Note this in your color journal. When your sample chips are dry, sort them into delicate, intermediate and powerful colors. Arrange them on a chart in columns similar to the one shown here and adhere them with "Yes"! paste or acrylic medium. Then see what happens when you mix colors from different columns and observe how you have to adjust for differences in tinting strength. ■

Tinting Strength

Test tinting strength so your colors don't surprise you by overpowering other colors or by disappearing when you combine them with stronger colors. Here you can see how widely colors differ in this characteristic. Once again, brands and media make a difference. Some artists like weaker paints because they're easy to use as glazes, but be aware that the power won't be there if you need it.

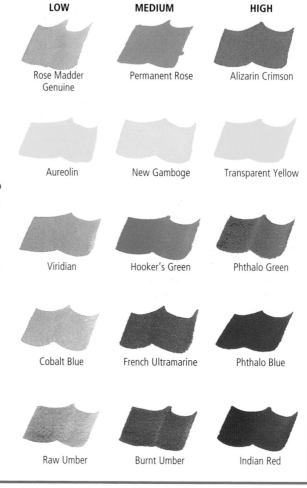

LOW	MEDIUM	HIGH
Rose Madder Genuine	Permanent Rose	Alizarin Crimson
Aureolin	New Gamboge	Transparent Yellow
Viridian	Hooker's Green	Phthalo Green
Cobalt Blue	French Ultramarine	Phthalo Blue
Raw Umber	Burnt Umber	Indian Red

Know the Strength of Your Colors

Rothel creates a serene setting by using delicate, unified colors with no extremely powerful colors to overwhelm them. Although colored pencils aren't mixed in the same way wet media are, it's still important to know the strength of your colors. Once the colors are down, it's hard to remove them without altering the tooth of the paper.

TO MARKET
Jane Higgins, watercolor on paper, 22" × 30" (55.9cm × 76.2cm)

Strong Color Statement

Powerful colors were used to create this painting, and delicate pigments wouldn't have contributed anything. Higgins knows exactly which colors she needs to make a direct color statement. The strong shapes and bold colors are perfect partners here. Also notice the granulating colors in the shadows (see the next section on granulation).

Granulating Colors

Some waterborne pigments, when applied in a fluid manner, will settle into the valleys of a textured paper, making interesting granular effects that suggest fog, the density of a storm cloud or texture on a sandy beach. *Granulation* is a natural characteristic of these colors, not a defect. Some artists love this textured effect, and others prefer a completely transparent look. What's your preference?

Other Texture Techniques for Watermedia

One popular trick in watermedia is to sprinkle salt into a damp wash, creating a crystalline texture. The permanence of this technique is questionable. Some experts advise against this practice, citing possible effects of salt damage to paper or unknown reactions to mineral pigments. If salt residue remains on your painting, condensation or humidity may reactivate it. For short term use in illustration, this may not matter. Otherwise, for a similar effect, spatter water into a pigmented wash that has just lost its shine, or spritz a damp wash with rubbing alcohol. If you still want to use salt, test this technique on damp paint to find which pigments will give the best crystalline effect.

Salt

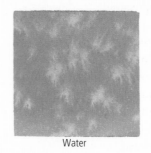

Water

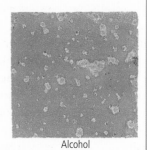

Alcohol

Textures in Watercolor

Salt makes a clear pattern in a damp wash, but it may be hazardous to the permanence of your painting. Water makes a similar texture, perhaps not quite as crystal-like, which is sharper with some pigments than with others. Spattered alcohol creates a circular pattern rather than the crystalline texture made by salt, and is less likely to be damaging.

EXERCISE

Finding Granulating Colors

On a sectioned sheet of cold press or rough watercolor paper, dampen a square with water or diluent. Brush fluid paint over the damp area, then pick up the sheet and rock it gently from side to side. Don't brush back over the wash or you may pick up the granulating paint and ruin the effect. Let the paint dry. Repeat with all your colors, and examine each sample for pigments that settle into the valleys of the support. List the names of the granulating colors in your color journal. ■

Granulating Watercolor Pigments

Test your fluid colors so you can recognize those that granulate on a wet surface. These colors deposit visible particles of pigment on almost any support. Nongranulating colors make a smooth film over the surface. Several colors in the right-hand column are nongranulating. By the way, are you remembering to label your swatches as you do the exercises?

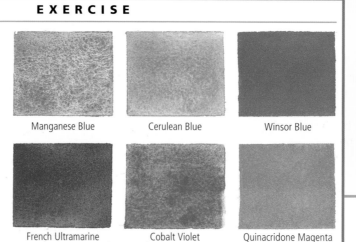

Manganese Blue Cerulean Blue Winsor Blue

French Ultramarine Cobalt Violet Quinacridone Magenta

Rose Madder Genuine Viridian New Gamboge

Raw Umber Burnt Umber Venetian Red

Raw Sienna Burnt Sienna Perylene Maroon

Spreading Colors

While granulating colors stay where you put them, others burst into bloom on a damp surface, creating exciting effects. Some *spreading colors* may bleed through top layers of paint or gesso unless sealed with acrylic medium.

Other interesting effects appear when you combine granulating and spreading colors. The spreading color creates a halo around the settling paint, an effect with interesting applications: highlights on edges of fuzzy objects, fur or sunlit clouds, for example. Results will vary according to how damp the surface is, how much you load your brush, and how quickly the paint dries. You can use a hair dryer to speed drying if you want to prevent a color from spreading too much.

▲
TWILIGHT
RADIANCE
Lawrence C. Goldsmith
Watercolor on paper
18" × 24"
(45.7cm × 61cm)
Collection of the artist

Wet-in-Wet Technique
Nothing quite compares with the flow of watercolor on wet paper, but it's always more effective if the colors you use are "movers." The wetness of the paper also determines how much the paint will spread. Remember that colors are further diluted when applied to a damp surface, so use a little more paint than you would on a dry surface.

EXERCISE

Watching Colors Blossom
On a sectioned sheet of watercolor paper, dampen a section with water or diluent. Load your brush with fluid color, and touch the corner or point of the brush to the support. Let the color move on its own over the damp surface. Repeat with your other colors, and record the results. Do you like what happens when the paint moves? Next, mix a granulating color, such as Cerulean Blue, with a spreading color, like Alizarin Crimson, on your palette, and touch the mixture to a dampened square on the sectioned sheet. Watch how the colors separate. Record your observations in your color journal, noting how you might use this effect. ■

Spreading and Settling Watercolors
The watercolors in this example were applied to wet paper. Cerulean Blue will stay just about anywhere you put it, because it's a "settler." Spreading colors will continue to creep as long as the surface is slightly damp. For example, I'm sure Cadmium Orange would eat your studio if given a chance! When settling and spreading colors are mixed, they tend to separate on a damp surface, creating an interesting halo effect.

Cerulean Blue	Manganese Blue	Winsor Red
New Gamboge	Cadmium Orange	French Ultramarine
Manganese Blue Cadmium Orange	Cerulean Blue Alizarin Crimson	French Ultramarine Burnt Sienna
Phthalo Green Alizarin Crimson	Aureolin Phthalo Blue	Cerulean Blue New Gamboge
Manganese Blue Cadmium Scarlet	Cerulean Blue Burnt Sienna	Cobalt Blue Cadmium Scarlet

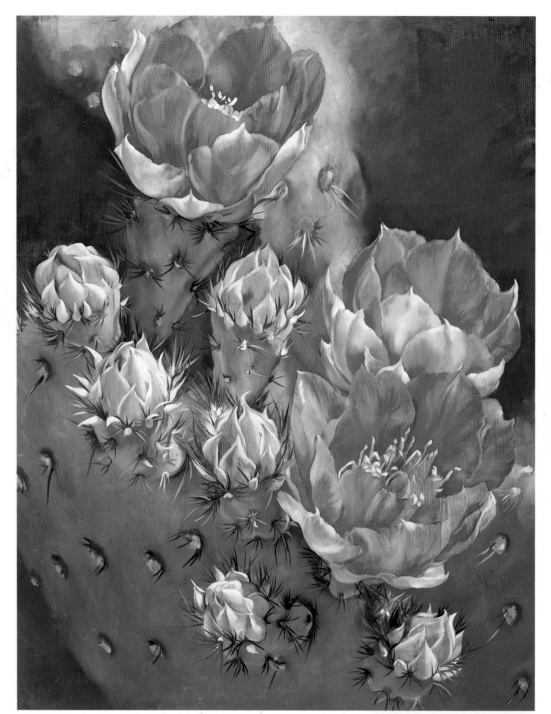

NOPAL CON FLORES ROSOS
Brenda Semanick
Oil on canvas
48" × 36" (121.9cm × 91.4cm)

Spirited Combinations
Lively color mixtures flicker throughout this dynamic painting, capturing your eye and moving it around the picture with vibrant energy. There's no dull, overmixed color here.

> 'HOWEVER PAINTING MAY EVOLVE, COLOR WILL REMAIN ITS PRIME MATERIAL.'
>
> JOHANNES ITTEN

Optical Mixing
The warp on a loom influences every color woven across it because of optical mixing, which occurs when small juxtaposed areas of color are perceived by the eyes as a mixture. In this scarf, the warp is the pale yellow fringe that blends rainbow tints into soft, harmonious colors.

Controlling Color Mixtures

The cardinal rule of color mixing in painting and drawing media is "Don't mix too much." Even if you're using the right colors, overmixing can dull a mixture. A good mixture shows the original colors used and the mixture itself, for example, yellow and blue, as well as green. This broken color gives livelier color vibration. Also, you may be courting disaster if you put too many colors into a mixture. For greater control over mixtures, mix colors of the same approximate value. Fiber artists can make small woven, knitted or quilted samples to mix their colors in warp and weft, and collage artists can make mosaics of small paper clippings. In these applications colors are mixed by the eye instead of a brush.

Don't Overmix
Keep your colors clean and don't mix too much. As you pick the color up and lay it on your support, you should still be able to see clearly all the colors used in the mixture.

EXERCISE

Practicing Color-Mixing Techniques
Prepare a sectioned sheet (see page 36) with masking tape. Mix any two or three colors, as described below, to see the difference between overmixing and correct mixing techniques.
- First, for comparison, mix the colors well into a solid color, and place a swatch of this on your chart.
- Next, mix the colors lightly on a clean palette. Add a little of each color to the edges of the mixture and sweep your brush across the palette to pick up some of each color. Place a swatch of this mixture next to the first on your chart. Apply the color directly to the dry surface without repeated brushing.
- Then, try mixing your colors on the support instead of the palette by applying them directly to the support and mixing lightly, so the parent colors don't lose their identity.
- Make another swatch using fluid media: dampen the support, drop fluid colors in and allow them to *mingle*. Help them a little by rocking the support. Use a little more paint this time, so the water or diluent on the support doesn't thin the color too much.
- Finally, run a fluid wash of one color and quickly run a second wash of another color of the same value and consistency over the wet color. Add another layer of a different color if you like, only don't stir up the colors you've already applied. If you have the right proportions of color and water, you'll get a glowing mixture, no matter what colors you use. ■

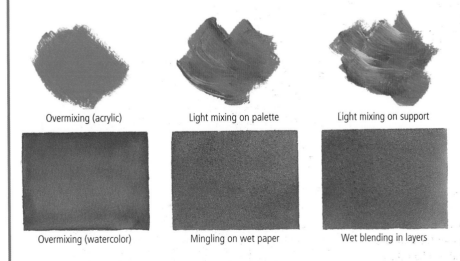

Overmixing (acrylic) Light mixing on palette Light mixing on support

Overmixing (watercolor) Mingling on wet paper Wet blending in layers

Creating Lively Mixtures
It doesn't really matter what method you use to create lively mixtures, as long as you remember to mix lightly. In the first samples (left) of both acrylic (above) and watercolor (below) I deliberately mixed flat, uninteresting color. In the remaining samples, the color comes alive when I put it down and leave it alone, without overmixing.

Split-Primary Color Mixing

Wouldn't you love to have a foolproof method of mixing color, so you can get the color you want every time? One of my first teachers insisted we use three primary colors to mix every color, but many of the mixtures were dull and lifeless. It took me a long time to figure out how to overcome this problem. When you master the *split-primary color-mixing system*, you'll never make mud again.

To make clean color when mixing secondary and tertiary colors, always use two primaries that have no bias toward the third primary. If either of the primaries has the slightest inclination toward the third primary, you will get a low-intensity mixture. For example, if you mix Alizarin Crimson with Indian Yellow, you'll get a dull orange mixture, because the crimson has a definite bias toward blue. Blue, the third primary in this case, is the *complement* (opposite) of the orange you're mixing. In a nutshell:

- Complements always lower the intensity of mixtures.
- The complement of a secondary mixture of any two primaries is the third primary.
- For pure, bright color, avoid using the third primary, even in small amounts.

These are the six primaries you need to mix pure, bright colors:
- a warm red (Winsor Red, Permanent Red or Cadmium Red Light)
- a cool, blue-red (Alizarin Crimson, Carmine or Permanent Rose)
- a warm yellow (Indian Yellow, New Gamboge or Cadmium Yellow Medium)
- a cool, lemon yellow (Winsor Lemon, Lemon Yellow or Cadmium Lemon)
- a warm blue (French Ultramarine)
- a cool blue (Phthalo Blue or Prussian Blue)

For Best Results

When mixing paints, have only the colors you need on your palette. Your palette can be any shape, but I've found that students grasp color-mixing concepts quickly when they can see them on a round Speedball ColorWheel Palette. Keep your colors clean by rinsing out your brush before you pick up another color, and wipe your palette before you change mixtures.

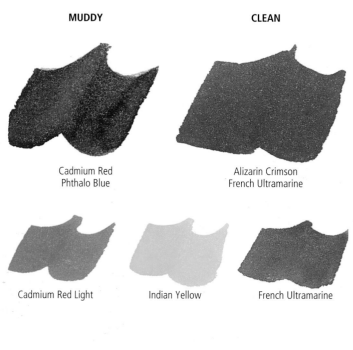

MUDDY | **CLEAN**

Cadmium Red
Phthalo Blue

Alizarin Crimson
French Ultramarine

Cadmium Red Light

Indian Yellow

French Ultramarine

Alizarin Crimson

Lemon Yellow

Phthalo Blue

No More Mud

Blue and red should make violet, but if either of these two colors has a trace of yellow, the complement of violet, they make mud. Blue and red do make a clean violet if they both lean more toward violet.

Split-Primary Palette

If you use six colors—two each of the three primaries—it's easy to make pure, bright mixtures. But you have to have the right six colors.

Mastering Split-Primary Color Mixing

Now you can see for yourself how the theory works. Think of your color wheel as the face of a clock. Draw lines with a black waterproof marker from the center of the circle through twelve o'clock, four o'clock and eight o'clock. Place primary colors as follows: at twelve o'clock, warm yellow to the left of the line, cool yellow to the right; at four o'clock, cool blue above the line, warm blue below; at eight o'clock, warm red above the line, cool red below. For bright mixtures, follow this important rule: *Don't cross the black line!* For example, start out by mixing orange using warm red and warm yellow, which are both *within an area between lines*. Place the orange mixture at ten o'clock. For yellow-orange (eleven o'clock), add a little more warm yellow to

the orange mixture. For red-orange (nine o'clock), add more warm red to the orange mixture. These three members of the orange family will all be clean and bright if you used the right colors. Follow the same procedure for the rest of the wheel. To mix greens, use a lemon-yellow and Phthalo Blue or Prussian Blue. To mix violets, use a blue-red and Ultramarine. *Don't cross the line*. If your mixtures look muddy, check to see that you've got your colors properly laid out and try again. Record the correct combinations immediately in your color journal and memorize them. When this system becomes second nature to you, color mixing will be a breeze. Now, compare this color wheel with the one you painted in chapter two. ■

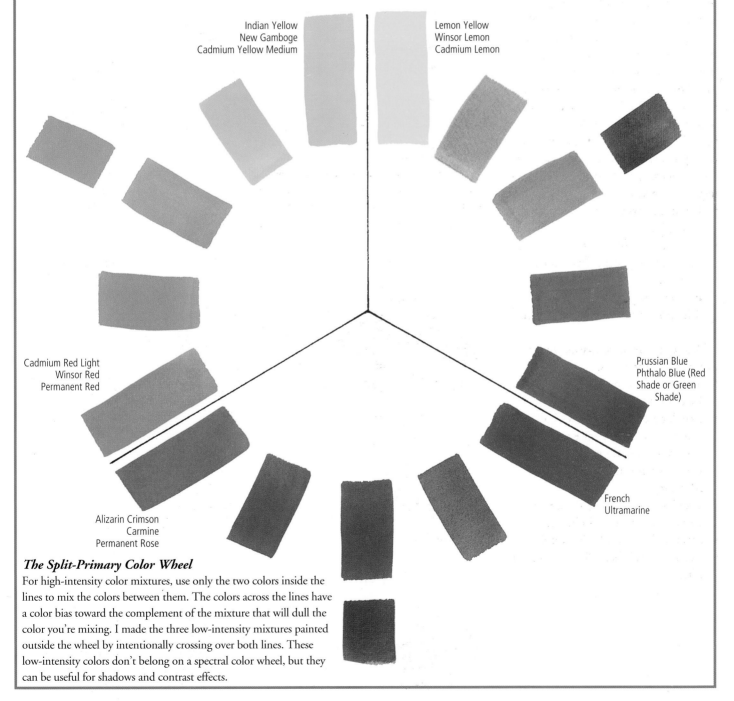

Indian Yellow
New Gamboge
Cadmium Yellow Medium

Lemon Yellow
Winsor Lemon
Cadmium Lemon

Prussian Blue
Phthalo Blue (Red
Shade or Green
Shade)

Cadmium Red Light
Winsor Red
Permanent Red

French
Ultramarine

Alizarin Crimson
Carmine
Permanent Rose

The Split-Primary Color Wheel

For high-intensity color mixtures, use only the two colors inside the lines to mix the colors between them. The colors across the lines have a color bias toward the complement of the mixture that will dull the color you're mixing. I made the three low-intensity mixtures painted outside the wheel by intentionally crossing over both lines. These low-intensity colors don't belong on a spectral color wheel, but they can be useful for shadows and contrast effects.

Mixing Low-Intensity Colors

Sometimes you need soft neutral colors to make the bright ones shine. Learn to achieve red-gray, violet-gray, blue-gray, green-gray—all the subtle, delicate grays in nature. In the struggle to keep from making mud, many artists avoid low-intensity mixtures altogether and fall back on tube grays and blacks, most of which deaden colors. Give your neutrals and low-intensity mixtures a *color identity*, leaning toward one of the colors in the mixture. I know it's an oxymoron, but I call these mixtures *chromatic neutrals*.

Exact complements (opposites on the color wheel) should mix to make neutral gray, but this usually works only with light, not paints. The truth is, you're better off mixing luminous, chromatic neutrals and not dull gray. If you're using the split-primary palette, mix two primaries to get a secondary color, then cross the lines or add the third primary to neutralize the mixture. And remember, don't mix too much. Whatever you do, don't throw tube neutrals into your painting, or they'll flatten the color. The best plan is to mix chromatic neutrals from the colors you started the painting with.

Mixing Neutrals Using Complements

Another way to neutralize is to mix complementary colors. Mix the colors using the split primaries or tube complements, as shown here. These mixtures are much more vibrant than true neutrals, because you can tweak the color identity in several directions to create a more interesting neutral.

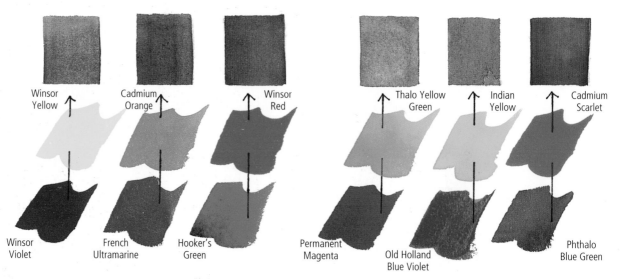

Winsor Yellow · Cadmium Orange · Winsor Red · Thalo Yellow Green · Indian Yellow · Cadmium Scarlet

Winsor Violet · French Ultramarine · Hooker's Green · Permanent Magenta · Old Holland Blue Violet · Phthalo Blue Green

EXERCISE

Mixing Lively Neutrals Using Burnt Sienna

Experiment with lowering the intensity of pure colors by adding Burnt Sienna. Try to match your mixtures to low-intensity earth colors like these: Yellow Ochre, Raw Sienna, Brown Madder and Indigo. Try Lemon Yellow, New Gamboge, Alizarin Crimson and Ultramarine mixed with Burnt Sienna. Do you see how the colors retain a trace of their hue—red, yellow or blue—as they grow lower in intensity? ■

New Gamboge + Burnt Sienna → "raw sienna"

Bright Red + Burnt Sienna → "light red"

Alizarin Crimson + Burnt Sienna → "brown madder"

Phthalo Green + Burnt Sienna → "Hooker's green deep"

French Ultramarine + Burnt Sienna → "indigo"

The Magic Color

One quick and easy way to lower intensity is to use the magic color, Burnt Sienna. This versatile earth color lowers intensity slightly without altering colors very much. Burnt Sienna modifies bright colors, changing them into subtle earth colors in a jiffy. Add it to your palette of split-primary colors. It's one of the most useful colors you'll ever find.

Mixing Low-Intensity Colors

Make a sectioned chart showing low-intensity, neutral mixtures from complements. Mix any two complements or near complements to create a gray or brown mixture, but retain the identity of one of the colors in the mixture. Play with all the colors in your paint box, finding different complementary or near-complementary pairs that achieve lively grays and browns. Take careful notes and record the results in your color journal. ■

Viridian,
Permanent Rose

Cadmium Scarlet,
Cobalt Blue

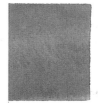
Cadmium Red Light,
Phthalo Blue

Cadmium Red Light,
Phthalo Green

Lively Low-Intensity Colors

You can use many different color combinations to make beautiful low-intensity colors by being sure the colors aren't exact complements. Experiment with colors that are different distances apart on the color wheel and see what you get. The nearer they are on the wheel, the more colorful the mixture. These combinations are much more exciting than neutrals squeezed from a tube.

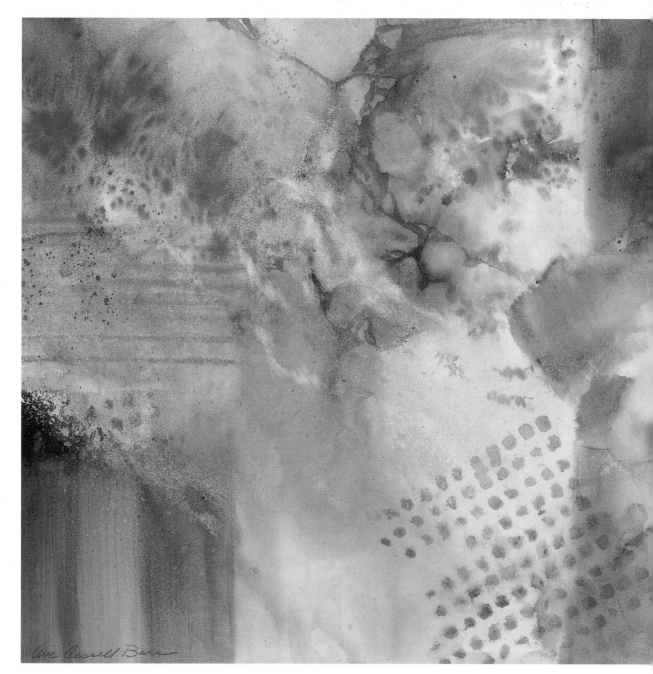

TO CATCH A
PIECE OF THE
SKY
Ave Cassell Barr
Watercolor and
watercolor crayon on
illustration board
16" × 16"
(40.6cm × 40.6cm)

Colorful Grays

Every gray in Barr's watercolor has a beautiful color identity. Soft wet-in-wet edges enhance subtle color changes as they flow throughout the painting, with just a bit of crisp texture for contrast. See if you can make a gray painting as colorful as this one.

Mixing Darks

Strong, rich darks may seem difficult, but they're not all that different from mixing the neutrals in the previous section. Taking into consideration the characteristics of your paints, you can easily see that some colors simply won't make dark mixtures. Choose colors that have relatively strong tinting strength and use them throughout the painting, not only in the dark mixtures. Don't introduce new colors into your palette at the last minute just to get darks. Dark colors are more effective when they're transparent, so use complementary transparent colors to create your mixtures, and don't apply them too heavily. Using formulas for darks almost guarantees they'll ruin your picture. For each painting, pick the combination of colors that is most likely to enhance that particular piece.

Making Dramatic Darks

Look at your transparency chart (see page 39). Select transparent, complementary primary and secondary colors of high tinting strength (see page 42) to start with: red and green, yellow and violet, blue and orange. Mix any red with any green in your medium of choice until you get a dark you like. Sometimes you will get brown or dark gray instead of black. Use these mixed darks in place of tube colors. Place swatches of your mixtures on a sectioned chart. Repeat the exercise with all your complementary and near-complementary pairs, including the tertiaries. Note in your color journal which combinations you like best. What do you think of these colorful darks? ■

Colorful Darks

Ivory Black and Lamp Black, at the top of this chart, have their uses, but they don't make colorful darks. The other mixtures shown here are much more vibrant. The most powerful colors to use for darks are Alizarin Crimson and Phthalo Green, with a dab of Phthalo Blue thrown in to change the color bias. If you want strong darks like this, be prepared to use these colors throughout your entire painting so they don't throw the color out of balance.

Ivory Black (warm black)

Lamp Black (flat black)

Alizarin Crimson
Thalo Green

Burnt Sienna
French Ultramarine

Cadmium Red Light
Phthalo Blue

Cadmium Orange
French Ultramarine

Cadmium Red
Hooker's Green

Winsor Violet
Hooker's Green

Sennelier Red
Phthalo Green

Thioindigo Violet
Sap Green

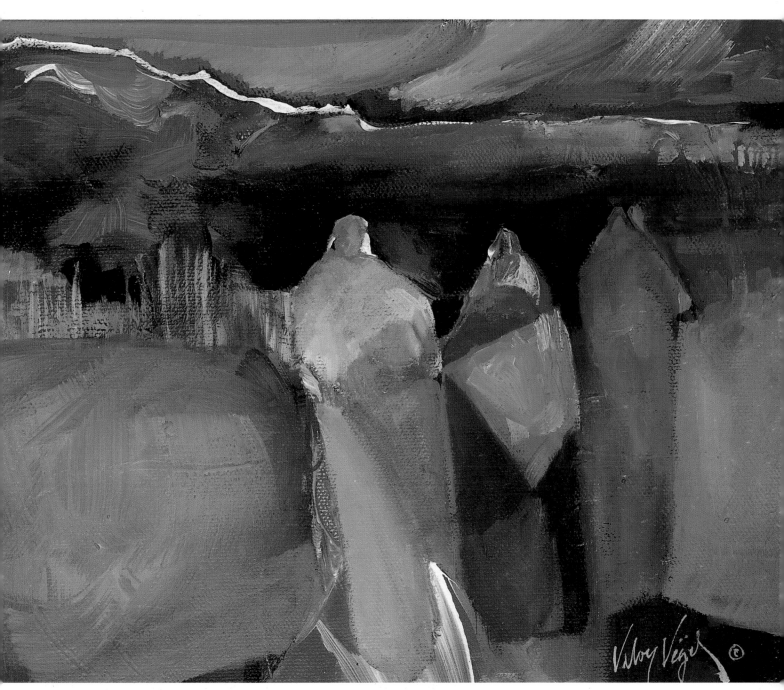

TENDERNESS
Veloy Vigil
Acrylic on canvas
8" × 10" (20.3cm × 25.4cm)
Courtesy of Gallery Elena, Taos, New Mexico

Dynamic Darks

Vibrant darks are beautifully integrated in this acrylic painting, with a combination of true neutrals and more colorful chromatic neutrals. Vigil contrasts background darks with slightly lighter, low-intensity passages touched with bright color. Dark areas throughout draw the viewer's eye irresistibly to the figures.

Modifying Tube Colors

When there are so many ways of mixing beautiful colors, why do some artists depend on ready-made colors? Take green, for example. Few manufactured greens are natural looking, and if you have a tube green you like, chances are you use it too much. This is true of almost any color you can name. An infinite variety of mixtures is possible with every color, as this exercise shows you.

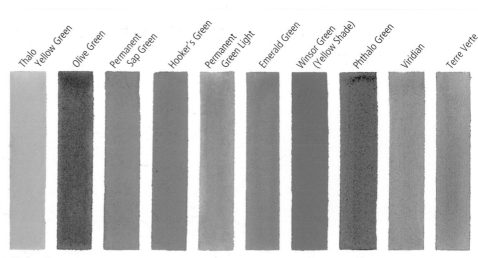

Tube Greens
Many beautiful greens are already mixed and packaged in tubes, like those shown here. The problem is, it's tempting to use them too much and everything begins to look the same. You'll find it's much more fun to make your own greens to fit each situation.

EXERCISE

Getting the Most From Tube Colors

You can easily adjust paint colors in any medium by adding small amounts of one other color to them. Squeeze Phthalo Green onto your palette (or any other color you wish, preferably one with high tinting strength). Mix just enough of a second color with some of the green to change it slightly. Place a swatch of the mixture on a chart. Label the sample with the names of the colors you used. Repeat with every color you have, mixing each with the original Phthalo Green. What a gorgeous array of colors! You'll discover exciting mixtures, no matter what color you start with. Try this with Phthalo Blue, Alizarin Crimson and Lemon Yellow. ■

Phthalo Green

Phthalo Green + Aureolin

Phthalo Green + Lemon Yellow

Phthalo Green + New Gamboge

Phthalo Green + Alizarin Crimson

Phthalo Green + Quinacridone Magenta

Phthalo Green + Permanent Rose

Phthalo Green + French Ultramarine

Phthalo Green + Cobalt Blue

Phthalo Green + Phthalo Blue

Phthalo Green + Raw Sienna

Phthalo Green + Burnt Sienna

Modifying Phthalo Green
Here I've added several different colors from my palette to Phthalo Green to see how many ways I can change it. As powerful as Phthalo Green is, many other colors modify it beautifully, providing delightful new colors to work with. Try this with other colors, too.

EXERCISE

Mixing Blue and Yellow to Make Green

Start with a sectioned sheet as in the illustration shown here. Using Phthalo Blue and Aureolin, mix green and place a swatch at upper left. To the right of this use Phthalo Blue again, but change the yellow to Lemon Yellow. Here's a slightly different green. Continue across the row with Phthalo Blue, changing only the yellow each time, until you've explored all your yellows. Start the next row with a different blue, Ultramarine, and mix this with Aureolin, the same as the yellow above. This results in a slightly duller green than the one you made with Phthalo Blue and Aureolin, but it's still a nice green. However, when you mix New Gamboge and Ultramarine, it's a different story—olive green, for sure. Finish the exercise with the rest of your blues, using the same blue colors across each row and repeating the yellow colors down the columns. ■

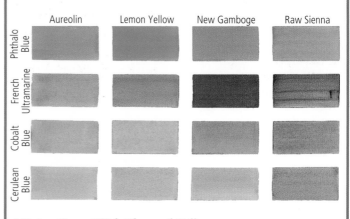

	Aureolin	Lemon Yellow	New Gamboge	Raw Sienna
Phthalo Blue				
French Ultramarine				
Cobalt Blue				
Cerulean Blue				

Mixing Green With Blue and Yellow
Yes, blue and yellow do make green—any kind of green you could possibly want. Prove it to yourself by trying these combinations. You can also do this exercise using an assortment of red and yellow paints to mix orange, or different reds and blues for violet.

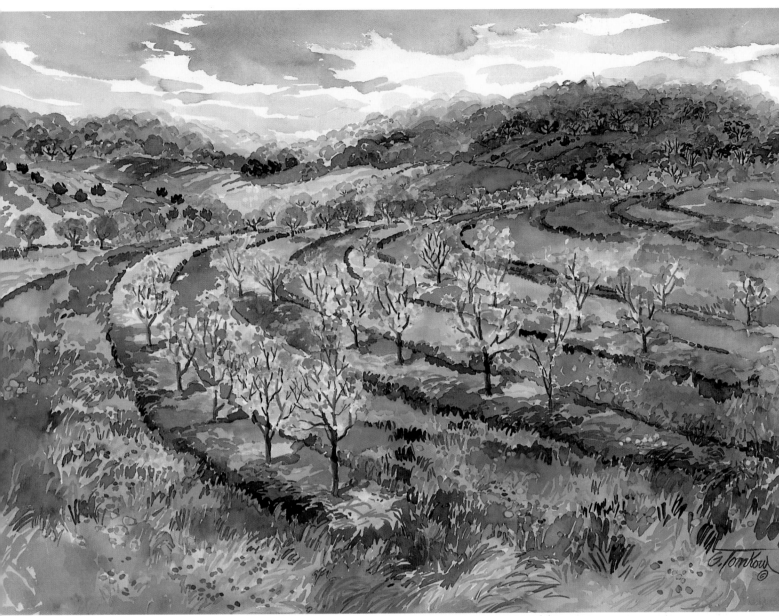

ORCHARD IN ROUND
Gwen Tomkow
Watercolor on paper
20" × 28" (50.8cm × 71.1cm)
Collection of the artist

Using Greens Effectively

A colorful blend of green mixtures and tube greens creates a lively surface throughout this picture, an excellent example of how to use greens effectively. Don't be afraid to use greens. They are troublesome only when you mix warm yellow with warm blue, or if you use the same boring green everywhere.

Painting With the Split-Primary Color-Mixing System

Once you've mastered split-primary color mixing, it's easy to use these colors in your artwork. With seven colors to choose from, including the six primaries and Burnt Sienna, you have more than enough colors to start with, but it's best to begin with just three or four in your picture so you can achieve color harmony. I'm going to take you step-by-step through the making of a watercolor, so you can see how I incorporate my ideas about color into the painting process.

Supplies
- Reference photos
- Sketchbook and pencil
- Photocopy of reference photo(s)
- 15" x 22" (38.1cm X 55.9cm) tracing paper
- 15" x 22" (38.1cm X 55.9cm) 300 lb. (640g/m²) Fabriano Uno watercolor paper
- 1/2-inch (12mm) low-tack tape

Watercolors
- Winsor Red
- New Gamboge
- French Ultramarine

Brushes
- large flat or round brush
- dagger striper brush

STEP 1 ▶

Inspiration and Values

I usually combine more than one photo or sketch into a single composition, rearranging elements to suit myself. I'll use the sky photo shown here for inspiration to start the painting, but let the watercolors have their own way without try-

ing to match the photo. I make a black-and-white photocopy of the barn to study the existing value pattern, then do a value sketch and rearrange the values to indicate some light coming in from the left side. Studying values is one of the most important steps in planning color work.

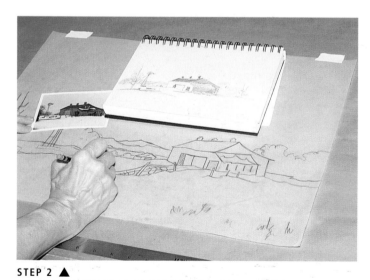

STEP 2 ▲

Transferring the Composition

I draw the composition on tracing paper the same size as my support, so I can work out the design without damaging the surface of my watercolor paper. I decide to make the barn less bulky than it is in the photo and extend the landscape across the page. The drawing is then transferred (see page 72) to 300-lb. (640g/m²) Fabriano Uno paper.

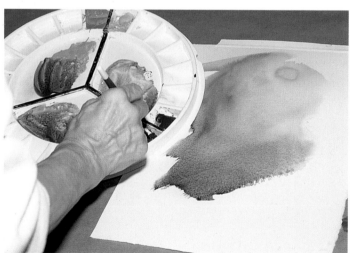

STEP 3 ▲

Different Color Combinations

Before I make my final selection of colors, I squeeze out fresh paint and mingle different combinations till I decide which ones I like best for the picture I have in mind. I like the granulation of French Ultramarine for the sky. I'll use New Gamboge and Winsor Red to round out the primaries. This is a warm palette that will give me a glow in the sky and beautiful violet shadows on the snow.

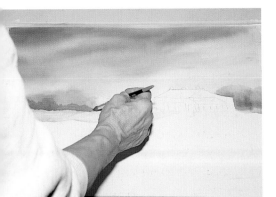

STEP 5 ▶

Snow and Barn

I dampen the paper in the foreground in sections to model the snow, using a diluted violet-gray from the cloud mixture and showing a little light from the sky reflected on the snow. I paint the barn and work back and forth across the painting, repeating colors to unify the picture and using cooler colors in the distance.

STEP 4 ▲

Sky and Background Trees

After taping the edges of the paper with ½-inch (12mm) white low-tack tape, I wet the paper with a large brush down to the base of the background trees, going around the shapes of the buildings. I flow the red and yellow around this skyline and into other areas in the sky. Then I make a rich mixture of French Ultramarine with the orange mixture of the other two primaries and paint in the dark clouds. While the sky is still slightly damp, I put in soft background trees.

STEP 6 ▶

Dark Tree

The tree at left is painted with a dagger striper brush in a darker value to stand out against the sky.

STEP 7 ◀

Finishing Details

I add other details to the middle ground and finish up with some spattered texture in the foreground.

FADING LIGHT
Nita Leland
Watercolor on paper
15" × 22"
(38.1cm × 55.9cm)

**TROPICAL SERIES
125—TROPIC
LEAVES**
*Mary Jane Schmidt
Acrylic on canvas
72" × 60"
(182.9cm × 152.4cm)
Courtesy of Rice and
Falkenberg Gallery*

Compatible Colors

Schmidt's strong, colorful paintings are constructed using compatible colors that are well matched for intensity and tinting strength. Because she works in acrylics, her paints are more opaque and seem brighter than watercolors; the brightness is partly because of the final finish of acrylic medium and varnish she applies.

'The artist is born to pick, and choose, and group with science, these elements, that the result may be beautiful— as the musician gathers his notes, and forms his chords, until he brings forth from chaos glorious harmony.'

JAMES A. MCNEILL WHISTLER

Working With Compatible Colors

Once you've tested the characteristics of your colors and mastered color mixing, you're ready to start organizing color. The color wheel is the visual aid for understanding cohesive, *compatible color* groups. Painters can mix the color wheels, and others can match the compatible wheels with suitable materials such as colored pencils, yarns, fabrics or paper collage. Mixtures of some compatible colors aren't as bright as the split-primary mixtures, but they're unified by their transparency or opacity, intensity and tinting strength. The result is a group of colors that work well together to approximate, rather than match, the primary hues and their mixtures.

MAKING COMPATIBLE COLOR WHEELS

Each set of three compatible colors described on the next few pages makes a highly distinctive color wheel, as you will see. The name of the compatible triad suits the characteristics of the paints used. Work with the exact colors shown on each triad to make a compatible color wheel.

MAKE YOUR OWN OBSERVATIONS

In your color journal, write down your observations of each palette: its value range, the character of the neutrals, your reaction to the mixtures and possible subjects that might work well with each palette. See if you can find other colors in your paint box that are compatible with each triad. Make a sketch using the colors.

STEP ONE

Make a Color-Wheel Template

Cut a 6-inch (20.3cm) color-wheel template from cardboard or stencil paper. Use a coin to trace twelve small circles equidistant around the wheel, at the positions of numbers on a clock. Cut out the circles with a stencil knife. Use this template to trace six color wheels on a 14" × 20" (35.6cm × 50.8cm) or larger white support.

STEP TWO

Fill in Compatible Color-Wheel Circles

Use only the three primary colors recommended for each compatible color wheel on the following pages, or the closest match you can find in transparency, intensity and tinting strength. Place colors representing yellow at the top of each wheel, blue at four o'clock and red at eight o'clock, labeling them with their paint names. Using these primaries, mix the colors between them and fill in the entire circle. You can start in any section—I'm working with red and yellow to mix the oranges here. Since there are no lines to cross, as on page 49, you'll find that some of these color-wheel mixtures aren't pure. That's okay, because with compatible colors we're not trying to make spectral colors. We're going for unity and expression in colors that work well together because they share specific characteristics. Go on to mix chromatic neutrals with different combinations of all three primaries, showing a color bias toward each color in the mixtures. Place swatches of these neutrals at the center of the circle (for now, don't worry about the color swatches shown outside the wheels; we'll work with those at the end of the chapter).

The Delicate Palette

Delicate tinting colors—Rose Madder Genuine, Aureolin and Cobalt Blue—make an exquisite, high-key color wheel, limited in contrast and beautifully transparent. In watercolor, these colors are nonstaining, easily lifted and extremely useful as glazes. Although they are pure, bright colors, they all have relatively weak tinting strength. Flowers are delightful subjects for the delicate palette, but there are other options. How about a misty river scene or a soft portrait? Light-filled landscapes are successful with these colors, but you can't make strong darks with them. Powerful darks would destroy the delicacy and subtlety of this palette. Used carefully, Burnt Sienna is a good addition because it enables you to increase your range of darks slightly. Following the general instructions on the previous page, make a color wheel and then a sketch with the delicate primaries. ■

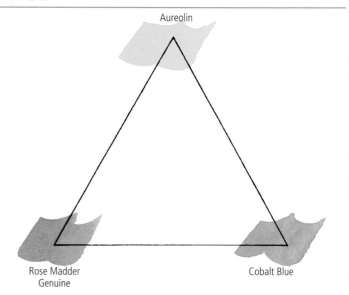

Aureolin

Rose Madder Genuine

Cobalt Blue

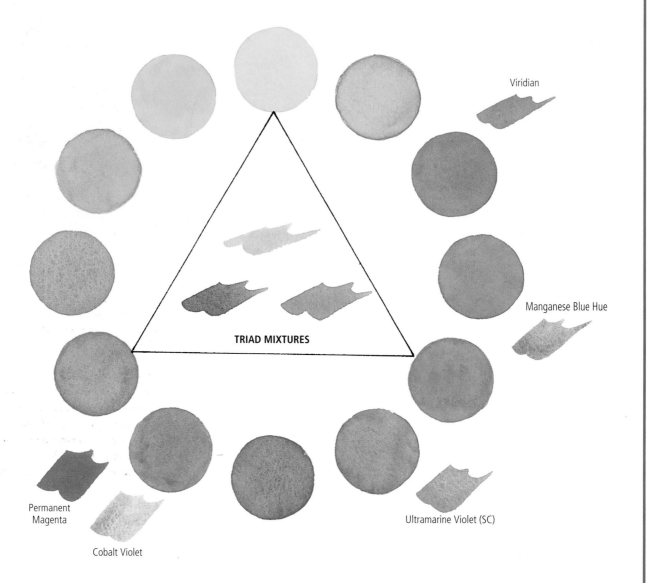

Viridian

Manganese Blue Hue

Ultramarine Violet (SC)

Cobalt Violet

Permanent Magenta

TRIAD MIXTURES

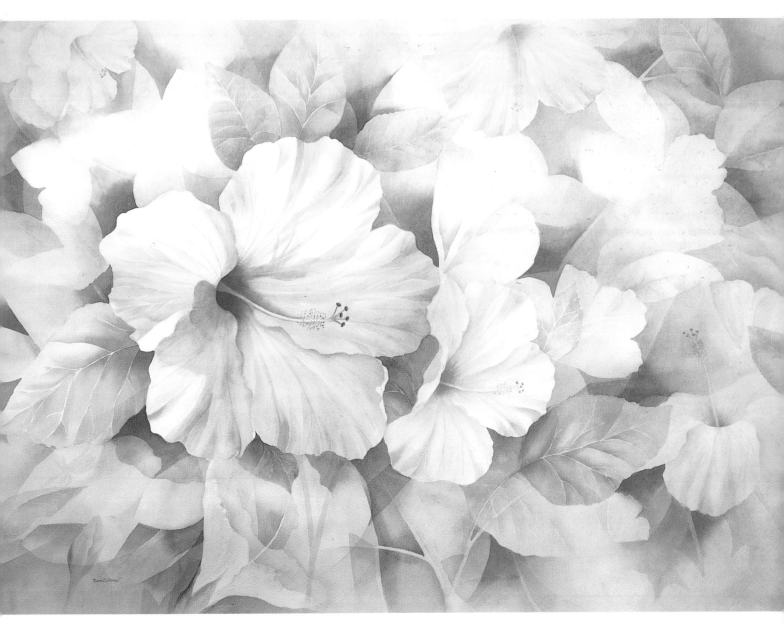

HIBISCUS HAVEN
Betty S. Denton
Watercolor on paper
30" × 22" (76.2cm × 55.9cm)
Collection of the artist

Soft Delicate Colors

Denton's floral illustrates the harmony of the delicate palette. She employs a layering-and-glazing technique, using well-diluted, delicate colors to build up flower forms. While some artists use soft edges for florals, this artist likes crisp edges with soft colors for a fresh, clean look.

The Standard Palette

The standard palette is a combination of high-intensity, transparent and opaque colors, with intermediate-to-strong tinting strength. These workhorse colors are found on almost every artist's palette: Cadmium Red, New Gamboge or Cadmium Yellow, and French Ultramarine. New Gamboge lends some transparency to the mixtures. Ultramarine is semitransparent, but the cadmium colors are very opaque. Many artists think of this palette as muddy. It has a wide range of values, but doesn't quite match the power of the intense palette shown later. This is an ideal palette for natural subjects: the olive greens of trees and grasses, the subtle violets of shadows, beautiful browns and earthy yellows. You can dilute mixtures for high-key paintings, but they lack the subtlety of the delicate palette. Even with its limitations, this is a very useful palette, particularly if you supplement the standard triad with other colors, like Alizarin Crimson, to improve its transparency in mixtures. Make the standard color wheel and use it in a sketch. ■

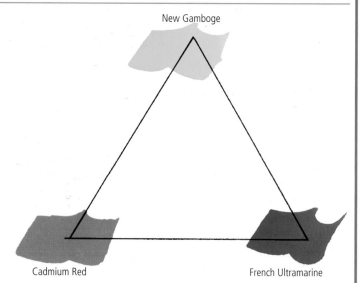

New Gamboge

Cadmium Red

French Ultramarine

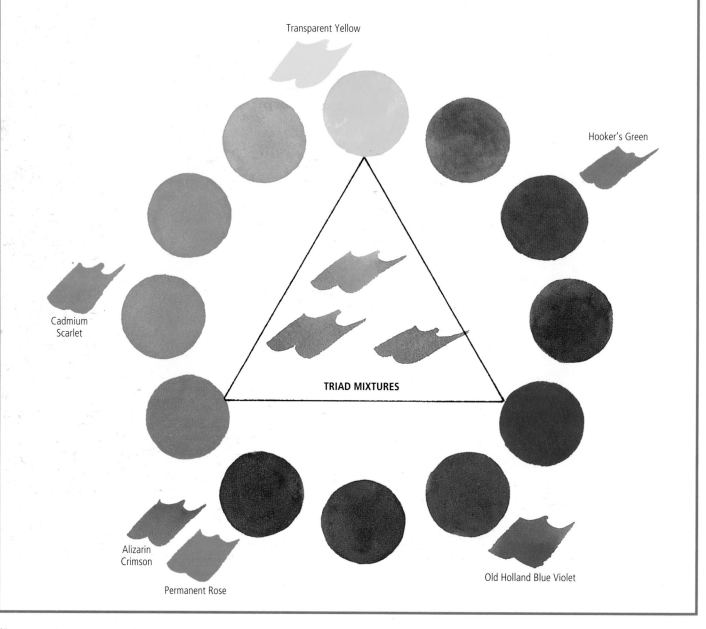

Transparent Yellow

Hooker's Green

Cadmium Scarlet

TRIAD MIXTURES

Alizarin Crimson

Permanent Rose

Old Holland Blue Violet

LE CHATEAU
Nita Leland
Watercolor on paper
24" × 18"
(61cm × 45.7cm)

Versatile Standard Colors

The standard palette offers a wide range of possibilities, from bright, high-intensity colors to toned-down, almost earthlike mixtures. I like this palette because I can achieve low-intensity greens and still have brighter blues, as in the sky here, as well as more red in my brown mixtures.

The Intense Palette

Transparent, high-intensity colors of great tinting strength, such as Winsor Red or Alizarin Crimson, Winsor Lemon and Phthalo Blue, make a versatile palette that offers a range from dramatic, bold statements featuring rich, intense darks to sensitive, elegant images using delicate tints. The value range runs the gamut from the lightest light to the darkest dark. These dynamic colors generate energy, brilliance and sharp contrast in any subject, including cityscapes, landscapes, portraits and flowers. Nonobjective or abstract compositions can be dazzling with this intense triad. The transparency of these colors makes them useful as glazes when well diluted, but their staining property merits a word of caution: They can't be lifted easily once they're dry. Make a color wheel and a sketch with the intense triad, then record your observations in your color journal. ■

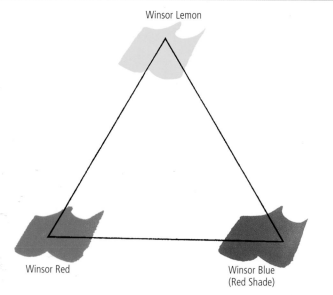

Winsor Lemon

Winsor Red

Winsor Blue
(Red Shade)

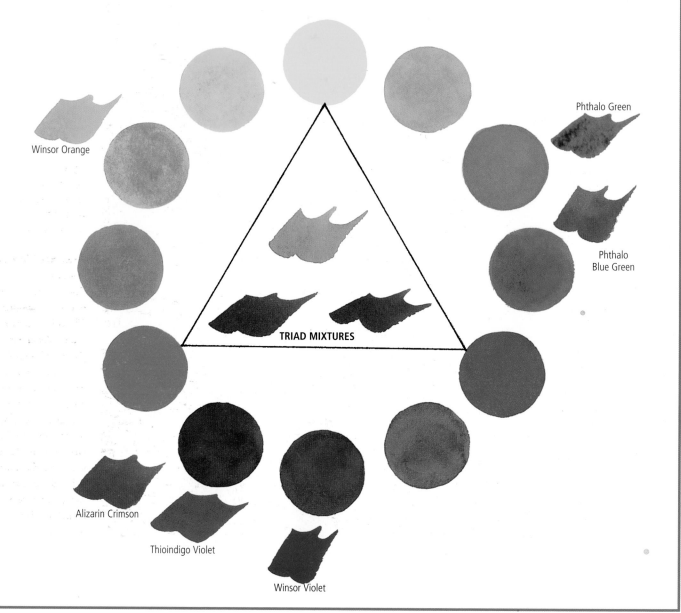

Winsor Orange

Phthalo Green

Phthalo
Blue Green

TRIAD MIXTURES

Alizarin Crimson

Thioindigo Violet

Winsor Violet

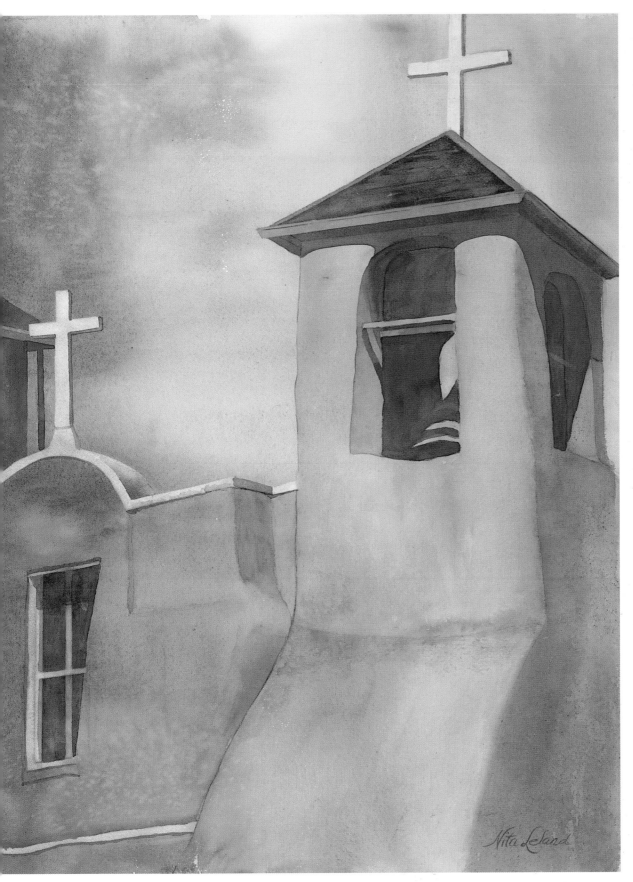

ICON
Nita Leland
Watercolor on paper
24" × 18"
(61cm × 45.7cm)

Beautiful Intense Colors

The intense palette is one of my favorites. The colors blossom beautifully on wet paper, so it's great fun to drop them in and watch them move on the paper. For this painting I began with the idea of a wet-in-wet horizontal landscape, but the moving colors decided to be a background for a church in New Mexico.

The Opaque Palette

If you're looking for unique expression, the opaque palette is a sure way to get it—but it's tricky. The mixtures are subtle and distinctive. Colors for this wheel are Indian Red, Yellow Ochre and Cerulean Blue. While Cerulean Blue seems a bit bright for a low-intensity palette, its density and opacity allow it to fit right in. Indian Red has a stronger tinting strength than the other two colors, but together they seem to work. Extreme darks are impossible, but you can get dark enough to have effective value contrast. The limited color range of the mixtures makes it interesting. Work on a wet surface with the colors, laying them in with a big brush, then leaving them alone. If you try to move the colors around, you'll make instant mud and disturb the granulating effects of the colors. Paint rocks, buildings and landscapes with this palette, and don't bypass portraits and flowers as interesting possibilities. Make your color wheel with the opaque triad, then do a sketch using these colors. ■

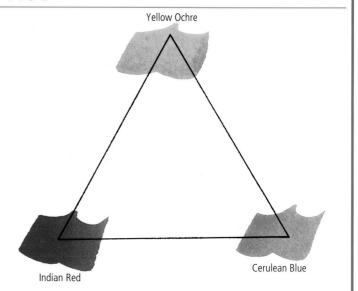

Yellow Ochre

Indian Red

Cerulean Blue

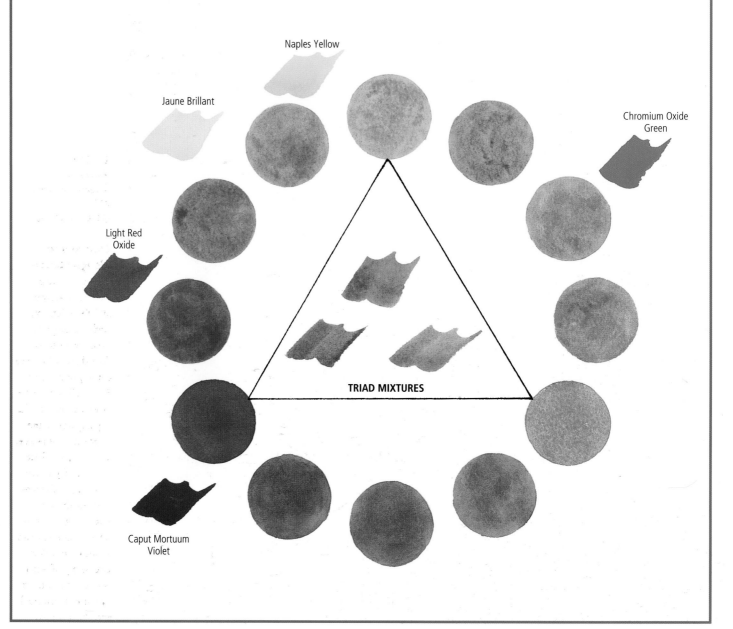

Naples Yellow

Jaune Brillant

Chromium Oxide Green

Light Red Oxide

TRIAD MIXTURES

Caput Mortuum Violet

RELICS
Nita Leland
Watercolor on paper
22" × 15"
(55.9cm × 38.1cm)

Harmonious Opaque Colors

Cerulean Blue granulates beautifully on 300-lb. (640g/m²) Arches cold-press paper, so I simply flowed the color onto damp paper with a 3-inch (76mm) hake brush and rocked the paper gently so the pigment would settle. The opaque palette makes dusky violets and rich, earthy red-oranges; the low-intensity green mixtures harmonize with all the other colors. Use plenty of water with these colors, so they don't turn thick and chalky on you.

The Old Masters' Palette

The early masters were limited in their choices of colors and used those very much like the ones in this palette: Burnt Sienna, Yellow Ochre or Raw Sienna, and Payne's Gray. This palette of wonderful values and intermediate tinting strength yields low-intensity and semitransparent mixtures. It's surprising how many artists fall in love with the old masters' palette when they try it. Its subtlety is moving and highly effective. Any subject is appropriate, but it's especially interesting in portraits and autumn florals. With Burnt Sienna and Payne's Gray substituting for red and blue, violet mixtures don't exist; instead, a good dark takes their place. Greens and oranges are low key and mysterious. This is the only time I recommend using Payne's Gray on your palette, as a color in its own right and not as a quick fix to add darks to a painting. Complete the old masters' color circle and make your sketch and your color journal notes. ■

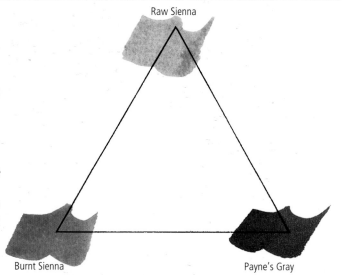

Raw Sienna

Burnt Sienna

Payne's Gray

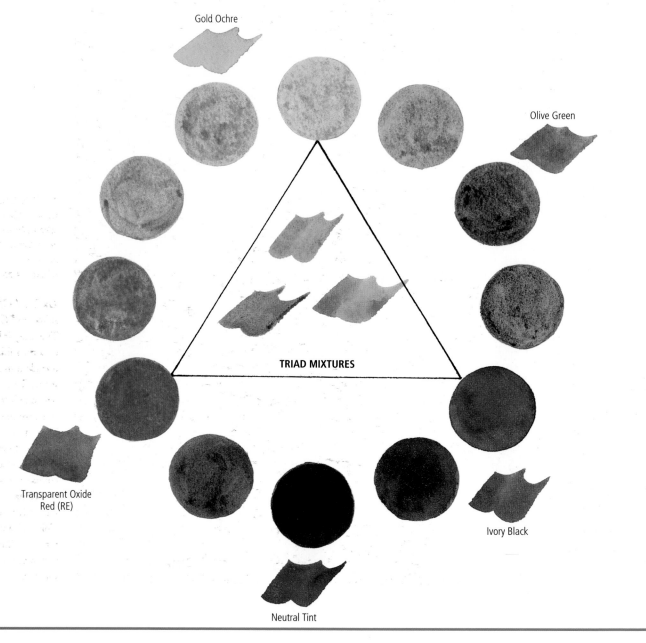

Gold Ochre

Olive Green

TRIAD MIXTURES

Transparent Oxide
Red (RE)

Ivory Black

Neutral Tint

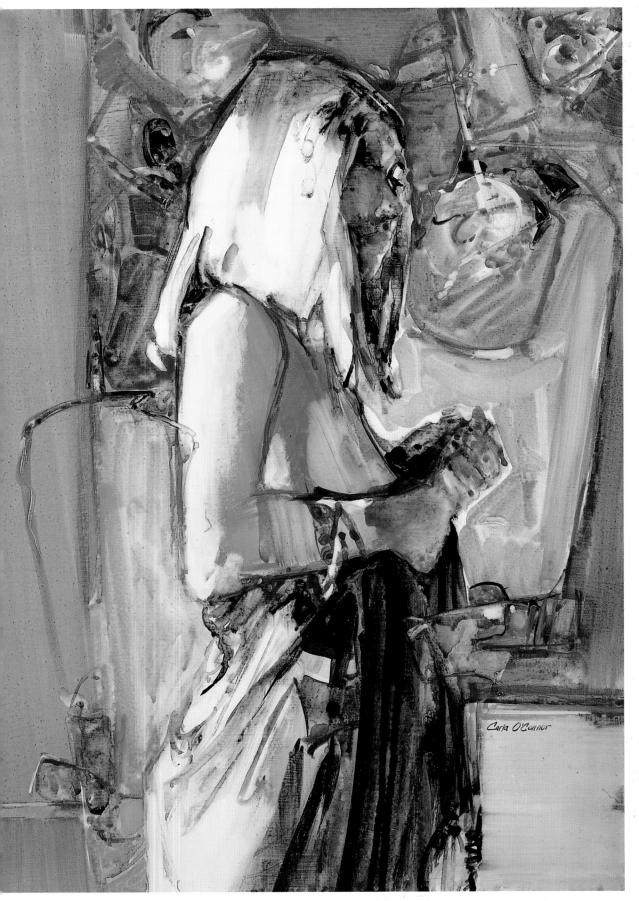

AFTER EIGHT
Carla O'Connor
Watercolor and gouache
on watercolor board
30" × 22"
(76.2cm × 55.9cm)

Unified Old Masters' Colors

The unity inherent in compatible colors is evident in this serene figure painting, which reflects the low-intensity color impression typical of the old masters' palette. O'Connor's colors set a pensive mood that whispers rather than shouts. This is clearly not the place for Phthalo Green or Cadmium Orange.

The Bright Earth Palette

This is my personal favorite among the low-intensity compatible triads. The bright earth palette has powerful tinting strength and is beautifully transparent. With this palette you can achieve extremes of value from bright lights to rich, powerful darks. Using Brown Madder, Raw Sienna or Quinacridone Gold, and Indigo, you are once again forfeiting violet; but if you need it, you can tweak the color in your painting by including a brighter red or blue that will yield a violet mixture. Color mixtures of the bright earth palette are more transparent and somewhat brighter than those of the old masters' palette, but still low in intensity. The palette makes distinctive portraits and abstract landscapes, but almost any subject will work. Brown Madder and Indigo are staining colors, so you won't be able to do much correcting with this palette. Mingle the colors and make three sketches with the bright earth palette, allowing a different color to dominate in each one. What do you think of the value and color range of these colors? Write your thoughts in your color journal. ■

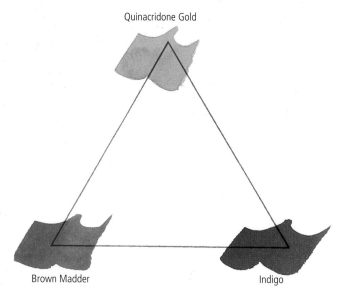

Quinacridone Gold

Brown Madder

Indigo

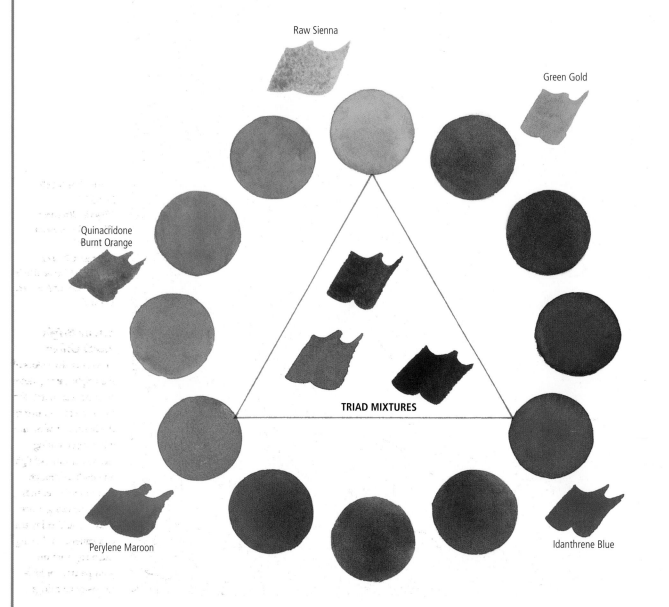

Raw Sienna

Green Gold

Quinacridone
Burnt Orange

TRIAD MIXTURES

Perylene Maroon

Idanthrene Blue

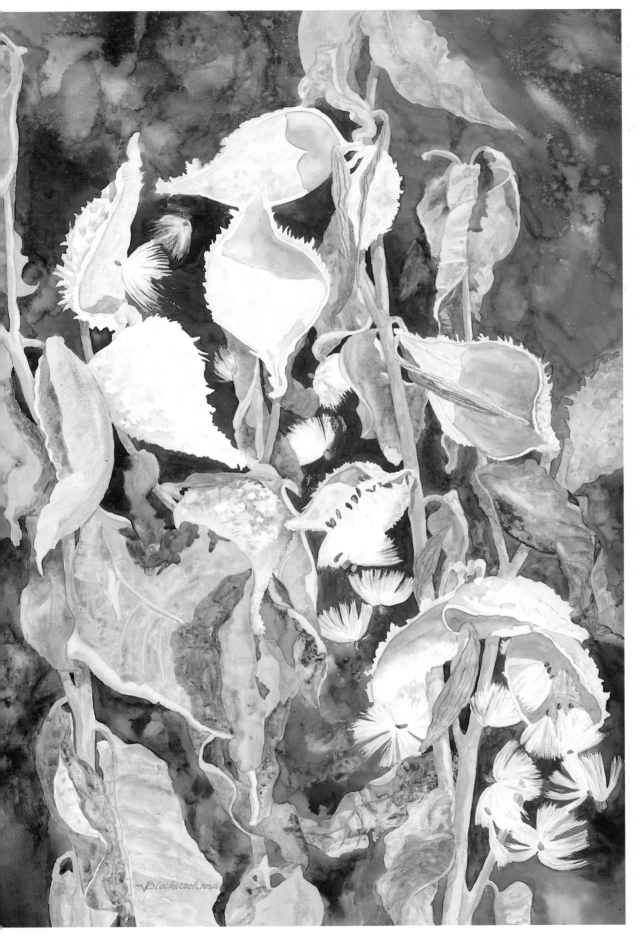

LIFE ON THE LOOSE
Virginia Blackstock
Watercolor on board
36" × 28"
(91.4cm × 71.1cm)
*Courtesy of Frame Works
Gallery, Grand Junction,
Colorado*

Strong Bright Earth Colors

Low-intensity colors of
the bright earth palette
are a perfect match for
this subject, capturing
the harmony of nature
while representing
strong contrasts of light
and dark. Although
you can mix neutrals
like these using other
colors, you'll enjoy the
convenience of having
them together on
your palette for low-
intensity paintings.

Comparing Compatible Palettes

Supplies
- 12" × 16" (30.5cm × 40.6cm) or larger sheet of paper suitable for your medium of choice
- Drawing pencil
- Tracing paper
- Soft graphite pencil
- Cotton swab
- Rubbing alcohol
- Colored pencils
- Color journal
- Compatible palette colors

The color effects of compatible palette groupings are so useful that artists in nonpainting media can also use them to create harmonious artwork. In this demonstration you'll see how compatible palettes compare by making six sketches of a single subject using each of the palettes to create a distinctive mood, pushing the colors in each palette to show their special characteristics. For example, make the delicate sketch relatively high key, show the power of the intense and bright earth colors, and so forth.

STEP 1 ▶

Make a Simple Drawing

Section a 12" × 16" (30.5cm × 40.6cm) sheet of paper (or larger) into six equal rectangles. Then make a simple drawing on tracing paper that you can easily transfer six times to this support. I include just a few large shapes and an area that will remain white, leaving out unimportant details. You can make your sketches nonobjective designs if you want to. Then I shade in a simple value pattern.

STEP 2 ▲

Transfer the Drawing

Turn the sketch over and rub the back with a soft graphite pencil where you see your lines through the tracing paper. To set the graphite so it won't smear my watercolor paper, I dampen a cotton swab with rubbing alcohol and wipe lightly over the graphite rubbing. When the alcohol is dry, I turn the drawing over and lay it on each section of the watercolor paper, tracing the lines with different colored pencils for each section, so I can see which lines I've traced. If the transfer becomes too faint, simply rub the back with graphite again and set with alcohol.

STEP 3 ▲

Try Out Combinations

In your color journal, mingle the colors of each compatible palette, trying out different combinations and color effects. When you find ones you like, mark them with the names of the palettes and the paint colors included in the mixtures, so you know which ones to use on the comparison sheet. I rarely use more than three colors for each palette, but you can include other colors you find compatible.

STEP 4 ▶

Paint the First Color Sketch

After I've selected the colors I plan to use for all the sketches, I paint the first sketch with the delicate palette.

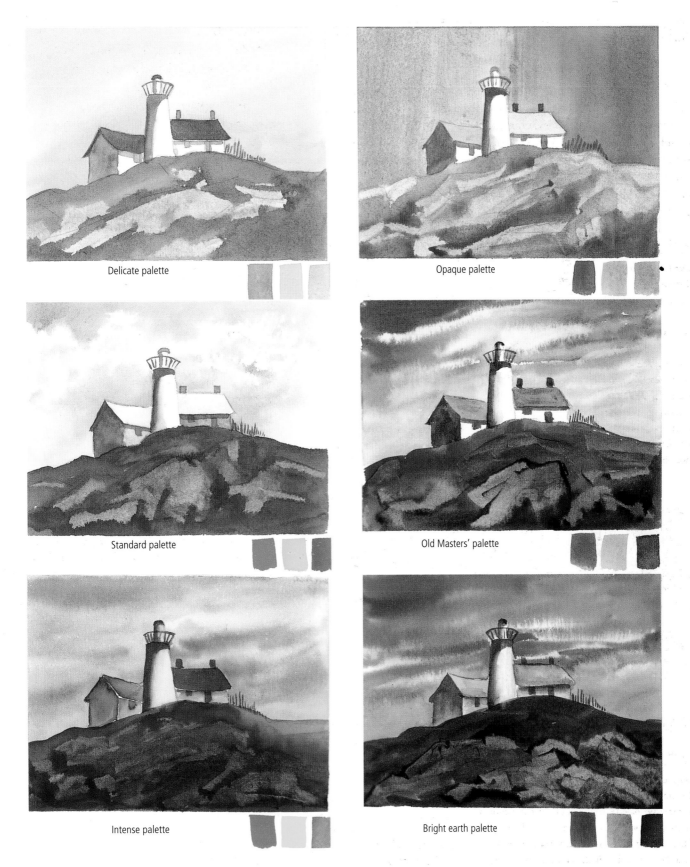

Delicate palette

Opaque palette

Standard palette

Old Masters' palette

Intense palette

Bright earth palette

Finish Sketches Using Each Palette

When your color sketches are completed, place swatches of the colors you used below each one. Then label each sketch with the name of the palette you used. Step back and examine the sketches. Which do you like best?

What other subjects can you think of for each palette? Write your reactions to the colors in your color journal. The next time you're planning a picture, try out several different compatible palettes before you begin.

Mixing and Matching Compatible Colors

Pigment compatibility in transparency, intensity and tinting strength is a key to harmonious, distinctive color. But you don't have to limit yourself strictly to my colors. Compatible colors are points of departure, not formulas. Test your mixtures. Many colors share the characteristics of each group and can be used interchangeably. Use good judgment when you cross over to another group. Alizarin Crimson may work well with both the intense and the standard colors, but it's much too powerful for the delicate ones. Burnt Sienna fits in with every palette. Try Permanent Rose or Rose Doré on the delicate palette. Explore variations of the old masters' palette using Ivory Black or Neutral Tint. Be sure your substitutions share some of the characteristics of the triad you're putting them into, or that you adjust adequately for any differences in transparency and tinting strength. Also, try different combinations of new colors. One exciting combination is an earth-type palette that includes three modern pigments: Perylene Maroon, Quinacridone Gold and Idanthrene Blue. What other compatible combinations can you find?

EXERCISE

Making a Compatibility Reference Table

Now that you've explored compatible palettes, this exercise organizes your colors into a workable system. Your test charts from chapter three will help you group colors according to their transparency or opacity, intensity and tinting strength. Begin by separating your colors into two major groups: high intensity and low intensity. Next, within each of those two groups, sort the colors according to their tinting strength: delicate, intermediate or strong. Finally, within each of these groups, match the colors for their transparency or opacity. Study the chart on this page to get you started. Make one like it in your color journal, adding your own colors. After you've selected the colors for each category, place a swatch of each compatible color outside the edges of the appropriate wheel on your large compatible color-wheel chart, as I have, to provide a visual reference for colors that share similar characteristics. Some colors may work equally well on more than one wheel. ■

Compatible Colors Chart

HIGH-INTENSITY COLORS

Delicate	**Standard**	**Intense**
(TRANSPARENT)	(TRANSPARENT OR OPAQUE)	(TRANSPARENT)
Rose Madder Genuine	Cadmium Red Medium	Alizarin Crimson
Aureolin	Cadmium Scarlet	Winsor Red
Cobalt Blue	Cadmium Lemon	Winsor Lemon
Manganese Blue Hue	New Gamboge or Indian Yellow	Phthalo Blue or Winsor Blue
Viridian	French Ultramarine	Phthalo Blue Green
Permanent Magenta	Thalo Yellow Green	Phthalo Green or Winsor Green
	Hooker's Green	Winsor Orange
	Cadmium Orange	Thioindigo Violet

LOW-INTENSITY COLORS

Opaque	**Old Masters**	**Bright Earth**
(VERY OPAQUE)	(TRANSPARENT OR OPAQUE)	(TRANSPARENT)
Indian Red	Burnt Sienna	Brown Madder
Naples Yellow	Raw Sienna	Perylene Maroon
Yellow Ochre	Ivory Black	Quinacridone Gold
Cerulean Blue	Neutral Tint	Indigo
	Payne's Gray	Idanthrene Blue
	Olive Green	Olive Green

Your Personal Basic Palette

It's time to narrow your selection to a workable number of eight to ten colors that reflect your individuality. The exercises in this book will help you decide on a balanced palette. Have at least two sets of primary colors similar to the split-primary palette or from any combination of two compatible triads. Be sure to include Burnt Sienna and a couple of your personal favorites. Remember, this is a *limited palette;* eventually, you'll expand it. When you've selected your colors, arrange them on a clean, white palette, leaving spaces between to add additional colors later (see page 37 for suggestions on setting up your palette). Experiment with your basic palette for a few weeks until you know it well, but don't hesitate to use other colors any time you want to. Relax and have fun with the colors. Never stop exploring. Dash off a couple of color mixtures in odd moments, when you don't have time to do a finished piece.

EXERCISE

The Four Seasons Revisited
Make sketches of the four seasons using any combination of three or four colors from each of your basic palettes. When these sketches are completed, compare them to the ones you did in chapter one. How do they differ from those you did with your old palette? Tell it to your journal. ■

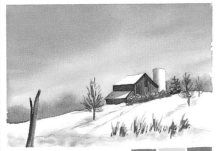

Winsor Red, Winsor Lemon, Phthalo Blue

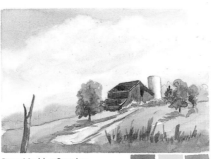

Rose Madder Genuine, Aureolin, Cobalt Blue

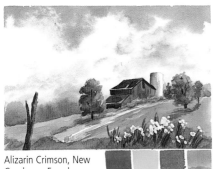

Alizarin Crimson, New Gamboge, French Ultramarine, Cobalt Blue

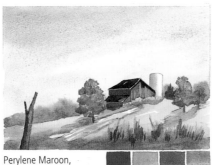

Perylene Maroon, Quinacridone Gold, Idanthrene Blue, Cerulean Blue

Explore the Possibilities
For my four-seasons paintings I used the intense palette, the delicate palette, the standard palette (plus Alizarin Crimson), and a new palette of modern pigments (plus Cerulean Blue), so you could see some of the color possibilities I've presented in this chapter. Compare these four-seasons sketches to the ones I did in chapter one (page 20).

Permanent Rose, Aureolin, Cobalt Blue

Rose Madder Genuine, Aureolin, Manganese Blue

Perylene Maroon, Quinacridone Gold, Idanthrene Blue

Variations on Compatible Palettes
Try these palettes and make up new ones of your own based on compatible pigments you find. Whenever you experiment with new colors, change just one color at a time, so you can evaluate the effect it has on mixtures with your other colors.

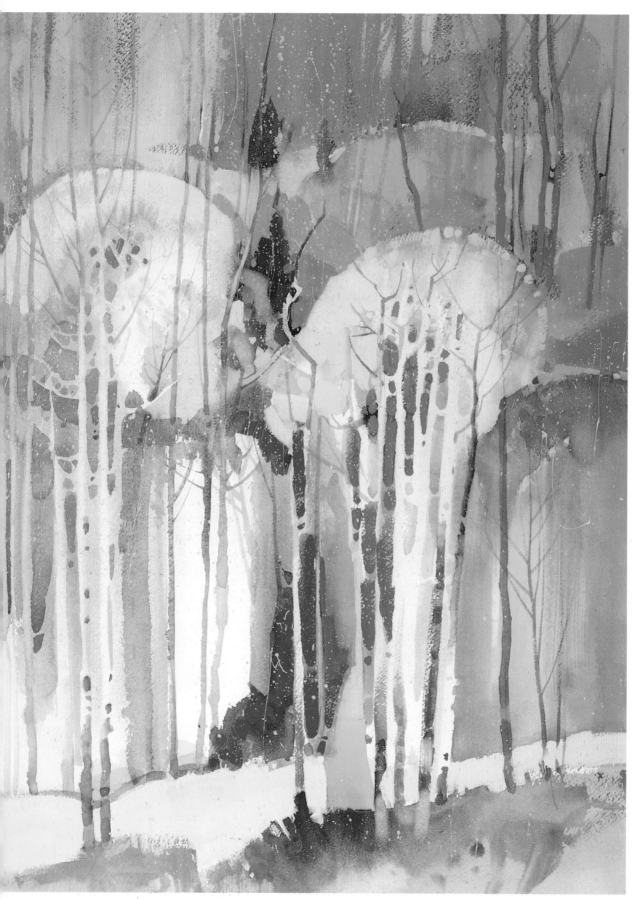

ASPEN PATTERNS, GOLD & BLUE
Stephen Quiller
Watercolor and gouache
on paper
26" × 18"
(66cm × 45.7cm)
Private collection

Complementary Color Scheme

Quiller's painting is a good example of an inventive color scheme that strongly suggests a sense of place easily recognizable to anyone who has been to Colorado in the fall. Golden aspen against blue sky, as well as blue and blue-violet complementary shadows, interact beautifully.

Expanding Your Palette With Color Schemes

The compatible triads explored in chapter five provide a great variety of color selections: high key, low key, intense and neutral. All are at your fingertips. The complete range of hues of the spectrum can be represented in compatible pigments—not in spectral perfection, to be sure, but harmoniously combined—giving mixtures of delicacy, strength or gentle neutrality. Numerous contrasts and effects are possible with these compatible triads. Color expression can be subtle and sensitive or dynamic and forceful, as you wish. What might be gained, then, by increasing the number of colors on the palette?

The goal of color exploration is to learn as much as possible about pigments, thereby achieving greater personal expression through color. So far, all of the colors on the circles have been mixed from three primary pigments. You haven't considered the possibilities of a palette having a complete selection of pure, unmixed colors straight from the tube to represent the hues—twelve primaries, secondaries and tertiaries of the fullest saturation possible with pigments. Such a palette can greatly expand your color expression. Now you're going to learn about two systems that will propel you somewhere over the rainbow, where all good colorists belong.

In 1895, educator Milton Bradley recommended a palette for teaching color that included red, yellow and blue, plus premixed green, orange and violet, thus eliminating the students' mixing of muddy secondary colors. My traditional expanded palette for artists, explained in this chapter, is based on Bradley's setup, plus six tertiary colors. Not long after Bradley's innovation, Herbert E. Ives suggested an alternative twelve-color system based on magenta, yellow and cyan as primaries, eliminating red-orange and blue-violet; this is the basis for my alternate expanded palette.

In choosing colors for *expanded palettes*, your first consideration is intensity, followed by transparency and tinting strength. Select transparent colors wherever possible, and look for similar tinting strength. Choose the colors you like best, but if they don't work, don't hesitate to change them. Put your *color personality* to work. If a color scheme calls for yellow and you like a warm yellow that leans toward orange, don't be afraid to use it.

But first, get your colors in order. Throw away stiff, broken tubes, discontinued colors and inferior student colors. Sort out colors you don't like and give them away. You'll probably never use them anyway. Test all your colors for transparency and tinting strength (as described in chapter three). Determine their handling characteristics and record the results in your color journal.

Premixed Colors
Milton Bradley's expanded palette led to the manufacture of school paint boxes such as this one. Premixed secondary colors made it easier to teach color theory, but not color mixing. You're better off with artists' quality colors.

A Fresh Start

If you're a painter, clean your palette no matter how hard it is. Remove old, soiled paint and colors you never use, so you can get a fresh start on a whole new way of thinking about color.

Expanding Your Palette

Using the charts on this page as your guide, select twelve colors for each expanded color wheel. Collage and fiber artists can gather paper, fabrics or yarns to match the colors. You don't have to duplicate my colors. If you like Permanent Rose better than Quinacridone Magenta, use it. Check the supply list in chapter three (page 36) to fill in the gaps. Trace two color wheels on a white support, using the template you made in chapter five (page 59). Starting with a high-intensity yellow for each wheel, place a swatch of it in the top circle. It's okay to use some colors on both wheels, or they can be completely different. Continue around the wheel, placing pure bright colors in their appropriate places. Be sure to label the paint names. ■

The Expanded Palettes

Use only high-intensity pigments for these expanded color wheels. You don't have to use different colors in every section, just at the locations of primary red/magenta (Winsor Red above, Quinacridone Magenta below) and primary blue/cyan (Winsor Blue [Red Shade] above, Winsor Blue [Green Shade] below). As you can see, the two wheels differ. On the alternate wheel, magenta (Quinacridone Magenta) replaces red (Winsor Red), which moves up to displace red-orange (Cadmium Scarlet); cyan (Winsor Blue [Green Shade]) replaces blue (Winsor Blue [Red Shade]).

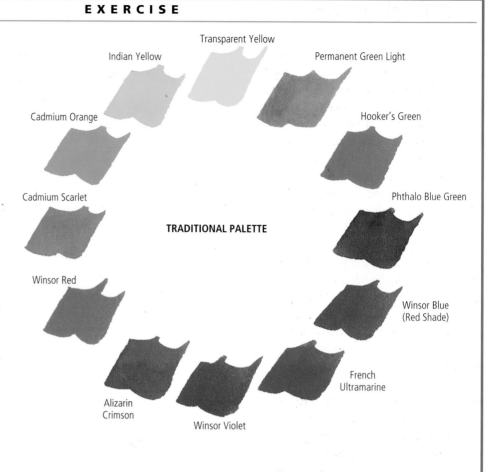

TRADITIONAL PALETTE

Transparent Yellow — Indian Yellow — Permanent Green Light — Cadmium Orange — Hooker's Green — Cadmium Scarlet — Phthalo Blue Green — Winsor Red — Winsor Blue (Red Shade) — Alizarin Crimson — French Ultramarine — Winsor Violet

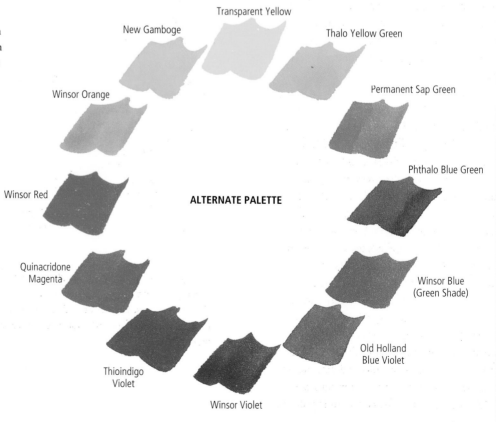

ALTERNATE PALETTE

Transparent Yellow — New Gamboge — Thalo Yellow Green — Winsor Orange — Permanent Sap Green — Winsor Red — Phthalo Blue Green — Quinacridone Magenta — Winsor Blue (Green Shade) — Thioindigo Violet — Old Holland Blue Violet — Winsor Violet

Color Schemes

It doesn't matter whether you work with paints or dry media; you can use the logical relationships of colors on the color wheel to control your palette. *Color schemes,* each of which is based on similarity or difference, usually feature a dominant color. Color schemes of similarity are *monochromatic* (one color in different values) or *analogous* (colors adjacent on the color wheel). Color schemes of difference are generally based on *complementary* or *triadic* relationships. An exception is pure color contrasted with neutral white, gray or black. The examples of mingled colors on the following pages are just a few of hundreds of possible combinations you can find with color schemes.

The harmonies and contrasts built into color schemes unify your work. This isn't an exact science, though, so you've got a lot of leeway. You may not like every combination; when all is said and done, trust your intuition. If you feel a color outside the scheme will enhance your painting, make a test scrap of the color and see how it looks with the other colors in the painting before putting it down permanently. Play with color schemes to see what you like. Then take risks and experiment with unusual color combinations. Understanding color schemes will free you to be more adventurous as you develop confidence in your color selection.

VARIATIONS ON EXPANDED PALETTES AND COLOR SCHEMES

You may be wondering if expanded palettes and color schemes also work with pale tints and low-intensity colors. Absolutely! For tints, simply use delicate pigments or dilute standard-strength colors. For low intensity, use the earth colors. Choices are more limited with these variations, so you may have to mix some of the colors. You can even make unusual palettes of iridescent acrylic paints (add the tiniest speck of black paint to bring out the color) or heather tweed yarns, for example. Color schemes can be applied to almost any color palette, including the split-primary color-mixing system in chapter four and the compatible palettes in chapter five.

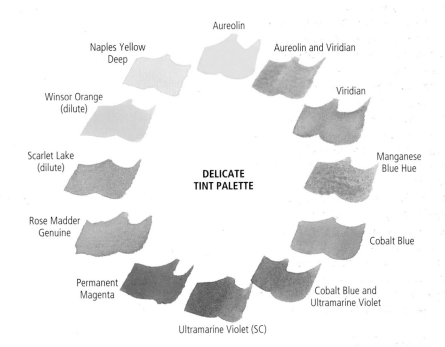

DELICATE TINT PALETTE

Aureolin · Aureolin and Viridian · Viridian · Manganese Blue Hue · Cobalt Blue · Cobalt Blue and Ultramarine Violet · Ultramarine Violet (SC) · Permanent Magenta · Rose Madder Genuine · Scarlet Lake (dilute) · Winsor Orange (dilute) · Naples Yellow Deep

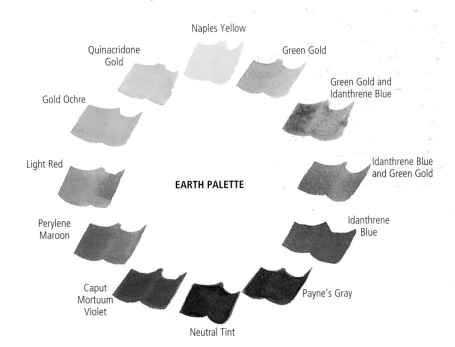

EARTH PALETTE

Naples Yellow · Green Gold · Green Gold and Idanthrene Blue · Idanthrene Blue and Green Gold · Idanthrene Blue · Payne's Gray · Neutral Tint · Caput Mortuum Violet · Perylene Maroon · Light Red · Gold Ochre · Quinacridone Gold

A Different Take on Expanded Palettes

If you prefer not to use colors as powerful as the ones on the standard and alternate palettes, you can use either the delicate or earth-color expanded palettes. Color schemes help you to use these colors much more effectively than trial and error.

Making Color Scheme Overlays

Use your color-wheel template (page 59) to make color scheme overlays to fit the expanded-palette wheels you made on page 78-79. Following the color scheme diagrams on the following pages, cut out circles the same size as those on your color wheels to match each color scheme (except for monochromatic and a pure hue against a neutral). Be sure to label each overlay with the name of the color scheme. To use the overlay, place it on top of a color wheel in various positions so the circles reveal the possible colors that can be used in various types of color schemes. ■

Choosing Color Schemes

At first I used old file folders to make an overlay mask for each color scheme; I placed these over my painted color wheels so I could see and understand color relationships. Then I invented my Color Scheme Selector, which makes it easy to dial up a color combination and evaluate it quickly.

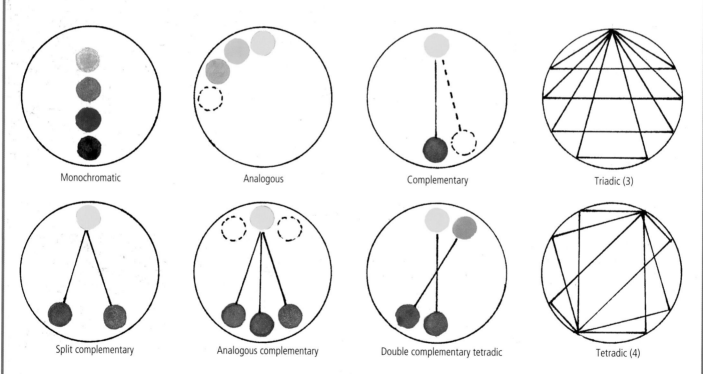

Monochromatic Analogous Complementary Triadic (3)

Split complementary Analogous complementary Double complementary tetradic Tetradic (4)

Color Schemes

There are many exciting possibilities for selecting colors without time-consuming guesswork; the dotted circles here indicate optional colors that could be used in addition to the other colors shown in the color scheme represented.

Monochromatic Color Schemes

The least complicated of the color schemes, a monochromatic scheme, has no discord. Simply use strong value contrasts of one color to create lights and darks with a dominant hue. Lighten or darken paint colors with white or black. To achieve the effect of light, don't darken your values to solid black; give them a clear color identity. Plan a source of light and create a sense of illumination from the implied source.

Reserve the lightest values for the highlights and lit planes. Emphasize soft edges and middle values for a misty effect.

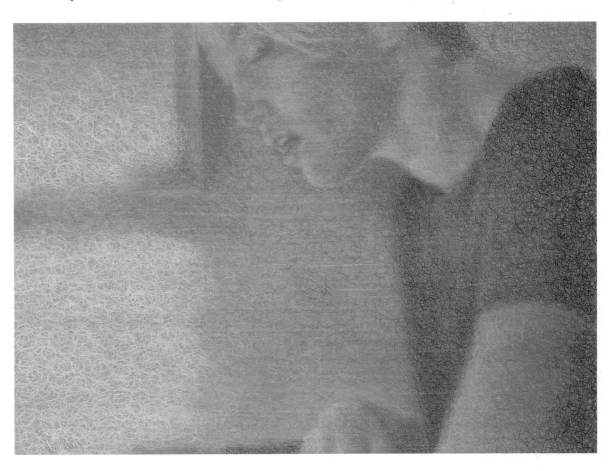

IT'S BURNING
Maggie Toole
Colored pencil on
Claybord
18" × 24"
(45.7cm × 61cm)
Courtesy of Sarah Bain
Gallery

A Monochromatic Look

Although Toole used other pencil colors for her values, this picture has the look of colored light that is achievable with a true monochromatic color scheme. Her circulism technique is an unusual layering process for colored pencil.

EXERCISE

Making the Most of One Color

Mingle a high-intensity color with Neutral Tint or Payne's Gray to discover the range of values you can make with this combination. Make several small, monochromatic sketches with a different base color in each, experimenting with value contrasts to achieve dynamic visual impact with a single color. Write your reaction to these color schemes in your color journal. ■

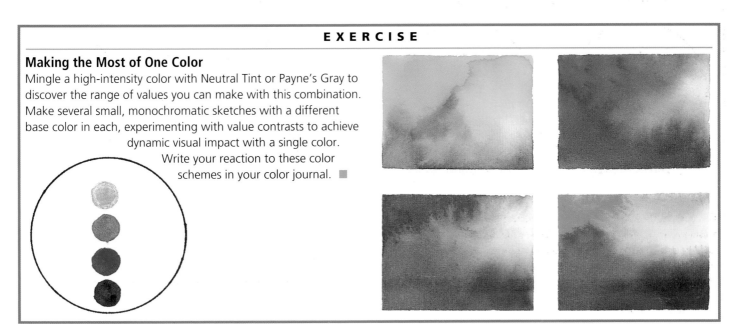

Analogous Color Schemes

An analogous scheme is always harmonious, because analogous colors are adjacent to each other on the color wheel, enhancing each other beautifully through subtle gradation from one color to the next. Color mixtures of three or four analogous colors are bright and clear; the color mixtures darken as they move toward a complementary relationship. With an analogous color scheme you can create a strong suggestion of illumination using gradual changes in value and intensity.

BREAKFAST
Susan Sarback
Oil on board
20" × 24"
(50.8cm × 61cm)
Collection of Drs. Leonard and Phyllis Magnani

Around the Wheel
Sarback has made a bold swing all the way around the color wheel, starting at yellow-orange, with warm analogous colors. She then moves counterclockwise through orange, red and violet, ending with a few accents of cool colors from blue-violet to blue-green. Notice how the pure colors are masterfully juxtaposed without a lot of muddy mixing.

EXERCISE

Working With Friendly Neighbors
Using any expanded palette, select three or four adjacent colors from the warm side of the color circle (anywhere from yellow to red-violet). Mingle the colors to test their mixtures; then, using the purest saturation of the colors as the darkest value, without adding gray or black, make a sketch using these warm colors to suggest a bright mood. Repeat the exercise, using colors from the opposite side of the wheel to project a cool, serene feeling. As you can see, analogous colors work beautifully together. Make a note of this in your color journal and jot down ideas for subjects using analogous color schemes. ■

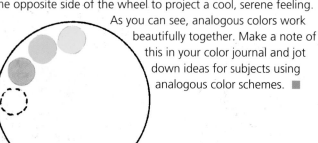

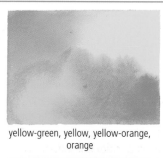
yellow-green, yellow, yellow-orange, orange

orange, red-orange, red, red-violet

red, magenta, red-violet, violet

yellow, yellow-green, green, blue-green

Complementary and Near-Complementary Color Schemes

It's amazing how colorful art can be using just two colors that are opposites on the color wheel. The colors in their pure state look brighter side by side because they possess the most dynamic of all color contrasts; but they neutralize each other when mixed. You can take advantage of both characteristics in a dynamic complementary color scheme.

You can also use the color next to the complement instead of the direct complement itself; mixtures of near complements won't make dull grays, no matter now hard you try. They yield lively low-intensity colors with a slight color bias that adds vibrancy to the mixtures. All of the complementary and near-complementary color schemes are distinctive and worth exploring.

REMNANTS OF AN EMPTY NEST
Cathy Nealon
Acrylic on canvas with paper, china fragments and found objects
32" × 16"
(81.3cm × 40.6cm)

Complementary Color Scheme

Notice several strong contrasts here: value, intensity, temperature and the complementary blue-and-orange color scheme. Blue dominates low-intensity orange both in quantity and brilliance. Nealon has also taken an intuitive leap by adding other tiny color accents, but the basic color scheme prevails.

EXERCISE

Exploring Two Complements

Look at the colors of each pair of complements on your palette side by side, then mingle them. Select the combination you like best and do a small sketch using the two colors. Let them mix throughout the sketch, but use them at maximum intensity near your focal point. Make sketches with other complementary pairs for many rich, unusual color combinations.

Try Ultramarine Blue and Burnt Sienna for a remarkable range of colors. Burnt Sienna is a near complement to the blue, giving beautiful gray and dark mixtures. Find other combinations consisting of a pure color and an earth-tone complementary. Write them all down in your color journal. ■

red, green

red-orange, blue-green

orange, blue

yellow, red-violet (near complements)

Split Complementary Color Schemes

Split-complementary color schemes comprise three colors: one color and the two on either side of its direct complement. These wonderful color schemes provide new dimensions for overall color effects while maintaining orderly relationships on the color wheel for harmony and control in color mixtures. The colors in their pure state contrast strikingly and make colorful low-intensity mixtures.

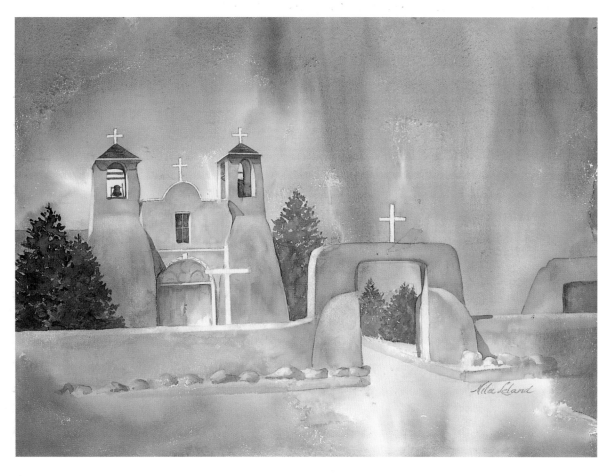

MIRAGE
Nita Leland
Watercolor on paper
18" × 24"
(45.7cm × 61cm)

Red-Orange, Yellow-Orange and Blue

I created a red-orange, yellow-orange and blue color scheme here, using Cadmium Scarlet, New Gamboge and French Ultramarine. Wet-in-wet mingling sometimes allows colors to intermix and make colors that aren't part of the basic color scheme. The blue-violet that appears here works just fine, but I was careful to avoid mixing greens.

EXERCISE

Splitting the Complements

Mingle various split-complementary combinations around your expanded-palette color wheels. There are twelve of these on each color wheel; try them all. Play with the colors to see what kinds of mixtures they'll make. Do they make rich darks? Do the mixtures lean toward gray or brown? Pick out your favorite combinations and make some sample sketches. List your ideas for subjects using some of these combinations in your color journal. In your opinion, how do these palettes stack up against the complementary color schemes? ■

Red, violet, yellow-green

Yellow-orange, red-orange, blue

Cyan, green, red

Blue-green, blue-violet, orange

Analogous Complementary Color Schemes

The more colors you use, the more important it is to establish logical relationships among them. When you combine three analogous colors with the complement of one of those colors, the resulting color scheme is one of analogous complements.

Analogous complements possess both the harmony of similarity and the contrast of difference. The analogous colors create color dominance; the complement enhances this effect by contrast and also neutralizes the mixtures. Take your choice of one or more of the three complements available for any trio of analogous colors (see the diagram below). If you include all six colors, however, be sure you retain the color dominance of one set of analogous colors.

GREEN BEAN
FIELDS
Pat Deadman, AWS, NWS
Watercolor on paper
22" × 30"
(55.9cm × 76.2cm)

Analogous Complementary Colors

This low-intensity color scheme uses yellow, yellow-green and green contrasted with low-intensity red. Analogous colors flow through the landscape, beautifully enhanced by complementary earth red, creating the ambience of midwestern bean fields in autumn.

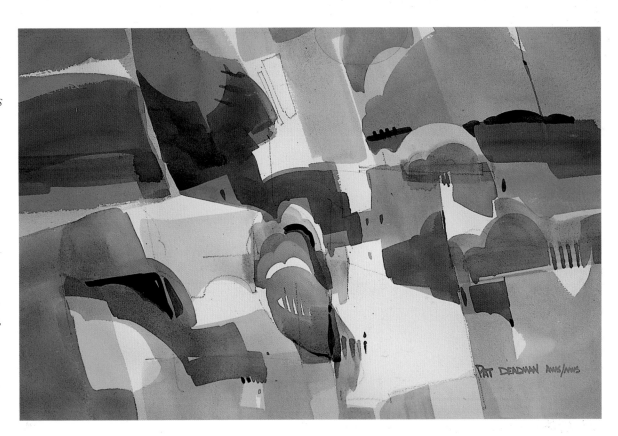

EXERCISE

Using Harmony and Contrast Together

Select three of your favorite analogous colors from the expanded color wheels, along with one complement of these colors. Mingle the colors, then make a sketch with them. Add a second complement and repeat the exercise. Next use all three complements, keeping the dominance of the original analogous colors. Finally, using all six of the analogous complements, reverse the dominance to the complementary side of the color wheel and repeat. Note the subtle differences between each combination of colors and record them in your color journal. How do these compare with the color schemes you explored earlier? ■

Blue-green, green, yellow-green, red

Red-violet, violet, blue-violet, yellow

Magenta, red, orange, blue-green

Yellow, yellow-orange, orange, blue-violet

Basic Triadic Color Schemes

Here we consider basic triads as color schemes and not simply a means of mixing other colors. As discussed earlier in this book, the two primary basic triads are: (1) red, yellow and blue; and (2) magenta, yellow and cyan. Both are bold and energetic. Both are popular in contemporary art and design.

The secondary basic triad in both expanded palettes consists of green, orange and violet. It is more difficult to use than a primary basic triad and less popular. There are also two sets of tertiary basic triads on each palette, which yield provocative and challenging mixtures.

STRAWBERRIES
Mary Padgett
Pastel on paper
12³/₄" × 19¹/₂"
(32.4cm × 49.5cm)

Basic Primary Triad

Padgett's use of the basic primary triad works well. Blue dominates through repetition in the shadows and pattern on the tablecloth. The colors are of similar intensity, and no extraneous colors weaken the color effect. Look at the Donna Howell-Sickles piece at the beginning of chapter two (page 22) to see another effective use of the basic primary triad as a color scheme.

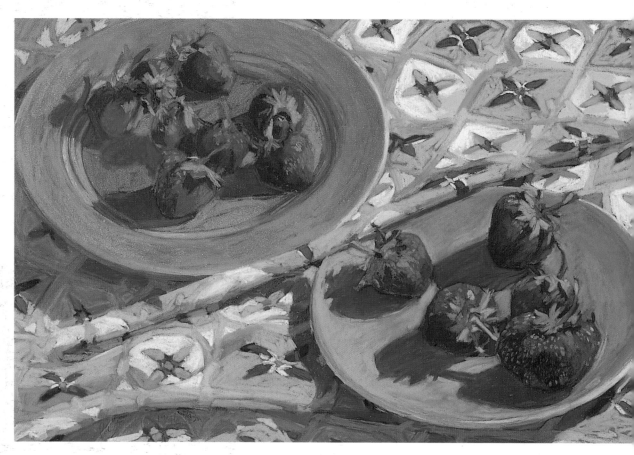

EXERCISE

Risking the Boldness of Basic Triads

Play the colors in each primary triad against each other, without allowing the colors to mix too much. Use bold, high-intensity colors. Then mix some low-intensity variations of these primaries; contrast them with the pure primaries. Also see what happens when you allow one of the primary colors to dominate. Consider the secondary and tertiary triads in the same way. Make sample sketches with combinations you like. Jot your observations in your color journal as you go along, so you'll have a record of your first impression of each combination to help you make important color choices later on. ■

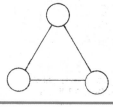

Magenta, yellow, cyan (primary)

Orange, green, violet (secondary)

Yellow-green, blue-violet, red-orange
(tertiary)

Yellow-orange, blue-green, red-violet
(tertiary)

Complementary and Modified Triadic Color Schemes

Complementary triads are easy to find, fun to use and their contrasts are exciting. Just select any two direct complements and add one of the two colors halfway between them. For example you may select red-orange and blue-green tertiary complements; the third color could be either yellow or violet. Each adds a distinctive spark to the original pair of complements and gives a totally different color accent.

Modified triads are made up of three colors, skipping over one color between each of the three, on a twelve-color wheel. They are nearly analogous, making for harmonious mixtures. But at each end of the three-color arc they make up, there are two colors that come close to being complementary, providing slightly more contrast than analogous colors. There are twelve unique modified triads.

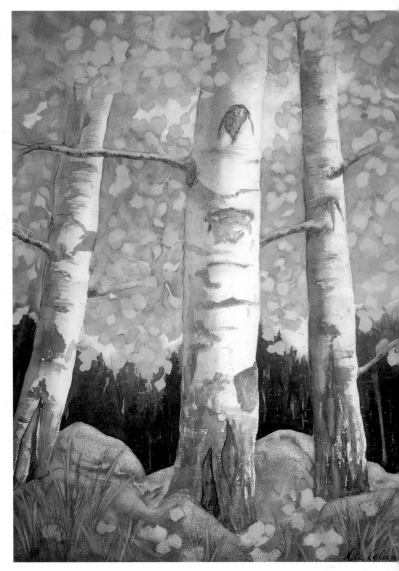

COLORADO GOLD
Nita Leland
Watercolor on paper
24" × 18"
(61cm × 45.7cm)

Modified Triad Colors

My color scheme is a modified triad of yellow, green and blue with yellow dominating. I used both Cerulean Blue and Phthalo Blue so I would have a light blue for the sky and a darker blue to mix the dark green background trees. I used Burnt Sienna to mix low-intensity dark yellows and the chromatic neutrals in the shadows.

EXERCISE

Exploring Complementary and Modified Triads

Mingle the colors of the complementary triads, then the modified triads. Can you see the striking differences between the two types of color schemes? Which do you prefer, the powerful contrasts or the more gentle harmonies? What subjects would work with each combination of colors? Make samples and sketches with the ones you like best. ■

modified

complementary

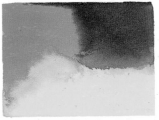

Red-orange, blue-green, yellow

Magenta, violet, cyan

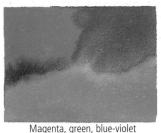

Magenta, green, blue-violet
COMPLEMENTARY TRIADS

Magenta, orange, yellow
MODIFIED TRIADS

Double-Complementary Tetradic Color Schemes

Double-complementary *tetrads* are four-color combinations that use two pairs of complementary colors forming a rectangle. Tetrads may form a square of any pair of complements plus the pair of complements equidistant between them; they may also consist of two adjacent colors with the two colors directly opposite them; or they may be formed by selecting two colors with one space between them and adding their complements.

> ### *Color Schemes Are Flexible*
>
> Be flexible with color schemes. They're a place to start, not the final destination. It doesn't matter if you can't pinpoint a color scheme after the painting is done.

NUCLEAR COWS
Lisa Palombo
Oil on paper
16" × 16" (40.6cm × 40.6cm)

Loose Double Complements

Now you can't say you've never seen a purple cow! I'm reading this scheme freely as a double-complementary tetrad of yellow, violet, orange and blue; although you can see traces of other colors here and there.

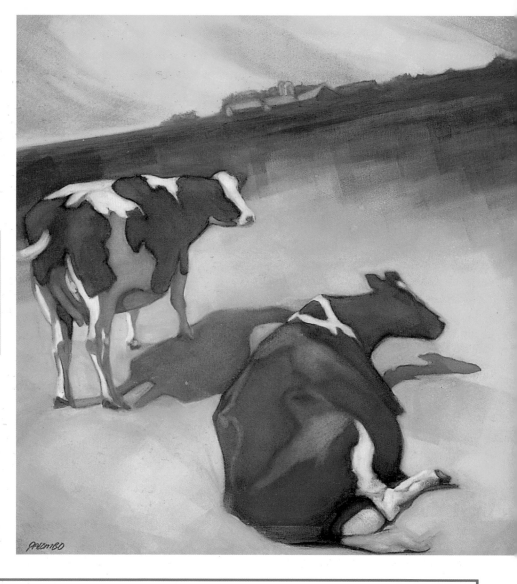

E X E R C I S E

Adding Complements Two Plus Two

Mingle the colors of a complementary tetrad and compare the results with the mixtures you made of a complementary triad based on the same colors. Do you like the addition of the fourth color? Work with other tetrads to find distinctive color combinations, mingling them, making sketches and samples. Review what you've done so far. Do you think you're a warm or cool color personality? High or low intensity? Have you discovered a strong preference for transparency or opacity? Are you leaning toward the traditional or the alternate palette? ■

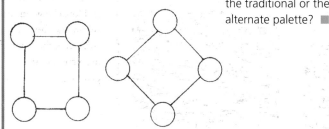

Magenta, green, violet, yellow

Red-orange, blue-green, violet, yellow

Red, green, violet, yellow

Red, blue-green, violet, yellow

DOUBLE COMPLEMENTARY TETRADS

Pure Hue Against a Neutral Color Scheme

The only color scheme of difference not based on complementary relationships consists of pure color against neutral gray, white or black. This scheme lends itself to strong graphic statements and is widely used in commercial advertising and lettering applications. For the most striking contrast, use either high-intensity, light-value colors against black, or high-intensity, dark-value colors against white. For a more subdued contrast, use a gray background. Keep in mind that any color bias in the neutral will affect the appearance of the pure hue.

▲

SEBRING CHALLENGE
Don Getz, AWS, KA
Acrylic on museum board
24" × 36"
(61cm × 91.4cm)

Sense of Movement

Although other colors are in the background, the overall color effect of this action piece is neutral. The accent that draws the eye is bright yellow in a sea of gray, which makes your eye move back and forth between the yellow and the car, enhancing the sense of movement in the painting.

EXERCISE

Using Bright Colors With Neutrals for Graphic Power

Explore the following contrasts in simple studies, using your favorite medium:

- Use high-intensity colors against white, gray, then black. Which do you like best? Write down your observations in your color journal.
- Now reverse the effect, making the background a pure color and the image a neutral.
- Lower the intensity of pure colors with a little black or a drop of Burnt Sienna. Check them against the neutrals again, noting the effects in your journal. ■

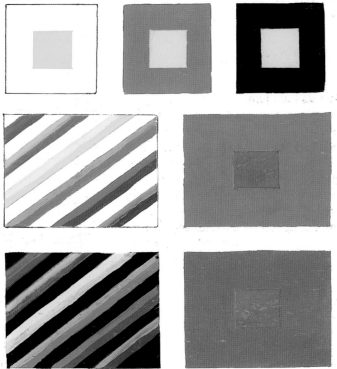

Working With Color Schemes

Supplies

- Small rectangular viewfinder cut out of cardboard, or an empty 35mm slide mount
- Magazines or photos
- Sketchbook
- Drawing pencil
- Color-scheme colors in your medium of choice
- Support for the medium of your choice
- Low-tack tape for making sectioned sheets

Color schemes are incredibly exciting to work with, but sometimes it's hard to know where to begin. With so many to choose from, it helps if you make studies to judge the color effects. Your color personality and intuition will help you decide which combination works best for the subject you want to paint. The following illustrations show you how to get started with color schemes in oils and watercolors.

STEP 1 ▶

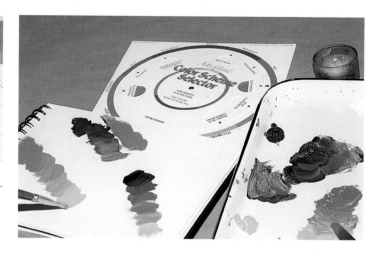

Viewfinder Designs

Make nonobjective designs that you can use over and over again as test patterns for color schemes. Cut a small rectangular viewfinder out of cardboard or use an empty mount from a 35mm slide. Place the viewfinder on top of a magazine ad or photo. Move it over the surface until you see a design you like—not necessarily a picture, but an interesting arrangement of lines and shapes. Don't worry about the color. Copy several of these designs in your sketchbook, as shown here. When you're ready to do your color studies, pick a design. Enlarge it and transfer it to a sectioned sheet.

STEP 2 ▶

Analogous, Monochromatic, Complementary Color Schemes

Here I'm trying out several of the color schemes I want to use with oil paints. I mix the colors on my palette with a small amount of Winsor & Newton Liquin to speed drying. In my sketchbook I've laid out an analogous scheme of warm colors on the left side of the page; at right is a monochromatic color scheme in Alizarin Crimson; above these two you can see a complementary scheme contrasting a value range of cool blue-green with bright red-orange.

STEP 3 ▶

Finished Color Sketches

My finished sketches are done on Fredrix Canvas Pad, a good surface for color studies in oils or acrylics. Each sketch is based on a logical relationship on the color wheel that results in color harmony and/or vibration. Try a new color scheme with each painting; you'll never get in a color rut again.

Analogous

Split Complementary

Monochromatic

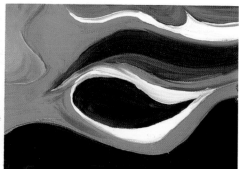

Complementary

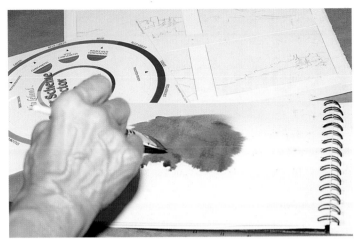

STEP 4 ▲

Analogous Color Mixing

For the watercolor studies below I decide to do a different subject for each color scheme, matching the colors to the subject or mood I want to paint. For the first one I select an analogous palette of blue, blue-green and green to represent the colors of the sea. I mingle the colors on wet paper to see how I like them. I select Rembrandt Phthalo Blue-Green, along with Winsor Blue (Red Shade) and Hooker's Green.

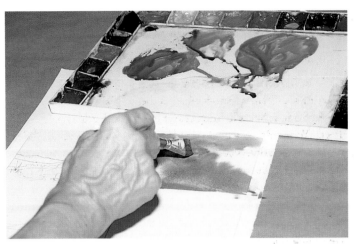

STEP 5 ▲

Seascape Sketch

After I transfer the sketches to a sectioned sheet, I begin with the seascape. You don't have to worry about unhappy accidents with colors if you do the mingling in your sketchbook, as I did. It's better to find mixtures that might throw a color scheme off in your sketchbook, rather than in the middle of a painting.

STEP 6 ▶

Various Color Schemes

After you've explored various color schemes in your sketches, remove the tape from your sectioned sheet. Place swatches of the colors you used below each sketch, labeling each with the name of the color scheme you used. I write some notes in my sketchbook to try the mono-chromatic snow scene with Cadmium Scarlet to see how it looks, and to experiment later with a small amount of comple-mentary red or red-orange accent in a seascape for contrast. I decide that the analo-gous complementary triad has possibilities for a southwestern or tropical landscape.

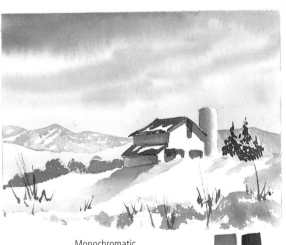

Monochromatic

Analogous

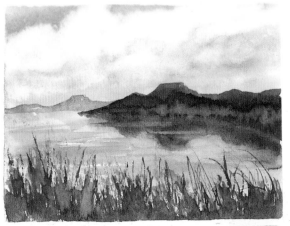

Complementary

Analogous Complementary

Using Color Contrast

Contrast is an easy concept to understand. Chevreul's theories of the seven contrasts of colors provide another useful tool for making color relationships work. Renaissance painters used mainly value contrast. Turner preferred intensity contrast, playing pure tints against low-intensity colors. The Impressionists relied on warm-and-cool temperature contrast, and the Fauves and modern color-field painters contrasted pure hues. Chevreul defined three additional contrasts: complementary, size and simultaneous.

'I am always in hope of making a discovery . . . to express the love of two lovers by a marriage of two complementary colors, their mingling and their opposition, the mysterious vibrations of kindred tones.'

VINCENT VAN GOGH

GARDEN SERIES 263—GARDEN BORDER
Mary Jane Schmidt, acrylic on canvas
72" × 60" (182.9cm × 152.4cm)
Private collection

Juxtaposing Pure Colors

This dazzling color effect is based on the contrast of pure hues and tints, which are consistently more intense than those seen in nature. They are supported here by sparkling white and selective dark accents. You can include all the pure colors in the spectrum if you juxtapose them rather than mixing them.

Hue Contrast

Intense colors placed side by side often produce powerful contrast. Primitive artists and children use hue contrast naturally and effectively. Stained glass, mosaics and Pennsylvania Dutch stencil designs are other good examples. Use as many colors as you like, as long as they're all pure and bright.

EXERCISE

Playing With Hue Contrast

Paint samples of pure, bright colors and cut them into 1-inch (25mm) and 2-inch (51mm) squares, or cut colors from Color-aid papers or magazine advertisements. Arrange different combinations of the squares, as shown in the illustration below, starting with a single color mounted on a background of another color. Notice how the colors react to each other: Some combinations seem to vibrate more than others. Which are your favorites? Make a sketch, using all the colors on your expanded-palette color wheel. Emphasize flat shapes, and go for bold, aggressive color using hue contrast. ■

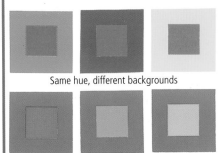

Same hue, different backgrounds

Different hues, same background

Pure Hue Contrasts

When you put bright colors against each other as shown here, they won't clash no matter how you combine them. That's why children's artwork is usually so vibrant and exciting. However, if you were to introduce mustard yellow or olive green into the equation, you would throw the color off and give yourself a whole new set of color problems to solve.

MOON AND THE MANDALA
Virginia Lee Williams
Acrylic collage on watercolor paper
28" × 20" (71.1cm × 50.8cm)

Variety of Contrasts

Using several kinds of contrast together creates a powerful, vibrant image. Pure hues play against each other here, with strong complementary and value contrasts as well.

Value Contrast

Full-contrast artwork has a complete range of values, from white through midtones to dark, and suggests normal illumination. Middle values usually provide the framework for value painting, with light and dark value contrast giving the work its visual impact. Learn to see degrees of difference in black-and-white contrast, so you can use value contrast more easily in color. A good value scheme enhances your color. For example, to create lustrous color with values, make a dark neutral background that suggests dim illumination, then you can add light value touches of bright color that will glow against the darker background.

GRAND MESA GORGE
Jeny Reynolds
Acrylic on watercolor board
10 3/4" × 15 1/4" (27.3cm × 38.7cm)
Courtesy of Reynolds-Heller Gallery

Contrast Is Essential

Strong value contrast adds impact to powerful shapes in this painting, while low-intensity color creates a striking effect of supernatural light on the mesa. Keep in mind that, as a rule of thumb, your picture is harmonious when colors are close in intensity *or* value, but not both at the same time; some contrast is necessary in one or the other.

EXERCISE

Exploring Value Contrast

Make a chart with three sections across and three down. In the first row, place three 2-inch (51mm) light-gray squares. In the second row, place three medium-gray squares; and in the last row, three black squares. Then, in the first column, place a 1-inch (25mm) white square on top of each 2-inch (51mm) square, from top to bottom; in the second column place three middle-value gray squares; and in the last column, three nearly black squares. Examine the value contrasts and comment on them in your journal. ■

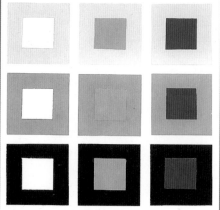

Value Contrasts

The squares with the greatest value contrast capture your attention; lighter squares seem filled with light, and darker squares appear more somber. When there is little or no contrast the squares become almost indistinguishable from each other.

Color Key

Use *color key* to bring your artwork to its full dramatic potential. *High-key* colors, the tints and middle tones at the light end of the value scale, are usually pure colors and represent bright illumination. Artwork using high-key color is cheerful and optimistic. *Low-key* color contrast is at the other extreme, indicating dim illumination, and is restricted to middle and dark values and low-intensity colors that create a serious, pensive mood.

ETERNAL LIGHT
Bren Quiett Reisch
Acrylics and gouache on paper
20" × 15" (50.8cm × 38.1cm)

Glowing Color

High-key color in this painting strongly suggests light. The optimistic mood is reinforced by the upward movement of lines and shapes.

▶
RAPTOR
Paul St. Denis
Watercolor dyes, inks
and gouache on paper
44" × 34 ³/₄"
(111.8cm × 88.3cm)
Collection of the artist

Striking Chromatic Neutrals

St. Denis's painting illustrates a dramatic use of striking chromatic neutrals. The somber, somewhat ominous overall impression is caused by the low-key color. Can you think of a subject suitable for low-key color? Give it a try.

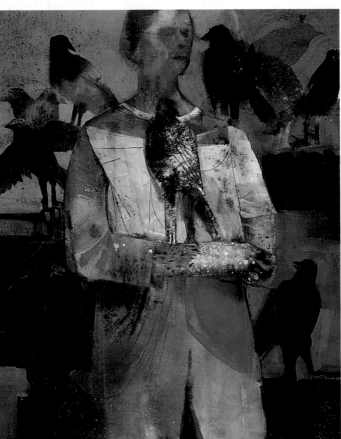

High-Key and Low-Key Contrast

Note the difference in mood between these two swatches. Starting with high-key or low-key dominance, you can add light or dark color accents as needed to emphasize your focal point and to create special effects of light. Check out the paint colors I used to create the earthy, low-key swatch.

Intensity Contrast

Intensity contrast comes from placing pure, bright color within areas of grayer, low-intensity color. Bright colors or pure tints surrounded by a field of neutrals sing out. J.M.W. Turner was a master at using pure, delicate tints adjacent to low-intensity colors. Limit the contrast to grays; black will overpower delicate tints.

▼

TIMES OF LIFE
Ellie Rengers
Acrylic on canvas
24" × 48" (61cm × 121.9cm)
Collection of Linda K. Coffman and
Charlotte A. Rehmert

Intense Figures, Low-Intensity Background

Bright, pure hues bounce against a low-intensity background, allowing the whimsical figures to stand out sharply. Notice how the colors in the foreground are echoed in the background, creating a unified color statement throughout the picture.

EXERCISE

Examining Intensity Contrast

Make a chart with 2-inch (51mm) squares of light-to-medium neutral gray and low-intensity colors as shown here. In the first column, place neutral grays. In the second, place low-intensity versions of primary colors. In the last, place low-intensity complements of the primaries. Place a 1-inch (25mm) square of one pure primary on the colors across each row, as shown in the illustration below. Write comments in your color journal about these intensity contrast effects. Next, select a color scheme and make a sketch or sample piece, mixing all colors to lower their intensity, then adding pure, bright colors from your color scheme for accents. ■

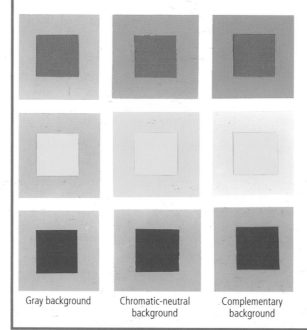

Gray background Chromatic-neutral background Complementary background

Intensity Contrast

Pure color stands out against neutral gray and low-intensity backgrounds. Which effect do you think is stronger, a pure hue against the same hue in a lower intensity (center) or a pure hue against a complementary low-intensity background (right)?

Making Colors Glow

Achieve an effect of iridescence by mingling delicate pastel tints and contrasting them with neutrals.

Iridescence

FEMALE BROOK TROUT
Mary Padgett
Pastel on La Carte paper
12³/₄" × 19¹/₂" (32.4cm × 49.5cm)

Contrasts Suggest Light

Padgett has intermingled tints and low-intensity colors effectively to suggest the iridescence of fish scales. Touches of high-intensity color suggest light reflected from a luminous surface. Careful handling is necessary to capture such an elusive effect; keen observation is a prerequisite. Practice playing high- and low-intensity colors against each other.

Temperature Contrast

The Impressionists relied on temperature contrast rather than value contrast to suggest light. Paul Cézanne used temperature more as a tool to manipulate form and space. Contemporary artists sometimes reverse warm and cool relationships to create energetic, provocative movement. Radiance emanates from artwork with warm dominance. When the cool temperature dominates, warm contrast keeps the piece from seeming unpleasantly chilly. Warm and cool contrast also provides movement around forms and through space, because warm colors appear to advance and cool colors to recede. All complementary contrasts are also temperature contrasts, but not all temperature contrasts are complementary.

INTO THE LIGHT
Diane Coyle, watercolor on paper
31" × 39" (78.7cm × 99.1cm), private collection

Temperature and Complementary Contrasts

The overall temperature effect in Coyle's floral is cool. She used a cool red against cool low-intensity greens. The temperature contrast between red and green is also a complementary contrast.

EXERCISE

Understanding Temperature Contrast

Choose a color scheme that is predominantly warm, for example, an analogous scheme including red-orange, orange, yellow-orange and yellow. Then, select a single contrasting complement of any one of these colors, between blue-green and violet, to provide temperature contrast. Make a sketch with warm dominance, using the cool color to add contrast in important areas. When this is done, select a range of cool colors with one opposing warm color and make a sketch with cool dominance and temperature contrast. ■

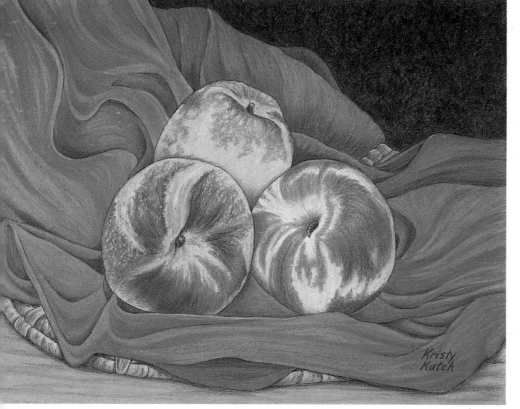

NECTARINE TRIO
Kristy Kutch
Colored pencil on drafting vellum
8" × 11" (20.3cm × 27.9cm)
Collection of the artist

Cool Backgrounds Recede

This still life is warm because of the dominance of the large red mass of fruit and smaller touches of yellow. Even though space is shallow in most still-life compositions, you can bring your subject forward a bit by placing a cooler, contrasting background behind it.

Reversing Color Temperature

If the illusion of distance is enhanced by placing warm colors in the foreground and cool ones in the background, it stands to reason that reversing the temperature would create ambiguous pictorial space. When a cool color overlaps a warmer color, the warmer color seems to push through the cooler one. Artists use this to create a push-and-pull effect that expresses vibrant energy.

EARLY EVENING, MONTEREY BAY
Benjamin Eisenstat
Acrylic on canvas
24" × 30" (61cm × 76.2cm)

Warm Colors Stand Out

Warm light on the big rock in the middle distance causes it to push forward and capture your eye immediately, making this form an imposing presence. Cooler foreground rocks seem less important, even though they are nearer. Remember this when you're having difficulty making your center of attention stand out: Warmer colors in your focal point might be the answer.

EXERCISE

Reverse the Temperatures

Plan an arrangement of overlapping shapes, such as a landscape with distant hills and sky, or several geometric figures on a plain background. Make two copies of your design, using tracing paper or a lightbox. Start with realistic colors, giving the first sketch a typical cool background and warm foreground. Then, reverse the temperatures, using the same colors to make a sketch with a warm background and cool foreground. ■

Cool background, warm foreground

Creating Ambiguous Space

Typically, you place warm colors in the foreground and cool ones in the background to achieve a sense of distance and to control eye movement through the picture. When you reverse this natural effect you create ambiguous space as the warm colors push forward and flatten the picture plane. Turn these sketches upside down for another view of color temperature reversed.

Warm background, cool foreground

Complementary Contrast

Complementary colors, as you know, are opposites on the color wheel. Placed side by side in high or low intensity, they enhance each other, but they neutralize each other in mixtures. Complementary contrast is one of the most useful—and widely used—contrasts in the artist's bag of tricks.

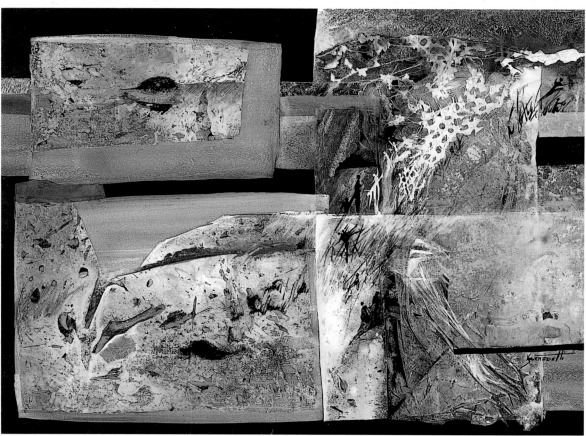

BOUNDLESS VISION
Karen Benedetti
Acrylic and handmade paper collage on paper
22" × 30" (55.9cm × 76.2cm)
Collection of Nancy A. Keller and Nicholas W. Korn

Color, Value and Temperature Contrast

Strong shapes and interesting textures are bound together into a cohesive whole by the simple but effective use of near-complementary contrast using blue and yellow-orange. Value and temperature contrast contribute to the visual impact.

EXERCISE

Showing Complementary Contrast

Make a chart illustrating complementary contrast, using your brightest paints or colored-paper clippings. Cut one set of twelve 2-inch (51mm) squares representing each hue on the color wheel and glue these to a white support. Then cut a set of 1-inch (25mm) squares of the same colors. Pair off the complementary colors and glue these small squares to the centers of the larger ones. If the colors you selected are truly complementary, they will seem to vibrate on the page. ■

Complementary Contrast

These studies reflect powerful combinations of complementary contrast, temperature contrast and contrast of pure hues. If you want unusual color, pay special attention to tertiary complements. They're less commonly used than primary/secondary combinations.

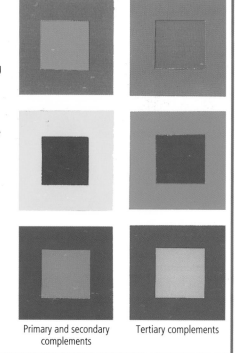

Primary and secondary complements Tertiary complements

Making Complementary Mixtures

You have a lot of leeway in selecting complements to take advantage of their powerful contrasts. Go through your paint box and select several pairs of complementary or near-complementary colors. Mingle or mix the colors on a sectioned support, so you can judge the effects of the pure complements and their mixtures. Exact complements make gray, but near complements make much more interesting chromatic neutrals and provide exciting complementary contrast. Write comments about these effects in your color journal and note combinations you'd like to use in future artwork. ■

Alizarin Crimson, Phthalo Green

Cadmium Orange
French Ultramarine

Lemon Yellow, Winsor Violet

Winsor Red, Hooker's Green

Winsor Orange, Cobalt Blue

Indian Yellow
Old Holland Blue Violet

Different Pigments for Complementary Contrast

Mixtures of complements should retain the color identity of one or both colors in the mixture, in order to continue the effects of complementary contrast. You can use various pigments to represent complementary pairs; you will always have temperature contrast between the colors.

Permanent Rose, Viridian

Cadmium Scarlet, Phthalo Blue

Aureolin, Thioindigo Violet

Quantity Contrast

In *The Art of Color* Johannes Itten states that colors have a specific proportional relationship to their complements, which must be maintained in order to achieve color balance. Since yellow is more brilliant than violet, use one part of yellow to three parts of violet for balance. One part of orange is as bright as two of blue, while red and green are roughly equal. To create vibration, change these proportions. Use a large color area to strengthen your color impression or break the color into small areas to create energy and movement. (See illustration on page 127.) However, pure color can be overwhelming, so when the large area is lower in intensity, even small bits of bright color within it appear brighter. Quantity contrast tends to make other contrasts even more effective.

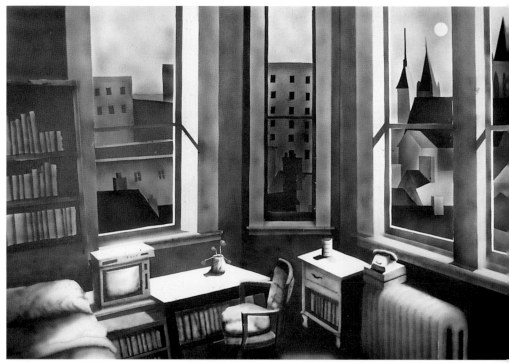

AFTER MIDNITE
Larry Mauldin, watercolor on board
30" × 40" (76.2cm × 101.6cm)

Quantity, Value and Intensity Contrast

This airbrushed painting has an unusual kick to it; the focal point of tiny red flowers is perfect. The trick of placing small, bright touches of red in a vast black-and-white background beautifully illustrates the effectiveness of quantity contrast along with value and intensity contrast.

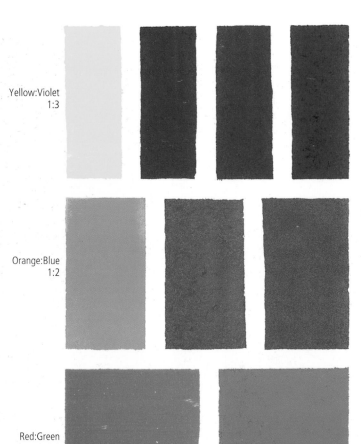

Yellow:Violet
1:3

Orange:Blue
1:2

Red:Green
1:1

Proportions of Complements

These swatches show the correct proportions of complements to establish color balance when you're working out a complementary color scheme, according to Itten's theories. However, this isn't rocket science, so play with different proportions of the colors to achieve the most effective contrast, using your intuition.

EXERCISE

Determining Quantity of Colors

Select a pair of complements, such as red-violet and yellow-green. Make a sketch or design using the same amount of each color. Repeat the design, using a very small amount of one pure color and a large field of the other. Then, reverse the colors in the same design. In another sketch, lower the intensity of one color and use it as a background for its opposite pure color, changing the proportions of the colors. Repeat this exercise with several different color combinations. ■

Simultaneous, Successive and Mixed Contrast

When your eye is exposed to intense color, it adjusts by seeing the color's complement simultaneously. The eye seems to need the complement for relief. In simultaneous contrast, adjacent colors produce complements at the edges where the two colors meet. For example, a bright red passage next to yellow may have a barely perceptible greenish bloom around the edges that affects the yellow, making it seem cooler. You can anticipate this and overcome the effect by using a warmer yellow to begin with.

Successive contrast is the complementary afterimage that appears when you look at a color for a while and then look away. You experienced this in chapter one with the red **X** (page 18). If you look at a second color, the complementary afterimage blends in *mixed contrast*, projected onto the color like a glaze. As you work, rest your eyes occasionally for more accurate color impressions and adjust your colors, if necessary, to compensate for mixed contrast.

Optical mixtures result when colors are not physically combined but juxtaposed as small bits of color placed so the eye is unable to differentiate individual colors from a distance. They are perceived as a mixture, having the average of the brightness of the component colors. In painting, this technique, called Pointillism or Divisionism, creates a distinctive beauty, a hazy luminosity.

BLUE HILLS
Roger Chapin
Pastel on Canson paper
18" × 24"
(45.7cm × 61cm)

Tiny Dots of Color Blend Visually

This is a fine example of the Pointillist technique; hold the picture some distance away from your eyes to appreciate how all the tiny dots of pastel blend into harmonious color. Look at it more closely to see how Chapin has combined these dots to create the effects of changing colors and values.

Taking Risks With Contrast

Pull out all the stops and use vibrant colors with strong contrasts. To make this work, simplify shapes and avoid too much detail. Decide what color scheme is most effective and which contrasts are needed.

STEP 1 ▲

Shapes and Values

Create a strong abstract design with colored shapes that emphasize value, temperature and complementary contrast. The big shapes and strong value contrasts in this photo of an adobe house are just what I have in mind. Make a photocopy and value sketch of your photograph, keeping the sketch relatively free of detail. That way you can study the shapes and visualize color placement.

STEP 2 ▲

Transfer Your Drawing

If you don't want your transferred drawing to be distorted from your reference photo, draw a grid on your sketch and on your support (mine is 16" × 20" [40.6cm × 50.8cm] stretched canvas) in the same proportions. Then sketch the corresponding sections of the photo grid into the support grid. Erase the grid if necessary; since I'm working in opaque acrylics I don't need to erase the grid, but I do, just so the lines aren't confusing.

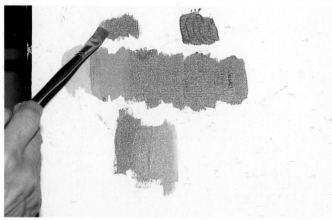

STEP 3 ▲

Color Scheme Selection

I like the idea of an analogous complementary color scheme with a warm dominance (yellow-orange, orange, red, red-violet, blue-green) based on the alternate expanded palette (see page 78) using acrylic Indian Yellow, Pyrrole Orange, Pyrrole Red Light, Quinacridone Magenta and Quinacridone Violet, with complementary Cobalt Teal and Cobalt Turquoise. To see the color harmony and vibrations of the colors you've selected, try them out on a scrap of canvas.

STEP 4 ▲

Painted Guidelines

I sketch out the shapes with a mixture of Quinacridone Magenta and Titanium White. This covers the pencil lines and gives guidelines for the underpainting to be applied; the painted lines will gradually disappear under succeeding paint layers. Colors and values can be adjusted relatively easily with opaque acrylic paints.

STEP 5 ▲

A Unifying Underpainting

I cover the entire canvas with an underpainting of red-orange, which will show through all the other layers of color to be applied over it, helping to unify the painting. Each shape is defined up to the magenta lines around it, with no texture applied at this stage.

STEP 6 ▲

Sky and Doors

I paint in the contrasting blue-green sky first, allowing just a sparkle of red-orange to peek through. I use the same color on the doors to help move the eye around the picture, but these will be modified later so they don't resemble the sky so closely.

ADOBE
Nita Leland
Acrylic on canvas
16" × 20"
(40.6cm × 50.8cm)

STEP 7 ▶

Texture, Color, Value

I gradually build the adobe forms (without trying to duplicate the photographic image) by painting layers of texture, color and value. Yellow-orange highlights help to define some of the shapes; a few strokes of bright magenta are touched into the finished piece to catch the eye.

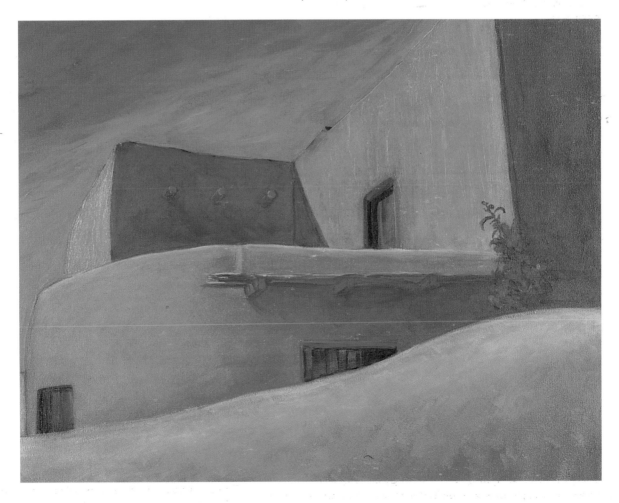

WHERE HAVE
ALL THE PEOPLE
GONE?
Joan Rothel, AWS, NWS
Watercolor on paper
22" × 30"
(55.9cm × 76.2cm)
Collection of the artist

Warm Unifying Light

A warm dominant light envelops this interior; direct sunlight strikes the chair and influences the color in the entire picture, including a second room lit by indirect light. Every color on every object in the scene is affected by this warm light, which unifies the whole.

'A painter is also master of his choice in a dominant color, which produces upon every object in his composition the same effect as if they were illuminated by a light of the same color, or, what amounts to the same thing, seen through a colored glass.'

M. E. CHEVREUL

EXERCISE

Observing Changing Light

Have you ever left a class and noticed that your work looked different after you got home? Look at your artwork under different lights to appreciate the effects of changing light. I view my work in my studio under full-spectrum fluorescent lighting, incandescent light and regular fluorescent lights, then in daylight. Notice the differences in dominant light when the weather changes. Jot down your observations in your color journal. ■

Expressing the Harmony of Light and Shadow With Color

Simulating light is a great way to use color creatively. Colors are influenced by natural light, artificial light, reflected light, shadows and textures. Careful observation is key to painting light. Let's look at what influences light and color.

Light varies so much, it can be difficult to see color accurately. Daylight is a combination of white light from the sun and blue reflected light from the sky, which changes throughout the day, season or region. Your eye doesn't automatically see these changes because your brain unconsciously adjusts to illumination. When Monet painted haystacks at different times of day, he was overriding this and recording what his eye actually saw in the changing light.

Harmony in Reflected Color

Hold a brightly colored object next to your hand in strong light, moving it away and back again. Observe how the color of your hand appears to change when you move the object. All colors in nature are influenced by surrounding colors that reflect back on them, especially when seen in bright light. A still life on a table may reflect the color of the table; the colors of objects in the still life reflect on each other and the table. Use this reflected light to move the viewer's eye around and unify colors so objects and shapes aren't isolated from each other.

SPARKLERS
Janie Gildow
Colored pencil on Rising
Stonehenge paper
15" × 11½"
(38.1cm × 29.2cm)

Reflected Light

Gildow has captured her still life with careful observation of complex light reflections in glass; the *reflected color* swirls around goblets, leading your eye to the flower lying serenely on the table. Reflected light can be very useful, even with a less-complicated subject.

The Color Harmony of a Single Light Source

To achieve a sense of *illumination*, use a monochromatic or analogous color scheme and strong value contrast in areas affected by the light. Start with a source of light present in the picture or strongly suggested. From this, create a brilliant light that reflects from the focal point and bounces off other planes facing the source of illumination. Then, allow values to fall away gradually into darkness. The lightest area in the painting may have an aura of light around it. Create *highlights* at the focal point by using a color that is lighter than the subject's color and adjacent to it on the color wheel. If your lighting effect works, the picture will appear to illuminate the area where it hangs.

VERMEER'S TABLE
Jada Rowland
Watercolor on paper
9¹/₂" × 7¹/₂" (24.1cm × 19.1cm)
Private collection

Observation Is Key
The strong light shown in Rowland's watercolor is the subject of the painting, holding the eye effectively, with its shapes repeated in the background. Rowland has done an excellent job of observing and representing how the light plays across the table and the figure. Remember, observation is the key.

Luminosity: A Radiant Glow

J.M.W. Turner was a master of *luminosity*, as were the nineteenth-century American Luminist painters, such as Albert Bierstadt and Frederick Edwin Church, who painted landscapes with stunning atmospheric effects. Intensity and complementary contrasts work well here, but strong value contrast spoils the effect. Make the purest area of color smaller and lighter in value than the low-intensity area around it. Allow this color to influence the composition throughout by using subtle gradations of analogous colors moving toward chromatic gray. Add accents of the dominant light, reflected throughout. Keep the color of the light untextured so it suggests light, not substance.

▼
QUICK PICK
*Gwen Talbot Hodges,
Watercolor and gouache
on paper
28⅝" × 20⅛"
(72.7cm × 51.1cm)
Private collection*

Luminosity Through Lifting

Some areas have been protected by masking fluid to retain whites throughout the glazing process, but the luminosity comes from lifting color to suggest bright light in some areas, with other areas of pure color added as highlights.

EXERCISE

Suggesting Luminosity

Begin with an area of pure, light yellow. Overlap the edge of the yellow with a pale red tint and blend the colors into an aura of yellow-orange to light red-orange around the yellow. Encircle this area with a slightly darker mixture of the same colors, adding a little complementary blue to lower the intensity of the colors. Blend again to keep the color moving away from the light, until you have a chromatic neutral of middle value at the outer edges. To place an object in front of this backdrop, use slightly darker values of the same color you used in the immediate background. ■

Making Luminous Colors

Make pure colors seem more luminous by using a field of low-key neutral color (not black) around them to suggest dim light, allowing areas of pure color to glow against the low-intensity background.

Glow of Light

Make trees in the distance slightly darker than the luminous sky behind them; gradually change the color to a darker violet or gray at the edges of the composition. The glow of the light spreads across the composition and fades into darkness.

Glazing

A *glaze* is a transparent layer of color over another color that permits the first one to show through. Glazes alter colors, but don't cover them up. Correctly applied, glazes have a delicate luminosity seldom equaled by mixing colors and applying them as a single layer. Transparent glazes are used in oils, acrylics and watercolors, and also in pastels and colored pencils. Acrylic paints are the ultimate glazing medium because they dry quickly, and once dry, they can't be lifted by successive glazes. Even in fibers, you can glaze the colors of a warp with thinner yarns or apply gauzy fabrics as glazes on a quilt.

Semitransparent colors can also be used as glazes if they're sufficiently diluted. Opaque colors usually make disagreeable glazes that cover the underlying color and mask the white support, leaving a chalky surface that stands out unnaturally against the background. However, well-diluted opaques can be used for translucent, misty glazes.

Some artists believe you can't layer multiple glazes without making mud, but the trick is in the selection of your colors. Use analogous colors and avoid dense, opaque colors and complements. Experiment with

Correct: glaze on dry background

Incorrect: glaze on damp background

Successive glazes—three colors

Analogous glazes

Complementary glazes

Opaque and overpowering glazes

your layered glazing effect before using it in an artwork. You can also apply your glazes in wet-in-wet layers to create vibrant color effects.

Glazing Techniques

Try your glazes—transparent colors work best—on a sample sheet before glazing your painting. For a clear, bright glaze use an analogous color. Glaze one primary over another to create a secondary color. To lower intensity, use a complementary glaze. A low-intensity glaze surrounding a bright focal point strengthens the impact of your center of interest.

EXERCISE

Experiment With Multiple Glazes

Run a graded wash of transparent color on an area of sectioned sheet, thinning the color progressively as you go down the sheet. Let the wash dry completely. Then run a second graded wash of a different transparent color halfway down the first. Notice how the glaze changes the underlying wash. Experiment with different combinations of three or more colors, grading some washes up and some down; then try repeating the first glaze over the others. The more dilute and transparent your glazes, the longer you can work with multiple glazes, particularly if you avoid complementary colors. Try glazes with semitransparent and opaque colors to see how they differ. Also, for interesting effects experiment with wet glazes, brushing color over color without any drying between. Write comparisons of glazes and glazing techniques in your color journal for future reference. ■

Graded glazes

Overlapping glazes

Glazes layered wet-in-wet

Layered and Graded Glazes

You can run a sequence of several glazes without getting mud if you use the right colors, yet they may eventually begin to neutralize each other, particularly if you overlap complements. I've used Rose Madder Genuine, Aureolin and Cobalt Blue for the panels above. At left is a wet-in-wet layering of Permanent Rose, Aureolin and Cerulean Blue.

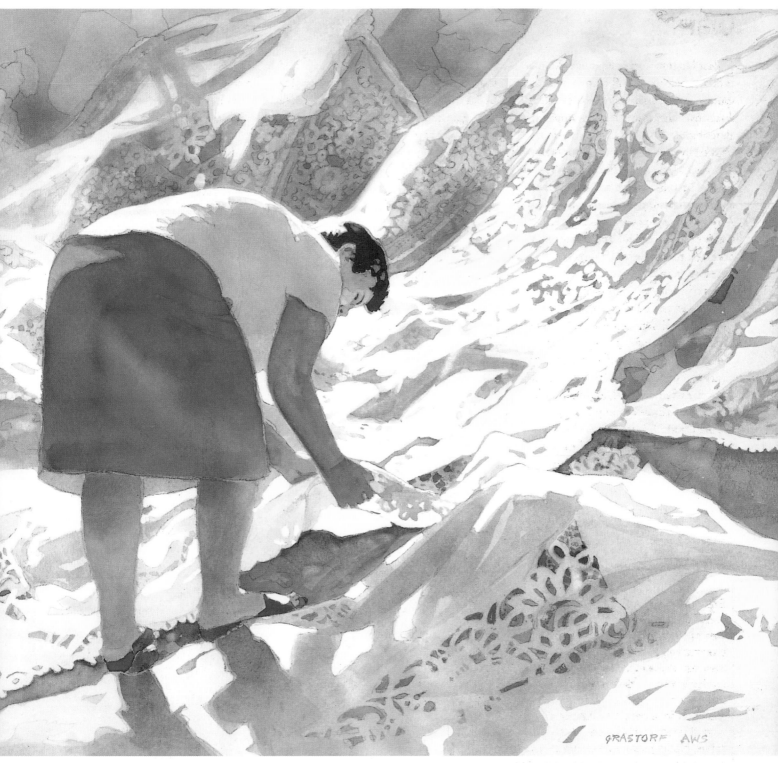

LINDOS LACE
Jean H. Grastorf
Watercolor on paper, 20" × 28"
(50.8cm × 71.1cm)
Collection of the artist

Striking Light Effects

Grastorf uses poured glazes of transparent primary colors to suggest bright light separating as it does in a prism, particularly striking when contrasted with the white paper.

Unifying Glazes

You can glaze an entire painting or any part of it, tying areas together beautifully with a single, modifying wash. There can be risks: Your glazes may not be pleasing over all the colors, and colors may bleed into damp glazes. Test your colors to see if they work well together. Glazing can be a useful correction technique when color is out of control with too many colors or disconnected color areas. Try glazing to calm a busy painting or to unify areas that aren't working. If you're working in watercolor, don't pre-wet the support before you run glazes or you'll pick up the underlayers. Before you begin, decide if you want to reserve the white areas with masking liquid.

Practice Unifying Glazes

Paint a simple landscape or practice glazing on an old painting. Run vertical transparent glazes of different pale tints over separate areas in the painting, as shown in the illustration below. Leave areas of unglazed color between the glazes for comparison. Try several different combinations and write the results in your journal. ■

Unity of Color

The colors in the sketch are strongly affected by glazes; blue sky turns green with a yellow glaze and becomes violet with a pink glaze; the yellow field is warmed by a pink glaze and dulled by the blue. If you isolate a glazed section, you can see the unity of color throughout that area.

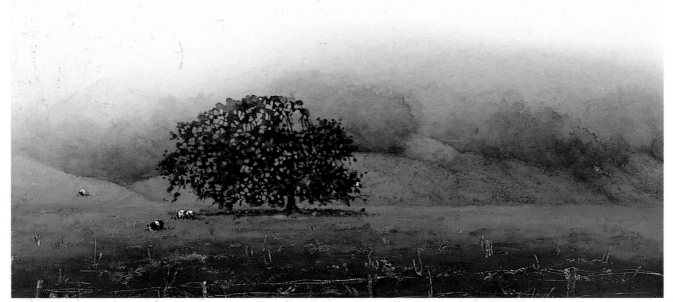

TO BE
Catherine Anderson
Watercolor on paper
18" × 30" (45.7cm × 76.2cm)
Courtesy of Long Grove Gallery, Long Grove, Illinois

A Luminous Glow

Anderson applies warm and cool layers alternately. She builds up a luminous glow with over one hundred transparent, low-intensity washes. There may be as many as fifteen colors in the graded washes, which reflect an atmospheric, dominant light of complete unity.

Toned Supports

Tone your support to set the stage for color dominance or contrast. Pastel painters frequently use tinted papers to contribute to total color impact. Weavers get a similar effect with a warp of a single color influencing every color woven across it. Glazes of transparent colors over a *toned support* are easily affected by an underpainting. With opaque colors, cover the entire support with a single color reflecting the desired dominant light or, for a vibrant color effect, its complement; then, allow this underpainting to show through by applying a layer of broken, dry-brush color. If you use tinted papers, restore whites with gouache or acrylic white.

EXERCISE

Using a Toned Support

Tone a support with a colored wash or use tinted paper. Do two simple paintings of the same subject, one on your toned support and the other on a white support. Use transparent glazes or broken color so the toned support can be seen. How does the toned support affect the painting? There should be a feeling of harmony, but the colors may not seem as bright. Repeat the exercise, using a different color for the underpainting. Note your results in your color journal. ■

Toned Supports

Tinted paper contributes to the overall color effect when used with opaque media (below left). Transparent watercolor doesn't fare quite so well with colored paper because the support changes the colors so much (below center). Acrylic on canvas gets a vibrant shock from a complementary underpainting (below right) and a less startling, but pleasing, sparkle from the white canvas showing through broken color (below far right).

Oil pastel on colored pastel paper

Watercolor on tinted watercolor paper

Acrylic on toned canvas Acrylic on untoned canvas

PLEIN AIR
PAINTER, TAOS
Charles Sovek
Oil on Masonite
6" × 8"
(15.2cm × 20.3cm)
Private collection

Bits of Light

You can see bits of underpainting that appear as little pieces of light around the edges of the picture, on the tops of the trees, and here and there throughout the painting.

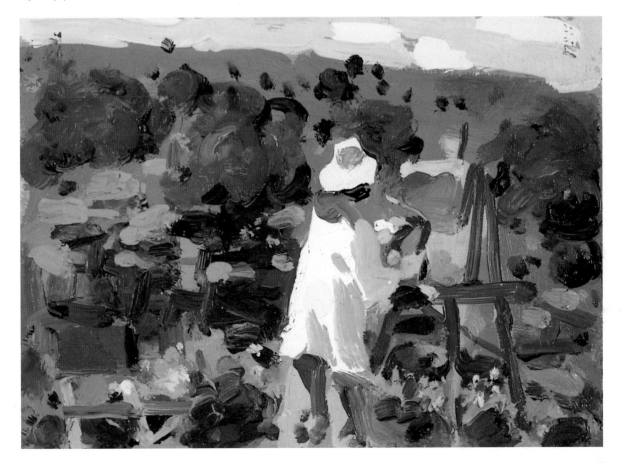

Color in Shadows

Think of shadows as a transparent veil, through which you can see the color of the surface they lie on, slightly darker in value than the surface, but not black and never opaque. Shadows needn't be neutral. Use a deeper value of the surface color, colors complementary to the dominant light illuminating the scene, or creative color that strengthens a color effect, not just cool blue or violet. If you prefer neutral shadows, use chromatic neutrals, mingling the colors rather than mixing them thoroughly. Experiment with different combinations of colors for rich, lively shadows.

PRIMROSE LANE
Gwen Talbot Hodges
Watercolor and gouache on paper
30¹/₄" × 22³/₄" (76.8cm × 57.8cm)

Capturing Light With Color

Hodges recognizes that capturing light is more than a matter of value contrast. She layers color wet-into-wet with transparent primary colors, starting with yellow, then red and blue, topping it off with touches of intense gouache to push the effect of light. Notice the colorful shadows.

E X E R C I S E

Painting Colorful Shadows

Make three small color sketches of a simple object seen on a sunny day. For the shadow on the first sketch lay down a transparent, neutral glaze. Glaze the second shadow with violet, the complementary color to warm yellow light. Over the third shadow, wash a warm glaze rather than a cool one, in a slightly darker value than the color of the object. If you can think of any other colors that would make creative, vibrant shadows, try them out. Compare these glazes and make notes in your journal on painting shadows. ■

Neutral

Cool

Warm

Shadows

At left and center are two of the most common ways of making shadows: with a neutral or a cool glaze. At right is a more vibrant combination showing a warm shadow that's only slightly darker in value than the building. This treatment does a much better job of suggesting warm, bright light.

SANTORINI
Jean H. Grastorf
Watercolor on paper
30" × 22" (76.2cm × 55.9cm)
Collection of the artist

Ambiguous Play of Light

Chromatic shadows create movement in a placid street scene and define interesting shapes throughout the picture. While it's useful to establish a light direction and consistent shadows in some pictures, the ambiguous play of light in this one is much more vibrant and exciting.

Painting Shadows

Some artists start by painting shadows first, building forms based on the light-and-dark pattern of an established direction of light. Then, they glaze color over these shadow patterns. Other artists complete the painting and add the shadows last, so that they will be less likely to confuse the direction of light while painting. Still others develop the shadows as they go along, keeping a fixed source of light in mind throughout. Try all three methods and pick the one that suits you.

Painting Shadows First

If you've never done a "shadows first" picture, try it now. Sketch your subject and create all the shadows with a low-intensity blue or violet or a chromatic gray. Pay careful attention to the patterns of the shadow shapes, connecting them to achieve a cohesive pattern. When the shadows are done, glaze over them with the colors of the objects, influenced by the dominant light to unify the picture. You can add additional color and value contrast anywhere it's needed, when the glazes are dry. ◼

Shadows Unify

The shadow pattern above moves across the sketch, unifying different areas in the picture. When you add color, the shadows fall into place without calling undue attention to themselves.

SUN TI
Susan McKinnon, NWS
Watercolor on paper
21¹/₂" × 29"
(54.6cm × 73.7cm)
Private collection

Strong Light and Color

Vibrant combinations of warm and cool colors in the shadows pick up the complementary hues that dominate this painting. Transparent glazes lie clearly on the smooth leaf surfaces, and the intricate shadow patterns are a strong counterpoint to the light.

Dominant Light

Different artists rarely represent light in the same way. To paint light, first you must carefully observe the light in nature and then determine what colors are needed to achieve that effect or change it, if you want a different effect. Careful observers can see continuous variations in light, but this takes practice. Natural light changes constantly and is primarily influenced by the time of day, the geographic region, the season and weather conditions. Be aware of changes in indoor artificial light as well as outdoor natural light.

Use your color journal to record your observations of light effects, then experiment with various ways of using color to represent them.

Time of Day, Weather, Season... These mingled colors show just a few of the myriad effects of dominant light. Try these combinations, then make up some of your own to express your favorite time of day, weather condition or season in color.

MORNING
PEARLY SOFT
Rose Madder Genuine, Cadmium Scarlet, Aureolin, Cobalt Blue

MIDDAY
STRONG CONTRAST
Permanent Rose, New Gamboge, French Ultramarine

LATE AFTERNOON
GOLDEN GRAY
Thioindigo Violet, New Gamboge, Cobalt Blue

SUNSET
BRILLIANT PURE COLOR
Alizarin Crimson, Cadmium Scarlet, New Gamboge, Phthalo Blue

MOONLIGHT
SOFT MONOCHROMATIC
Cadmium Red, Phthalo Blue

FOG
SOFT MONOCHROMATIC
Burnt Sienna, Raw Sienna, French Ultramarine, Davy's Gray

EXERCISE

Suggesting Dominant Light
On the following pages you'll find descriptions of several qualities of dominant light and artworks that illustrate different aspects of light, along with brief explanations of how color contributes to create that particular effect. Study these examples, then make sketches of your own, using color to capture the sensation described. Plan your color effect with color schemes to get the most consistent effect of dominant light. Record the colors you use for your effects for future reference. ■

Ways of Achieving Light Effects

Use these checkpoints to evaluate how the effect of light is achieved in the artwork that follows:

Color dominance
Contrast
Light source
Type of light (natural or artificial)
Color scheme
Glazing
Gradation
Toned support
Shadows
Reflected color

Time of Day

Every time of day has its own special light. Early morning light is luminous and clear with high-key color and gentle contrasts. Tints of scarlet, blue-green and violet express the awakening day. At midday a harsher light reveals intense contrasts of color and value, bleaching out highlights. Late afternoon light has a softer golden glow, with distant objects veiled with mist moving toward chromatic neutral tones. Twilight and early evening light are luminous, tending toward blue and violet, with the sunset a deep rich crimson. Atmospheric buildup throughout the day causes red rays to scatter widely and fill the sky and landscape with color.

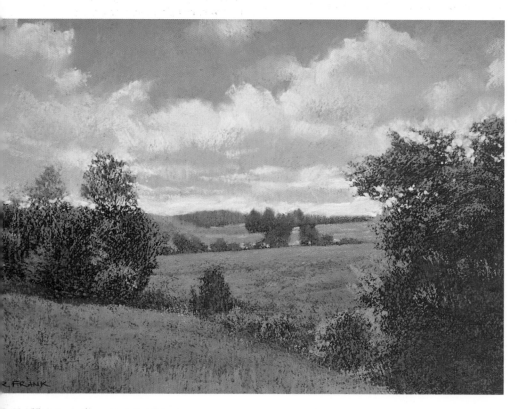

BREEZY DAY
Robert Frank
Pastel on paper
19" × 25" (48.3cm × 63.5cm)
Collection of the artist

Capturing Strong Contrasts
The yellow light of the sun bathes the green landscape, and blue sky reflects in the shadows. Frank knows every trick of painting light, so you may be sure his use of realistic local color is an intentional means of capturing the strong contrasts of light on a sunny day.

EXERCISE

Recording the Time of Day
Study the paintings on this page to analyze how artists have depicted a particular time of day. Make your own sketches of color effects showing the changing light of day. ▪

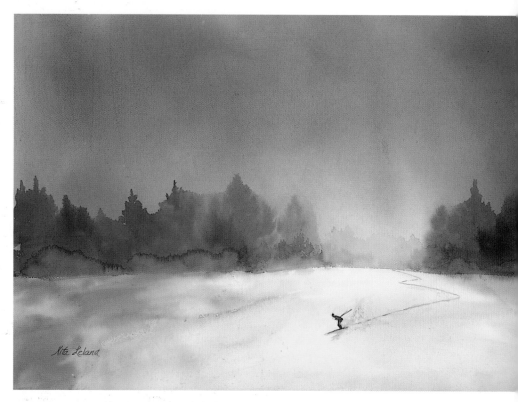

FREE SPIRIT
Nita Leland
Watercolor on paper
14" × 20" (35.6cm × 50.8cm)
Collection of Wes and Laura Leland

Expressing Time of Day
An intense palette of Winsor Red, Winsor Yellow and Winsor Blue makes rich, low-intensity washes surrounding the glow of the last light of day as it reflects off snow. Does light ever look like this? Probably not. But do the colors express the time of day effectively? I think so. You can take all kinds of liberties with color if you make your point.

Geographical Location

The color of sunlight in the northern hemisphere is warmer in summer than in winter. The light of the southwest differs from that of New England. What's the dominant light like in your region? If you're not sure about this, you can easily find out by visiting a local art exhibit. Artists tend to paint the light they are most familiar with, often without even being aware of the influence in their work. Study the light in other areas to see how different it is from the light you're familiar with.

WHISPERS
Barbara Kellogg
Acrylic, gouache and collage on paper
22" × 30" (55.9cm × 76.2cm)

Harmony of Dominant Light
Kellogg's mysterious painting suggests a cool northern atmosphere. Neutral grays are tinged with violet and pierced by cool yellow light. Abstraction benefits from the harmony of dominant light by creating an ambience felt by the viewer, even when the subject is vague or the painting is nonobjective.

PAROS,
THREE BOATS
Elin
Oil on canvas
18" × 24"
(45.7cm × 61cm)
Collection of the artist

Sharp, Clear Light
Certain places come immediately to mind when you think of bright light creating dramatic contrasts, and the area around the Greek islands is certainly one of them. Elin used Alizarin Crimson, Ultramarine Blue, Cadmium Yellow Pale, Thalo Green and Titanium White on gray-toned canvas to capture that sharp, clear light.

Seasons

Many artists see winter light as cold and use cool Phthalo Blue and violet with strong contrasts. Typical spring light is bright and tender, with gentler contrasts and clean, pure color: greens mixed with Cobalt Blue and Aureolin, and budding trees tipped with Rose Madder Genuine. The light of summer is more robust, with the rich color and contrast of a standard palette. When you think of autumn light, you might picture siennas and oxides against cool blue skies or brooding chromatic gray skies that imply the onset of winter.

E X E R C I S E

Capturing the Four Seasons

Let me persuade you to paint the four seasons one more time. It's a great way to work with light. This time, show the harmony of light in every season. Use some of the colors described here as your starting point, keying your color to characteristics of the seasons with compatible colors or color schemes. ■

COLORADO REST STOP
Nita Leland, watercolor on paper, 18" × 24" (45.7cm × 61cm)

Choose Colors Carefully

Blue skies and yellow cottonwoods are a dead giveaway for autumn in the west. But it makes a difference which blues you use to capture the season, as well as the place. I like Cerulean Blue here for the sky and water. It's neither too warm nor too cool and granulates beautifully in the background mountains.

MALBIS LANE
Robert Frank
Pastel on paper
12"×17"
(30.5cm × 43.2cm)
Collection of the artist

Summer Light

Here the yellow is yellow-orange; the greens are deep and dark, with traces of olive. We're into summer now. Trees are weighted with thick, dark green foliage. Shadows are deeper as well, with just a trace of hazy summer sky. What other kinds of summer light can you envision? Sunlight on the beach? A flower garden in full bloom?

Weather

Changes in the weather also have strong effects on dominant light. Clear weather has sharp contrasts and strong colors; fog and mist have close values and limited colors. A rainy day may be all neutral, except for the heightened color of wet objects reflecting in the puddles. Sometimes you can get a dramatic sense of a sudden storm approaching with a sunlit area surrounded by a background of black storm clouds.

SOUTH BRISTOL FOG ▶
Nita Leland
Watercolor on paper
15" × 22" (38.1cm × 55.9cm)
Private collection

Warm Maine Fog

I used Cobalt Blue, Aureolin and Cadmium Scarlet to create the warm Maine fog in this watercolor. Cadmium Scarlet and Cobalt Blue make a dense granulating wash that beautifully represents fog; the only chromatic hues in the picture are in the foreground areas.

EXERCISE

Doing Something About the Weather

List words that describe weather conditions, for example: *sunny*, *partly cloudy*, *stormy*, *rainy*. Look them up in a thesaurus or dictionary. What colors would you use to paint these different situations? Write ideas in your journal. Sketch a variety of weather conditions, using color to create the dominant light. ■

QUIET HARBOUR
Douglas Purdon
Oil and alkyd on canvas
16" × 20"
(40.6cm × 50.8cm)

Clear, Sunny Day

Purdon has captured a clear, sunny day to perfection with strong value contrast and clean color. The brilliant white of the boat flashes in the sun so you can almost feel its warmth, even though the temperature dominance is relatively cool.

Design Is a Choice

Good design is no accident. Everything, from the vertical or horizontal orientation of the support to the selection and arrangement of objects in a still life, reveals a choice made by the artist. These decisions are only partly intuitive; experienced artists usually base their decisions on previously learned design principles as well.

CINDI'S GIFT
Phyllis A. De Sio, acrylic on canvas, 30" × 20" (76.2cm × 50.8cm), collection of Mr. and Mrs. Richard J. Polehonka

Line

Value

Shape

Color

Size

Pattern

Movement

Unifying Color and Design

Successful artwork is solidly based on proven principles, with self-expression as part of the equation. Knowledge of design gives you confidence that you're going in the right direction; your intuition tells you if your plan really works. Georgia O'Keeffe called it "filling a space in a beautiful way."

Design is the arrangement of specific elements, like lines, shapes, values and colors, in a two-dimensional *composition*. Color, as it interacts with other elements, is a significant force in design. Your job is to direct the viewer's eye around your picture. Stay on the side of simplicity; too many colors and too much detail distract your viewers and make them miss your point. With a design based on sound principles, you're free to be more creative when you paint, without major design problems to solve as you go along. But don't treat your plan as though it were cast in concrete.

The ruling principle of artistic design is *unity*. Ideally, when a work is complete, nothing may be added or subtracted without destroying its unity. Your concept and your arrangement of design elements should form a harmonious whole. Good design creates balance and unity, reinforces your expressive idea, and prevents confusion and disorder. Examine the artwork in this section and throughout the book to see how artists combine elements and principles of design to create unity.

Guidelines for Good Design

Use the elements and principles of design as guidelines. Memorize them, use them consciously, and eventually they'll become second nature to you. Make a checklist and study your recent artwork to see how you use these important design tools. Which ones appear most frequently in your work? Which are the most effective? Where are your weak spots?

Elements of Design

The tools of design are the seven elements: *line, value, shape, size, pattern, movement* and *color*. Every artist uses these elements differently, but most elements are present to some degree in everything you do.

Line

Line is the versatile backbone of a design. Line may be structural, confining shapes or describing a form. Line is sometimes descriptive, representing specific things with linear characteristics, such as a rope or the twigs on a tree branch. Lines may be decorative, lyrical, calligraphic or textural. Intersecting lines help to locate a center of interest. The character of a line may be elegant or strident, lazy or energetic, qualities that are enhanced by color.

Vary Your Lines
Make a sharp, aggressive red line for excitement, a serene blue one for tranquility. A colored line analogous to its background harmonizes with it, while a complementary line stands out in sharp contrast. A jumble of colored lines creates texture and optically mixed color.

EXERCISE

Integrating Line and Color
Make sketches featuring colored lines. Try a variety of complementary, analogous and neutral lines, and study their effects. First, use lines as structural lines, containing objects. Then make descriptive lines, decorative lacy lines and symbolic lines, using colors representing feelings or emotions. Vary the color contrasts between the line and the background to change your emphasis. Note all these effects in your color journal. ■

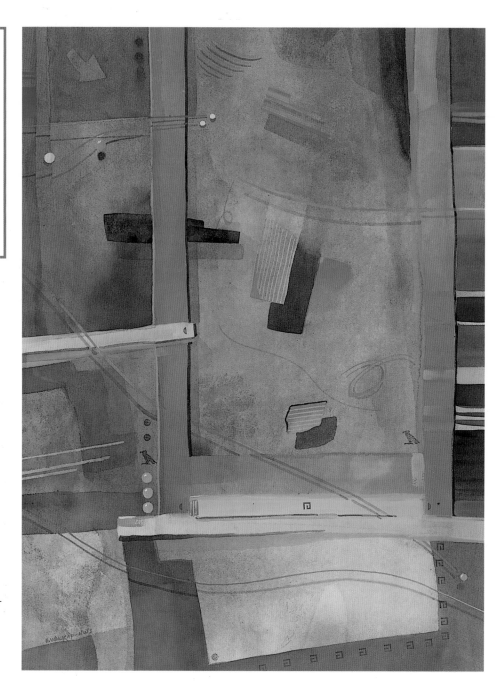

FUN WITH HIEROGLYPHS
Harold Walkup
Watercolor and gouache on paper
30" × 20" (76.2cm × 50.8cm)

Rhythm and Movement
The colorful lines in this painting move rhythmically in and out of the picture, turning hot and cold. The artist selected intense colors that emphasize movement and glow against a low-intensity background.

Value

Artists frequently debate the question of which is more important, color or value. Well, that depends on the artist, the subject, the message, maybe even on how you happen to feel on a particular day. Don't ever underestimate the importance of value, even if you're a colorist. Value planning should be one of the first steps in the development of your picture.

OTTERBEIN COLLEGE, TOWERS HALL
Nita Leland, watercolor on paper, 24" × 18" (61cm × 45.7cm), private collection

Color and Value Contrasts

Architectural portraits are usually full-value contrast paintings. By using a limited palette you can connect the subject to its surroundings with small touches of color that move throughout the picture, like the tinted clouds above. I placed my strongest contrasts of color and value in my focal point, the tower on the right.

EXERCISE

Coordinating Color and Value

Use collage to relate colors, shapes and values without the distraction of detail. In your color journal, arrange colored paper or magazine clippings in a few cut or torn shapes, paying special attention to value contrast. Make abstract or representational shapes, whichever you prefer. Try several arrangements before you glue them down with paste or acrylic medium. Make some high-key, low-key and full-contrast designs. Then, pick the collages you like best and interpret them in paint. ■

High-key values

Low-key values

Full-contrast values

Color Depends on Value

Values help distinguish shapes and identify objects. Color key is dependent on values for its expressive effect: The high-key light values here express a gentle, atmospheric feeling; the low-key darker values are more dramatic; the full-value contrast gives a strong visual impact.

Shape

Shapes may be simple, but they must also be visually interesting, with varying dimensions and edges. Whether your shapes are realistic or abstract, you can be inventive with color. A successful arrangement of colorful shapes is a visual delight. First, design the shapes and then make your subject fit into these shapes.

Combine Shapes
Combine several small shapes into larger shapes to simplify your composition and enhance color effects.

EXERCISE

Designing Colored Shapes
Cut or tear shapes of different colored papers in color schemes of your choice. Try various arrangements in your color journal until you have several you like. Make small color sketches based on your collages. ■

Vary Shapes
Vary the colors of the shapes slightly, even when they are similar, to create a more active surface. What colors do aggressive, energetic shapes call for? Sensuous shapes? Gentle shapes?

REEDS OF BLUE
Veloy Vigil
Acrylic on canvas
36" × 42"
(91.4cm × 106.7cm)
Courtesy of Gallery Elena,
Taos, New Mexico

Powerful Design
Vigil has created a powerful design of abstract shapes with a representational subject using luminous chromatic neutrals, beautifully contrasted with the repetition of pure tints and dark accents that move your eye irresistibly from one intriguing shape to another.

Size

Sizes of color areas have substantial impact on your design. When color areas are equal in size, the design remains static and the color expression ambiguous. Different-sized pieces of color are more interesting than the same colors in equal-sized shapes. Big, bold shapes showcase color, as in Georgia O'Keeffe's large-scale close-ups of flowers.

CALLEJON V
Dan Burt, AWS, NWS, watercolor on paper
22" × 30" (55.9cm × 76.2cm), collection of the artist

Large and Small Shapes
Strokes of color of various sizes create a lively, staccato rhythm throughout this picture. Colors are repeated along with flickers of white paper suggesting light. All are anchored by the dazzling white building in the center of interest.

Size Affects Impact
The larger an area of color, the greater the color effect. Colored shapes lose some of their impact when you scatter them evenly over a surface or arrange them in a repetitive pattern. In concentrated areas they have greater effect, especially if the field around them is a complementary color.

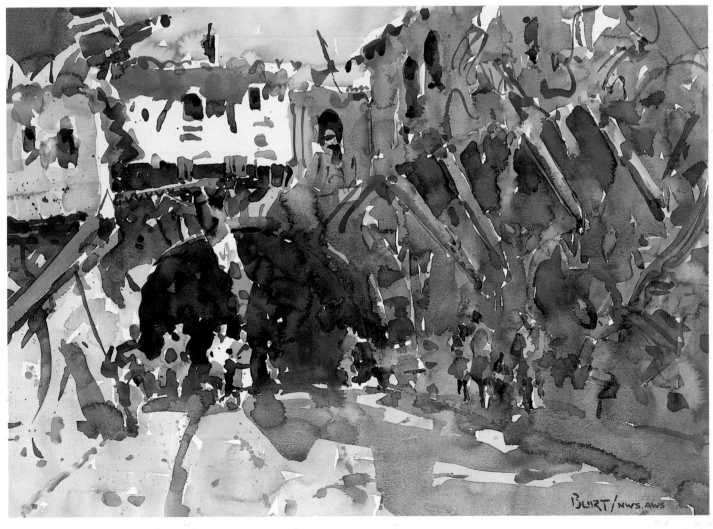

Pattern

Similarity and repetition of design elements create patterns across your artwork that guide the viewer's journey through your composition, sometimes providing decoration or the appearance of surface texture. When you repeat colors, make them relevant to the design and the color mood you want to express. Plan your repeated colors carefully to move the eye around the composition and into the center of interest. Bear in mind that pattern paintings don't always need a single focal point.

Various Patterns

Three patterns are working in this small magazine collage: The yellow flowers are the main pattern. They are accented with repeated patterns of small red flowers to keep your eye moving. In the third pattern, texture on the tree stump also contributes to the flow of the design.

IRON COUNTRY III
Glenn Bradshaw
Casein on handmade Okawara paper
12" × 17" (30.5cm × 43.2cm)

Energetic Design Pattern

Bradshaw juggles several types of colored patterns and shapes throughout his abstract composition. Repetition of shapes with variations in their sizes and colors makes for an energetic design pattern.

Movement

Color plays an active role in controlling direction and speed of movement in a composition. Horizontal movement is serene, vertical is dignified, and diagonal is active. Color temperature also affects speed of movement: Warmer colors appear to move more quickly than cooler hues. Use warmer colors in the foreground to capture attention, then move through progressively cooler hues into deep pictorial space. To create an energetic, push-and-pull effect, reverse color temperatures. To slow down the movement of high-intensity hues, lower their intensity.

TAKE #3
Robert Lee Mejer, watercolor on paper 30" × 22½" (76.2cm × 57.2cm)

Vertical and Diagonal Movement

The vertical thrust of this watercolor adds authority to strong colors, shapes and lines. Diagonals create movement and keep the piece from becoming static by varying from the dominant orientation.

PURPLE MESA, *Sheila Savannah, acrylic on paper, 22" × 30" (55.9cm × 76.2cm)*

Movement and Color Contrasts

Savannah's strong horizontal design is energized by diagonals in the foreground; notice how she has used contrasting color variations for these shapes.

EXERCISE

Controlling Movement

Make a sketch in the medium of your choice with several large horizontal shapes. Add two to three verticals or diagonals. Can you see how this energizes your design? Repeat the exercise, reversing color temperature (see page 99), changing your color scheme, using colored lines and shapes to create movement. ■

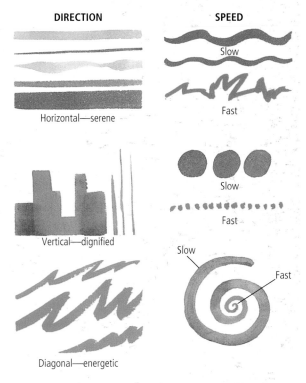

Color and Movement

You can use calm blue horizontals for serenity, powerful green verticals for dignity and vibrant red zigzags for energy. Allow intervals between lines and shapes to control the speed of movement. The warm-colored line that winds into a spiral moves more quickly where it is tightly wound than at its outer edge where the color is cooler.

Harmony

Contrast

Rhythm

Repetition

Gradation

Balance

Dominance

Principles of Color Design

Using the principles of color design in your artwork brings visual order to the elements of design just discussed. Plan these design relationships to support your expressive color concept. You'll use some elements more than others, which helps to define your style. When you fully understand the rules of design, you can deliberately break them for effect. The seven principles of design are *harmony, contrast, rhythm, repetition, gradation, balance* and *dominance.*

Harmony

Harmony results from the relationships of similar elements in a design, such as restful lines, monochromatic or analogous color, serene movement, close values, or comparable shapes and sizes. All of these contribute to a sense of unity.

SAMURAI HAIKU
Pat San Soucie
22" × 30"
(55.9cm × 76.2cm)
Private collection

Subtle Visual Excitement
This high-key value arrangement is harmonious because it lacks strong contrasts. Low-intensity colors flow together beautifully. There is just enough difference in color and value to create subtle visual excitement. As suggested in the title, there is poetry in such harmonious use of color. Try this when you want to create a lovely, serene painting.

Contrast

If you think too much harmony makes a boring picture, include contrasts of colors, lines and shapes in your composition. Dynamic contrast attracts attention to the most important area in your composition. Use value contrast for visual sensation, color contrast for emotional expression. Contrast edges, lines and shapes, changing colors to generate activity and movement.

To dominant horizontals add gentle obliques; to analogous colors, a flicker of complementary contrast; to high-key color, more value contrast. Make your piece vibrate with contrasting, energetic color by using color schemes based on differences rather than similarities. Exaggerate color and value contrasts for impact.

EXERCISE

Adding Color Excitement With Contrast
Create a solid design with simple shapes and value patterns. First, plan a sketch using an unrealistic color scheme with exciting colors. Then, whip up a color collage to see how the contrasting colors look together. If the piece seems too busy or the colors don't work, lower the intensity of some of the colors or lay a unifying glaze to create dominant light. ■

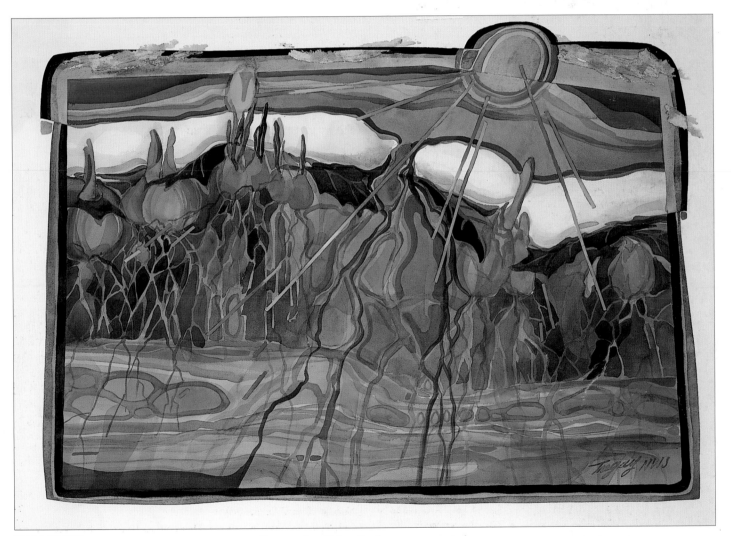

HARBINGER
Susan Webb Tregay, NWS
Watercolor on paper
22" × 30" (55.9cm × 76.2cm)

Contrasting Color Excitement

Pure hues against neutrals provide color excitement, with rays from the sun breaking into prismatic colors that vibrate against a low-intensity background. Compare this picture with San Soucie's *Samurai Haiku* (page 130) to understand the difference between harmony and contrast in color design.

Rhythm

Establish rhythm by varying the spaces between related elements in a composition. Use line and color to aid the rhythm: a staccato hot-pink zigzag or a sensuous, elegant blue flow. Avoid interrupting a rhythmic progression, unless you intentionally wish to stop the movement. Be consistent with the sequence of shapes and colors, but provide variety. Conflicting rhythms disturb unity, so don't try to jitterbug in the middle of a waltz.

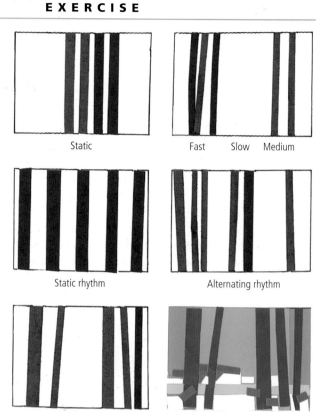

FABRIC FAMILY
Ellie Heingartner
Watercolor on paper
21¹/₄" × 26¹/₂" (54cm × 67.3cm)

Rhythmical Color Patterns

Follow the pattern of low-intensity textured mesh upward from the lower left corner. Then find repetition of the pattern in its shadow. Repeat color in rhythmical patterns with changes of size and shape.

Repetition

Repetition of line, color, value or shape reinforces whatever idea you're trying to communicate with that design element. Your viewer often singles out a certain color or shape and follows it through the composition. Avoid random placement. Plan carefully and place repeats where they will enhance rhythm, movement and pattern and help the viewer's journey through the composition. Use variety with repetition to prevent boredom. There is no magic number for recurrences of a color. Use good judgment in your repetitions.

GOING DOTTY, TOO
Jada Rowland
Watercolor on paper
30" × 20"
(76.2cm × 50.8cm)
Collection of Bill and Cynthia Magazine

Rhythm and Repetition

In this delightful, nearly monochromatic watercolor, similar repeating shapes are changed slightly in size or value and placed in rhythmic sequences to make the whole much greater than its parts.

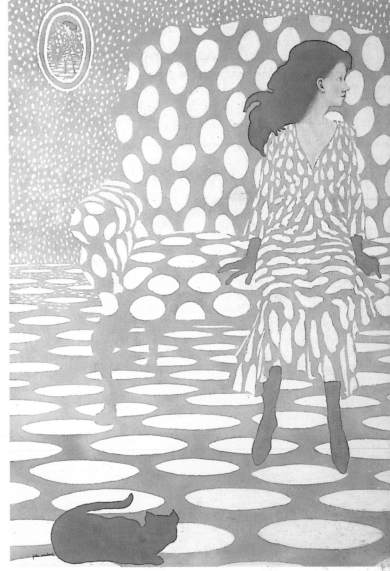

ANCESTRAL SPIRIT DANCE #208
Willis Bing Davis
Oil pastel on black rag board, 60" × 40"
(152.4cm × 101.6cm)

Pulsing Staccato Rhythms

To work out an effective color pattern with pulsing staccato rhythms, use repetition with variations. This dynamic piece is unified by a network of colored lines and shapes against a black background that captures your attention.

EXERCISE

Using Repetition With Variation

Develop a sketch exploring color repetition. Give your repetitions variety and rhythm. When working from nature, be selective among all the colors and shapes you have to choose from. Simplify. Find the important colors and place them strategically. Then, repeat them with variations: red that is muted to Burnt Sienna or cooled down to violet; blue that is grayed or slightly tinged with green. ■

Gradation

Gradual changes in design elements indicate movement, providing graceful transition from one color area to another. For example, you can change color temperature gradually from warm to cool or change color values from light to dark. As shapes change, alter their colors, too. Gradation supports unity better than abrupt change, unless you wish to express a concept like violence or anger.

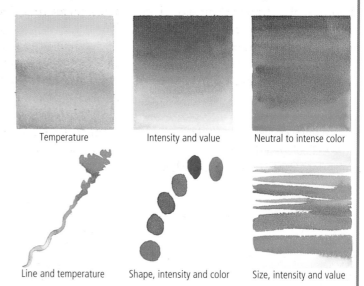

Temperature Intensity and value Neutral to intense color

Line and temperature Shape, intensity and color Size, intensity and value

Gradual Changes

Gradual changes in design elements can be executed in numerous ways, contributing to rhythmic movement across a piece or into background space. How could you use some of the gradations above with your subject matter?

ON THE EDGE
Edwin H. Wordell
Mixed watermedia on
collage papers
40" × 60"
(101.6cm × 152.4cm)

Gradation Creates Movement

Wordell uses gradation to draw you through a tunnel-like shape into the background. Warmer colors, lighter values and higher intensities are near the front of the shape, with gradual changes in these elements as you move into the tunnel.

Balance

Balance results when design elements are distributed to produce an aesthetically pleasing whole. Identical elements on both sides of a picture make a symmetrical, formal design. Asymmetrical balance means unlike or unequal elements are arranged to counterbalance each other. Color intensity, value and temperature are other balancing factors.

The more elements you include, the more difficult your balancing act. Formulas don't work. Play with the color, till you feel it works. Will a small hot spot balance a large cool area? Does an intense passage seem too heavy for a neutral area? Use formal balance to suggest dignity, but don't get stuffy about it. The more emotional your message is, the more asymmetrical the balance and the more conflict in colors. Each touch of color changes color balance. When the balance essential to unity is achieved, your piece is finished. You'll know it when you see it.

Carla O'Connor

CELADON
Carla O'Connor
Watercolor and gouache on watercolor board
30" × 22" (76.2cm × 55.9cm)

Symmetrical

Off balance

Asymmetrical

Balance and Unbalanced
The top collage is balanced symmetrically (a little stiff to my way of thinking); the center collage is too heavily weighted on one side; the lower, asymmetrical collage seems better balanced. Trust your intuition to tell you when you've established visual balance with major and minor shapes. The ability to do this comes with practice.

Asymmetrical Color Balance
Forms are balanced by following muted reds from one head to the other and back across the picture to the smaller bits. Cover those smaller pieces with your hand. Do you think the composition would be balanced without them?

Dominance

When elements conflict, dominance restores unity. Color dominance makes the color statement coherent, focusing attention on your expressive intent. Colors usually dominate through intensity or quantity: the brightest color or the greatest area of color. Small areas of a single bright hue, when contrasted with a large neutral field, control because of their brilliance. A large shape of a single color overpowers several small shapes of different colors. Many bright colors are ruled by the one with the greatest area or highest intensity. A dominant color theme, with counterpoints of contrasting colors, creates interest and movement.

E X E R C I S E

Emphasizing Color Dominance

Select a color scheme for a sketch and plan your color to achieve dominance in one or more of the following ways:

- Temperature (warm or cool)
- Shape (curved or angular with colors to match)
- Intensity (bright or dull)
- Dominant light

Using elements and principles of design, select one to have greater importance than the others. Decide on your color dominance, planning the hue, value and intensity of every color area, its temperature, size and placement, for a unified composition. ◼

SPIRITS OF TSAVO
Sharon Stolzenberger
Watercolor on watercolor board
30" × 40" (76.2cm × 101.6cm)

Dominant Colors Unify

Stolzenberger toned her background with the dominant colors, then painted elephants in slightly darker values of the same colors. Even if she had used a few other colors, the overall dominance of the preliminary washes would continue. The effect is of a chromatic mist that unifies the entire scene.

Designing a Color Collage

Color design is particularly important in collage, where diverse materials must be unified by some kind of common element. In this demonstration I combine natural objects with painting, which is relatively simple when you start with a color theme to tie things together.

Supplies

- Collage materials, such as leaves, twigs, rice paper, marbled paper, fibers, bark
- Acrylic mediums—gloss, matte and gel
- Brushes, such as the hake brush and big, flat synthetic brush used here
- Soft rubber brayer
- Plastic-coated freezer paper
- Crescent #310 illustration board
- Watercolor or acrylic paints in palette of your choice
- Sketchbook
- Small weights

STEP 1 ▶

Collage Materials

Collect more things than you think you might need to create a collage, so you don't have to stop and hunt while assembling it. I'm using leaves and twigs I picked up in Canada during a workshop session. I also have some tinted rice paper and marbled paper I can use, as well as assorted fibers and bark. I gather my acrylic mediums and tools and cover my collage work surface with plastic-coated freezer paper.

STEP 2 ▲

Acrylic Gloss Medium

I begin by encasing the leaves and twigs with acrylic gloss medium to strengthen and protect them from deterioration. The medium looks milky white but will dry crystal clear. I've also coated my 15" × 20" (38.1cm × 50.8cm) Crescent #310 illustration board on both sides with medium to seal it; this is standard procedure in collage to ensure that all objects are protected from contamination by other objects or air pollution.

STEP 3 ▶

Painted Background Pattern

After mingling watercolors in my sketchbook I decide that the old masters' palette (page 68) will make the most effective color combination to unify the collage. I place two pieces of Masa rice paper on my drafting table and paint strokes of color across them with a hake brush. I continue painting until I see a pattern I'd like to use for the background.

STEP 4 ▲

Setting the Tone

Background colors set the tone for the rest of the collage. I let the rice paper dry, then tear the paper in places to create more interesting edges. I then use a big, flat synthetic brush to spread acrylic matte medium across the entire surface of the coated illustration board. I quickly place the painted rice paper on the wet medium, gently rolling it flat with a soft rubber brayer.

STEP 5 ▲

Twigs and Leaves

I begin to arrange the natural materials, using verticals to frame the picture on the right side. I select encased twigs and leaves to harmonize with the background color, then adhere them with Golden's regular gel medium applied to the touch points where they come in contact with the surface of the board. To assure they're bonded, some pieces must be held down with small weights until they dry. I've saved the yellow leaf for the focal point because it picks up the yellow in the background so beautifully.

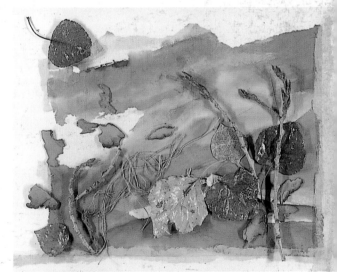

STEP 6 ▲

Unifying Colors

I add more bits of bark and fiber, then finish up with an irregular border of torn, tinted Unryu rice paper that echoes the warm colors in the collage and enhances the color design. Although nature is the subject of the collage, color is the unifying element.

CANADA
Nita Leland
Collage with watercolor and found objects on illustration board
15" × 20"
(38.1cm × 50.8cm)

Conclusion

The great colorists didn't try to achieve distinguished color by trial and error, and neither should you. Delacroix spent long hours at museums studying the colors of the masters. Van Gogh, a powerful and impulsive painter, respected orderly relationships of colors. Kandinsky used color as emotion—but he knew his color theory well. The more you experience color, the sooner your intuition acquires a solid foundation to spring from. Overcome lazy habits of seeing that lock you into your first impression. In time you'll become aware of the subtleties of color in every-thing you see. But don't simply report what you see. Use color to express the forces that energize your subject.

This book gives you guidelines, not rules. Remember that random selection usually leads to confusion and the destruction of visual order. Matisse said that color reaches its expressive potential only when it is organized and reveals the emotional involvement of the artist. Logical organization and expressive communication are mutually dependent. Strike a balance, comprising what you know and what you feel, to produce a successful color statement.

STREET CATCH
Laura Duis
Watercolor on paper
20¹/₂"× 28¹/₂"
(52.1cm × 72.4cm)

Exuberance and Enthusiasm

These pure, bright colors are typical of this artist's style. Her watercolors strongly reflect her color personality as she captures an almost spectral light.

EXERCISES

Seeing Color Everywhere

Look for color everywhere—in music, in poetry, in life. You're the sum of all you see, hear and experience. Enrich yourself, and the richness of your life will be revealed when you paint. Visit museums and galleries, taking your color journal with you, to record the ways artists use color to communicate. Note different color combinations, study their color mixing and how they use complements, contrasts and light. The next time you plan your color for a piece, begin with a color idea from your notes. ■

Finding Poetry in Color

Select a subject or poem you like and examine your feelings about it, jotting down words that describe these sensations. Note colors you think match the sensations. Be selective, eliminate detail, and dream up a creative color plan. What essential qualities do you want to convey? Make a sketch, expressing your feeling with color, using any of the palettes in this book. Don't just tell a story; help your viewers to share your emotions. ■

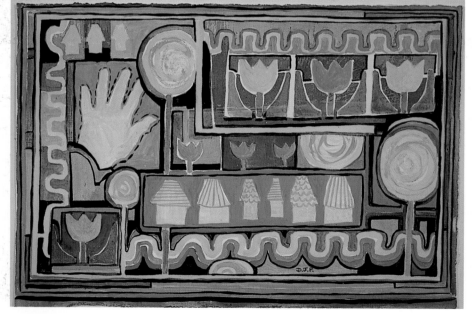

HAND-PRINT
Doris J. Paterson
Acrylic on paper, 7¹/₂"× 11" (19.1cm× 27.9cm)

It's a Feeling

Paterson works intuitively with color in paintings that recall the spirit of a child. It's important to understand that all the rules, guidelines and theories in the world shouldn't be allowed to interfere when something "feels right" and you know instinctively that it works.

WINTER SEA
Pat Dews, AWS, NWS
Ink, acrylic and paper collage on paper
22" × 30" (55.9cm × 76.2cm)
Private collection

Expressive Abstraction

Abstract design can be as expressive as realism. As Matisse said, "Above all, express a vision of colors, the harmony of which corresponds to your feeling." Dews has used an effective analogous color scheme of red-violet, violet, blue-violet, blue and blue-green with a field of low-intensity color as a background. That impulsive bit of red is a sign of the artist intuitively rebelling against a predictable outcome.

STYLE

Style is the unique imprint of your personality on your artwork. Do what comes naturally, and style will take care of itself. Trust yourself and develop your own subjects, colors and compositions, rather than using material created by other artists. Your techniques and your medium help to determine your style. How you design your artwork to communicate with your viewer is another mark of style. Your preference for particular colors and the way you combine them identifies your style as clearly as handwriting. Use color fearlessly and your distinctive style will evolve.

EXPRESSING YOURSELF

Trust your intuition. Your selection of colors is highly personal, as you reveal your individuality through your color choices. Try selecting your colors first and then finding a subject that suits your colors. When you understand the logic of color schemes, you can reveal your true feelings with expressive color. As you develop more confidence in your choices, you'll become more creative with color. Color is the force that communicates your deepest feelings to the eye and heart of the beholder.

Your art should be a synthesis of nature, your medium and you. Let color be the force that unifies these elements and shapes them into your unique style. And never stop exploring color. What you learn will give your work impact to match your artistic vision.

EXERCISE

Making Color Your Subject

For an intellectual challenge, emphasize design and formal relationships with color as your subject, using geometric patterns or organic shapes. When you choose colors without a representational subject, they are entirely your colors. Select an abstract viewfinder design (see page 90) or create an original geometric pattern of your own design. Choose one of your favorite color schemes and make a color sketch of your design. ■

SPRING
KALEIDOSCOPE
Marsh Nelson
Acrylic on museum board
10" × 16"
(25.4cm × 40.6cm)

Inventive Color Rhythms

Don't bypass realism; just let inventive color speak for you. This painting reveals the vision of the artist in the rhythms beneath the surface of nature. Find a creative way to express your uniqueness.

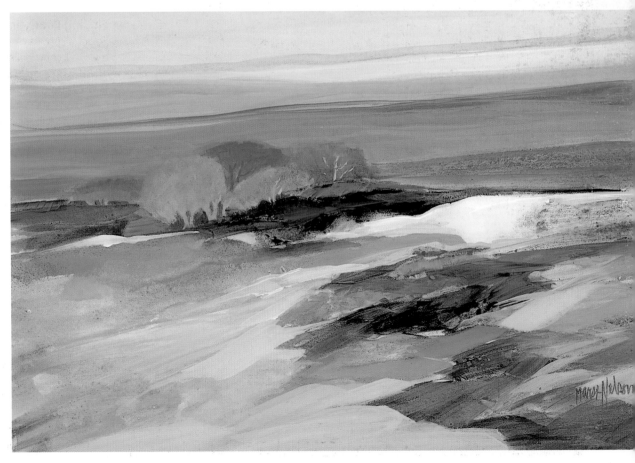

Selected Bibliography

Albers, Josef. *Interaction of Color.* New Haven: Yale University Press, 1975.

Birren, Faber. *Creative Color.* New York: Van Nostrand Reinhold, 1961.

Borgeson, Bet. *The Colored Pencil.* Rev. ed. New York: Watson-Guptill Publications, 1995.

Chevreul, M.E. *The Principles of Harmony and Contrast of Colors and Their Applications to the Arts.* New York: Van Nostrand Reinhold, 1981.

Dawson, Doug. *Capturing Light and Color With Pastel.* Cincinnati: North Light Books, 1991.

Dobie, Jeanne. *Making Color Sing.* New York: Watson-Guptill Publications, 1986.

Eckstein, Helene W. *Color in the 21st Century.* New York: Watson-Guptill Publications, 1991.

Hope, Augustine, and Margaret Walch, ed. *The Color Compendium.* New York: Van Nostrand Reinhold, 1990.

Itten, Johannes. *The Art of Color.* New York: Van Nostrand Reinhold, 1973.

Kandinsky, Wassily. *Concerning the Spiritual in Art.* New York: Dover Publications, 1977.

Lamb, Trevor, and Janine Bourriau, ed. *Colour: Art & Science.* Cambridge: Cambridge University Press, 1995.

Lambert, Patricia, Barbara Staepelaere and Mary G. Fry. *Color and Fiber.* West Chester, Pa.: Schiffer Publishing Ltd., 1986.

Leland, Nita. *The Creative Artist.* Cincinnati: North Light Books, 1990.

Leland, Nita, and Virginia Lee Williams. *Creative Collage Techniques.* Cincinnati: North Light Books, 1994.

Leslie, Kenneth. *Oil Pastel.* New York: Watson-Guptill Publications, 1990.

Metzger, Phil. *The North Light Artist's Guide to Materials and Techniques.* Cincinnati: North Light Books, 1996.

Page, Hilary. *Guide to Watercolor Paints.* New York: Watson-Guptill Publications, 1996.

Quiller, Stephen. *Color Choices.* New York: Watson-Guptill Publications, 1989.

Quiller, Stephen. *Acrylic Painting Techniques.* New York: Watson-Guptill Publications, 1994.

Sarback, Susan. *Capturing Radiant Color in Oils.* Cincinnati: North Light Books, 1994.

Sargent, Walter. *The Enjoyment and Use of Color.* New York: Dover Publications, 1964.

Sovek, Charles. *Oil Painting: Develop Your Natural Ability.* Cincinnati: North Light Books, 1991.

Verity, Enid. *Color Observed.* New York: Van Nostrand Reinhold, 1980.

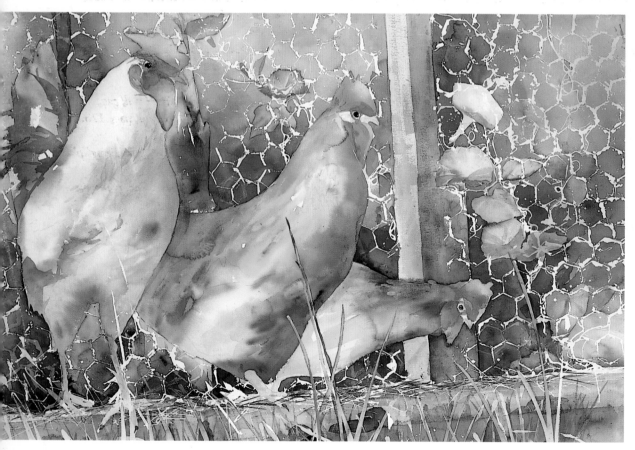

CHICKENS
David R. Daniels
Watercolor on watercolor board
40" × 60"
(101.6cm × 152.4cm)
Collection of the artist

Pushing Realistic Color

Realistic color can be pushed by using vibrant high-intensity colors and complementary vibrations. Daniels goes with the flow and lays down the colors of the chickens to contrast with a complementary, low-intensity background.

Contributors

All contributor art is used by permission and is copyrighted by the individual artist.

Catherine Anderson: *To Be*, page 112.

Ave Cassell Barr: *To Catch a Piece of the Sky*, page 51.

Karen Becker Benedetti: *Boundless Vision*, page 100.

Virginia Blackstock: *Life On The Loose*, page 71.

Glenn R. Bradshaw: *Iron Country III*, page 128.

Dan Burt, AWS, NWS: *Callejon V*, page 127.

Roger Chapin: *Blue Hills*, page 103.

Diane Coyle: *Into the Light*, page 98.

David R. Daniels: *Chickens*, page 140.

Willis Bing Davis: *Ancestral Spirit Dance #208*, page 133.

Pat Deadman AWS, NWS: *Green Bean Fields*, page 85.

Betty S. Denton: *Hibiscus Haven*, page 61.

Phyllis A. De Sio: *Cindi's Gift*, page 122.

Pat Dews, AWS, NWS: *Winter Sea*, page 139.

Laura Duis: *Street Catch*, page 138.

Benjamin Eisenstat: *Early Evening, Monterey Bay*, page 99.

Elin [Pendleton]: *Paros, Three Boats*, page 119.

Robert Frank: *Breezy Day*, page 118; *Malbis Lane*, page 120.

Don Getz, AWS, KA: *Sebring Challenge*, page 89.

Janie Gildow: *Sparklers*, page 107.

Lawrence C. Goldsmith: *Twilight Radiance*, page 45.

Jean H. Grastorf: *Lindos Lace*, page 111; *Santorini*, page 115.

Ellie Heingartner: *Fabric Family*, page 132.

Jane Higgins: *To Market*, page 43.

Gwen Talbot Hodges: *Primrose Lane*, page 114; *Quick Pick*, page 109.

Donna Howell-Sickles: *Songs for the Piecutter*, page 22.

Barbara Kellogg: *Whispers*, page 119.

Stephanie H. Kolman: *Slipped Cog—Self Portrait*, page 21.

Kristy A. Kutch: *Nectarine Trio*, page 98.

Lynn Lawson-Pajunen: *Memories of Maui #1—Red Ginger*, page 40.

Larry Mauldin: *After Midnite*, page 102.

Susan McKinnon, NWS: *Sun Ti*, page 116.

Robert Lee Mejer: *Take #3*, page 129.

Shirley Eley Nachtrieb: *Salsa Garden*, page 8.

Cathy Nealon: *Remnants of an Empty Nest*, page 83.

Marsh Nelson: *Spring Kaleidoscope*, page 139.

Carla O'Connor: *After Eight*, page 69; *Celadon*, page 135.

Mary Padgett: *Female Brook Trout*, page 97; *Strawberries*, page 86.

Lisa Palombo: *Nuclear Cows*, page 88.

Doris J. Paterson: *Hand-Print*, page 138.

Ann Pember: *Peony Bloom*, page 38.

Douglas Purdon: *Quiet Harbour*, page 121.

Stephen Quiller: *Aspen Patterns, Gold & Blue*, page 76.

Bren Quiett Reisch: *Eternal Light*, page 95.

Ellie Rengers: *Times of Life*, page 96.

Jeny Reynolds: *Grand Mesa Gorge*, page 94.

Joan Rothel, AWS, NWS: *The Morning After*, page 42; *Where Have All the People Gone?*, page 106.

Jada Rowland: *Vermeer's Table*, page 108; *Me In Milan*, page 11; *Going Dotty, Too*, page 133.

Pat San Soucie: *Samurai Haiku*, page 130.

Susan Sarback: *Breakfast*, page 82.

Sheila Savannah: *Purple Mesa*, page 129.

Mary Jane Schmidt: *Garden Series 263—Garden Border*, page 92; *Tropical Series 125—Tropic Leaves*, page 58.

Brenda Semanick: *Nopal Con Flores Rojos*, page 46.

Charles Sovek: *Plein Air Painter, Taos*, page 113.

Paul St. Denis: *Orchid*, page 1; *Raptor*, page 95.

Sharon Stolzenberger: *Spirits of Tsavo*, page 136.

Gwen Tomkow: *Orchard in Round*, page 55.

Maggie Toole: *Still Hopeful*, page 11; *It's Burning*, page 81.

Susan Webb Tregay, NWS: *Harbingers*, page 131.

Ortrud M. Tyler: *Fire Opal*, page 12.

Veloy Vigil: *Reeds of Blue*, page 126; *Tenderness*, page 53.

Harold Walkup: *Fun With Hieroglyphs*, page 124.

Virginia Lee Williams: *Moon and the Mandala*, page 93.

Edwin H. Wordell: *On The Edge*, page 134.

For information...
on how to obtain the *Nita Leland*™ *Color Scheme Selector*, contact
Nita Leland
Dept. EC
P.O. Box 3137
Dayton, Ohio, 45401-3137

Glossary

achromatic lacking color; black, gray or white; neutral

additive color color derived from light mixtures

analogous colors adjacent colors on the color wheel; such as blue, blue-green and green

balance distribution of elements producing a state of equilibrium in a composition

chiaroscuro strong light-and-dark contrast in drawing and painting

chroma see *intensity*

chromatic having color (as opposed to achromatic black, gray and white)

chromatic neutral see *color identity*

color constancy adaptation of the eye to changes in illumination

color identity an obvious color bias in a mixture

color index number an identification number referring to a specific pigment composition

color personality individual preferences for particular colors or paints displayed in an artist's work

color scheme orderly selection of colors, according to logical relationships on the color wheel, used in an artwork

color solid a three-dimensional form showing the properties of color

color wheel a circular arrangement of the colors of the spectrum

colorant coloring matter; pigment or dye

colorist one who stresses color relationships in artwork

compatible colors pigments matched for similarities in transparency or opacity, intensity and tinting strength

complementary colors opposites on the color wheel

composition arrangement of the elements and principles of design to create a unified, artistic whole

contrast opposition; a dynamic element of design; juxtaposition of dissimilar elements in an artwork

dominance having one design element of greater importance than another

dominant light or color representation of different lighting effects caused by changes in season, weather, time of day or region; the predominant light or color in a composition

dye a transparent colorant absorbed by the surface it colors

expanded palette an increased number of colors from the six basic primaries and secondaries, which includes twelve hues

fugitive color or pigment a chemically unstable pigment that fades or changes noticeably under normal conditions of light or storage

glaze a transparent or translucent veil of color modifying an underlying color

gradation gradual, successive change

granulation sedimentary effect in washes

harmony pleasing result of relationships between design elements or principles

highlight the point of greatest illumination

hue the spectral name of a color, such as red, orange, yellow, green, blue or violet

illumination an effect caused by a light source

intensity the degree of purity or brightness of a color

key the dominant value relationships in a picture: high key includes medium-to-light values; low key includes medium-to-dark values; full contrast includes light, medium and dark values.

limited palette selection of a small number of colors to use in an artwork

line structural, descriptive or symbolic design element in a composition, having little volume; for example, an outline or contour defining a shape

local color the actual color of an object

luminosity a quality of radiance or glow in an artwork

medium materials used in a specific art technique; also, a paint additive

mingle to blend paints without excessive mixing, so colors still retain some of their identity

mixed contrast overlay of an afterimage on another color; see also *successive contrast*

monochromatic having a single color

movement horizontal, vertical or oblique directional thrust into the space and across the surface of an artwork; quality representing motion

neutral see *achromatic*

opacity having covering power; not transparent

optical mixture occurs when small areas of color are juxtaposed and perceived by the eye as a mixture

paint coloring matter (pigment) suspended in a liquid

palette the white surface on which colors are mixed; also the set of colors selected by an artist for use in an artwork

pattern placement of repeated colors, shapes or values in a design

pigment powdered coloring matter used in the manufacture of paints

primary color a color that cannot be mixed from other colors: red, yellow, blue, magenta, cyan

properties of color hue, value, intensity, temperature

reflected color or light color or light on an object that is reflected off adjacent objects

repetition recurrence of similar units of color, shape or value

rhythm an ordered sequence of recurring elements to control speed of movement and energy in a composition

saturation see *intensity*

secondary color a color resulting from the mixture of two primary colors: orange, green and violet

semiopaque slightly or nearly opaque

semitransparent partially transparent

shade medium-to-dark value of a color

shape an enclosed area or object in a design

simultaneous contrast any one of several effects colors have on each other when juxtaposed and viewed together or successively

spectrum the band of colors produced when white light passes through a prism: red, orange, yellow, green, blue, violet

split primaries a warm and a cool pigment for each primary color (six primaries); used in color mixing

stain a color that penetrates the surface (see *dye*)

style characteristic techniques or colors of an individual artist; an artist's distinctive manner of expression

subtractive color color derived from paint mixtures that absorb all color except the local color of the object, which is reflected

successive contrast the afterimage of a complementary color seen after viewing a color

temperature the relative warmth or coolness of colors

tertiary color mixtures of a primary and its adjacent secondary: for example, red-orange or blue-green

tetrad a color scheme having four colors with a logical relationship on the color wheel

tint a light value of a color

tinting strength the power of a color to influence mixtures

tone a color modified by gray or a complement

toned support or ground paper or canvas having a preliminary wash or undertone as preparation for painting or drawing

transparency a quality of paint or dye that permits light to penetrate and reflect off the white surface of a support or allows another color to show through, as in a glaze

triad a color scheme having three colors with a logical relationship on the color wheel

unity the ruling principle of artistic design, in which all elements are ordered to contribute to a harmonious whole

value the degree of lightness or darkness of a color

> 'Color is a power which directly influences the soul.'
>
> WASSILY KANDINSKY

Index